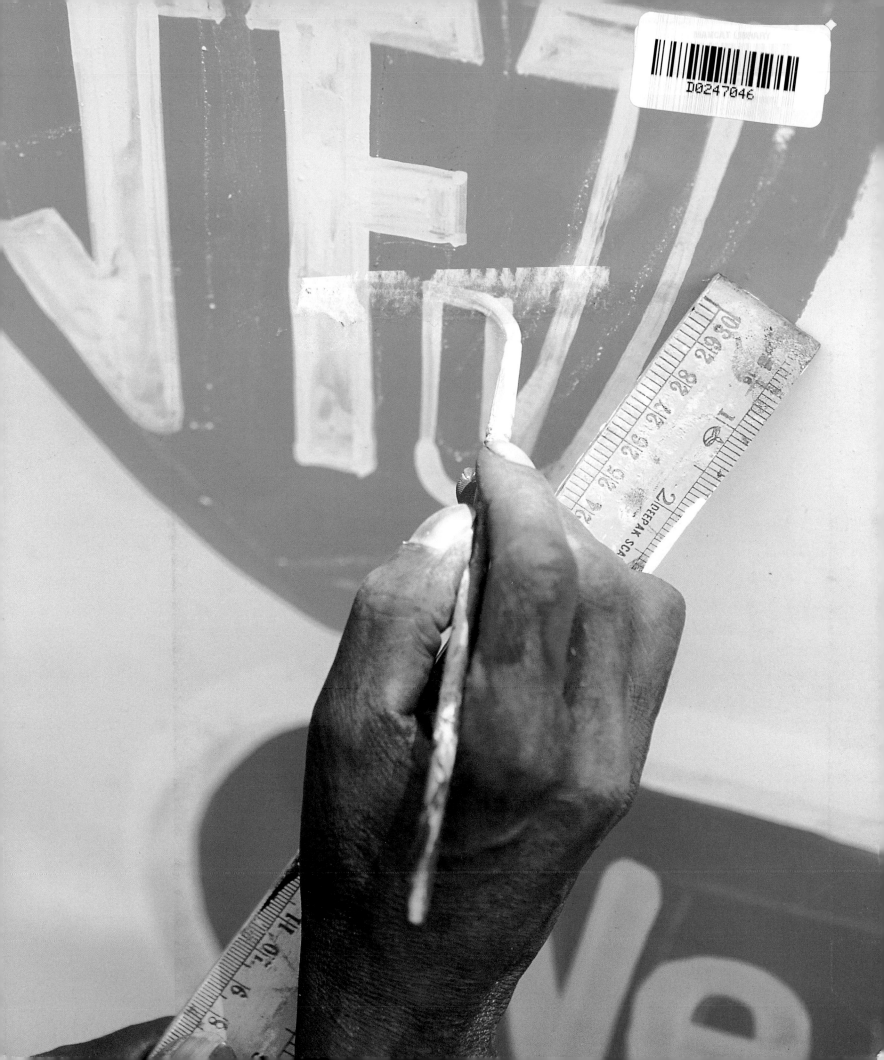

LAURENCE KING

Published in 2003 by
Laurence King Publishing Ltd
71 Great Russell Street
London WC1B 3BP
United Kingdom
Tel: +44 20 7430 8850
Fax: +44 20 7430 8880
e-mail: enquiries@laurenceking.co.uk
www.laurenceking.co.uk

Copyright © text and design 2003
Keith Lovegrove

A catalogue record for this book is
available from the British Library.

ISBN 1 85669 333 3

Printed in China

Photography by Andrew Hasson

Graphicswallah

GRAPHICS IN INDIA

Keith Lovegrove

Introduction

'Wallah' is an Anglo-Indian word that describes a person who is employed or, to a lesser extent, volunteers to do a task. It is a common term in the Hinglish (Hindi-English) vocabulary and can be tacked on to any trade or activity – for instance, taxiwallah, dhobiwallah (washerman or washerwoman) and every rajah's favourite palm-swinging servant, the punkahwallah.

This book is dedicated to the graphicswallahs who ply their trade across the Indian continent. From colourful advertisements for domestic consumables and escapist entertainments to dour municipal public information announcements, they reflect Indian life and offer a graphic clue to understanding the country's complex social structure. Conversely, Indian street graphics can distract both visually and psychologically from social reality. The all-pervasive forest of hoardings is usually a static but sometimes mobile veneer that, for a moment, diverts attention away from the people, religion, poverty, wealth and all the other ingredients that make India unique.

PAGE ONE The low-tech tools of the traditional signwriter.
PREVIOUS PAGES Naive simplicity: a symbol painted on a tour bus visiting the Gateway to India monument in Mumbai.
ABOVE Sundowner: the last rays of sun illuminate an advertisement on the wall of a bicycle repair shop in Tiruchirappalli, Tamil Nadu.

Today's graphicswallahs are shopkeepers, professional signwriters, creative advertising executives, film hoarding painters and anyone who puts felt tip to paper, oil to canvas or inkjet to vinyl. To encounter street graphics in India is to experience a metaphorical slapping of the visual senses, from a fleeting glimpse of an abstract letterform in psychedelic colours to the textures and complex narratives of the film hoardings of southern India. Colour palettes seem boundless and innovation reflects booming commercial growth, resulting in a plethora of concepts. This book is not a definitive guide to graphics in India, but a selection that celebrates the idiomatic creativity of Indian commercial art.

Contents

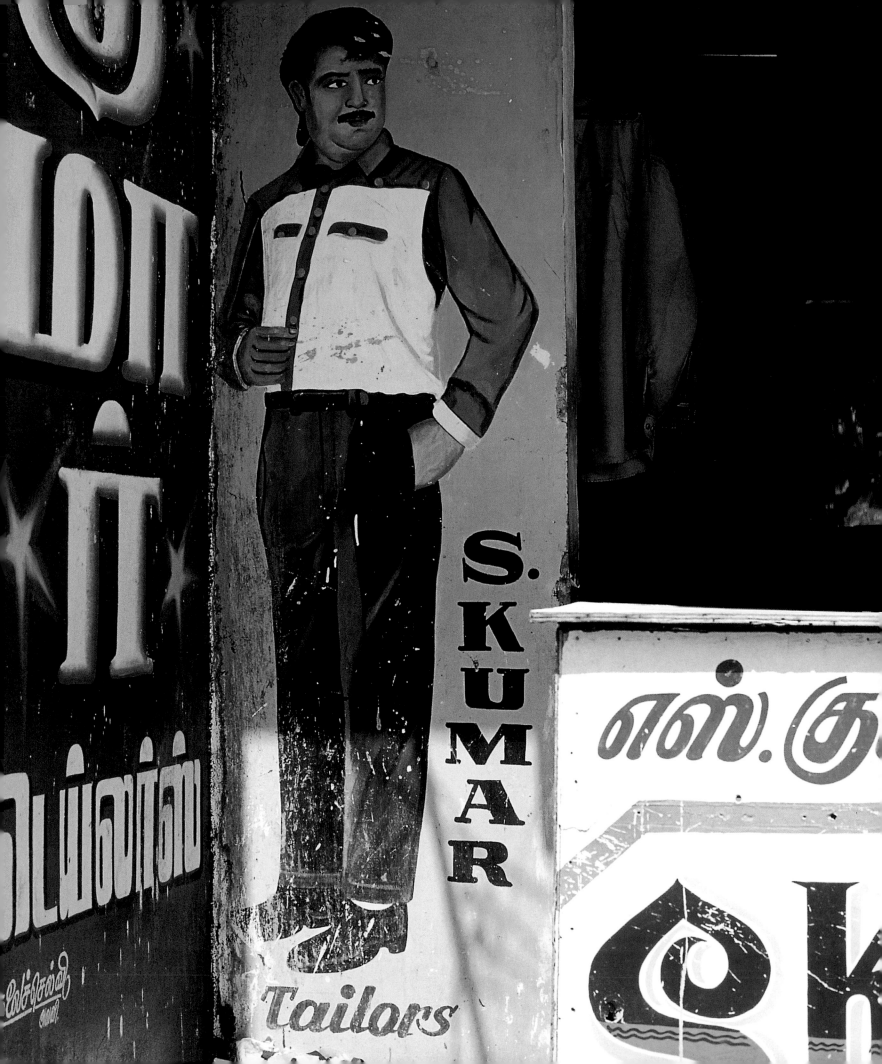

FACING Bespoke haute couture: a lone tailor with a foot-powered Singer sewing machine trades from the suburbs of Madurai in Tamil Nadu. **ABOVE** Closed for business: the front shutter publicizes the shop's wares with graphic simplicity.

Trading partners

India is rich. It is a land saturated in diversity, yet it has one of the most unique national identities of the world. India's topography, people, food, politics and religion meld into a colourful cultural *masala*, and commerce is at its heart. The country's location between the Arabian Sea and the Bay of Bengal, on the trade route to the South China Seas, has resulted in thousands of years of outside interest. The West's popular perception is that international trade began in 1498 when Vasco da Gama landed at Calicut on the west coast in what is now called Kerala. In fact, the Romans, Arabs and Turks had been trading on that particular coastline for centuries before the Portuguese arrived.

The Indus Valley civilization is one of the oldest in the world. There is evidence of agricultural settlers in the region as early as 8500 BC. Aryan tribes from southern Russia and Mesopotamia were the first invaders with serious intent, colonizing the Punjab in 1500 BC; as a result, in the 20th century Nazi propagandists claimed German descent from the Caucasian marauders. The Aryans merged with the earlier inhabitants. This mixture of settlers and invaders created classical Indian culture; what became one of the world's earliest urban

civilizations was scattered over the northwest of the country. Political government moved east and commerce and religion motivated many powers to influence Indian society. In the Vedic-Aryan period, the Aryans introduced a caste system and created sacred Sanskrit texts known as the Vedas. Combined with later texts, these philosophical teachings developed into Buddhism and Hinduism. The foothills of the Himalayas were the birthplace of Buddhism and Jainism, while Hinduism subsequently spread to be readily adopted by the majority of India's population. Invaders into the subcontinent from the northwest and the Sultanate of Delhi's rise to power introduced Islam. Sikhism has made a widespread and distinctive contribution, while Christianity has been espoused by millions for almost 2,000 years.

 The first of many peoples to migrate to India and settle are now a very small percentage of the population. India's original native people were descended from the earliest migrants of the African continent. The Dravidians of southern India originated in Central Asia, coming from the Mediterranean thousands of years before the Aryan invaders. Today, the ratio of settlers to invaders has balanced out in favour of the former and the only raiding now being practised is of the corporate kind.

ABOVE An advertisement for a sari shop reflects the colours of the brightly painted ancient gopurams of the Sri Meenakshi temple in Madurai.
FACING A contrasting colour palette highlights the brand. Anchor manufactures electrical goods.
OVERLEAF A rural idyll is invaded by advertising hoardings.

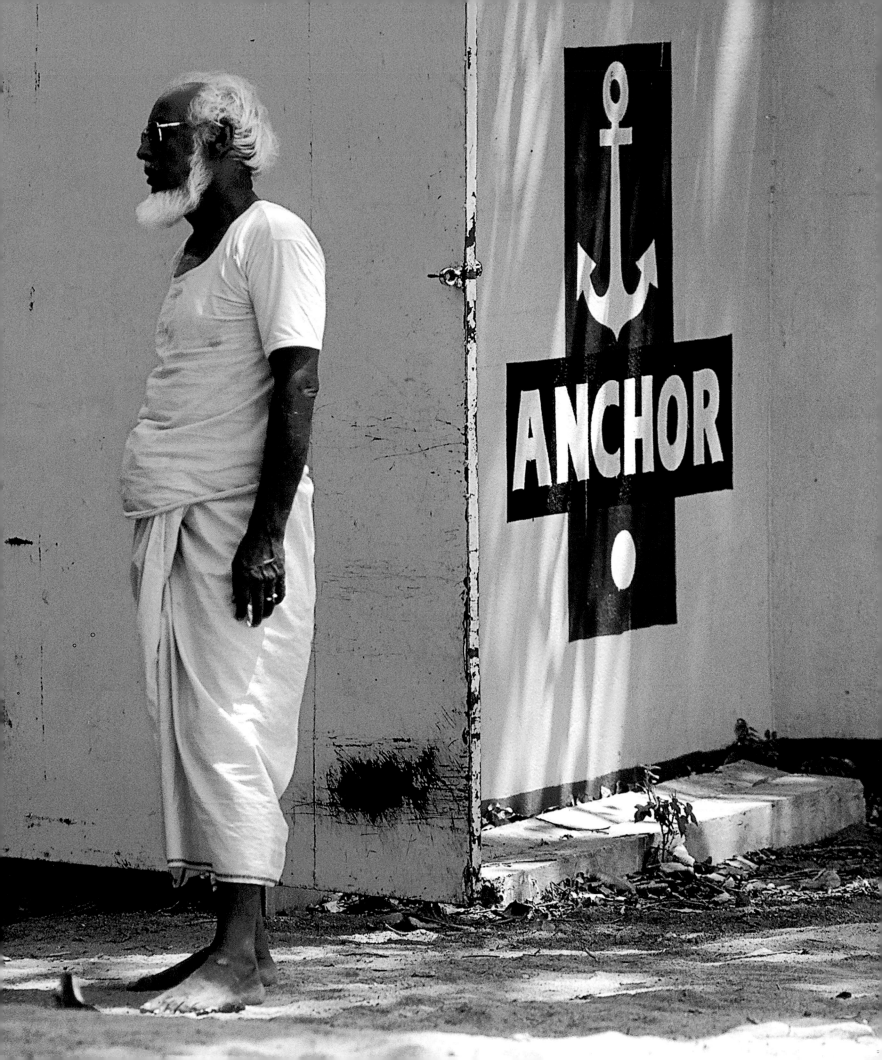

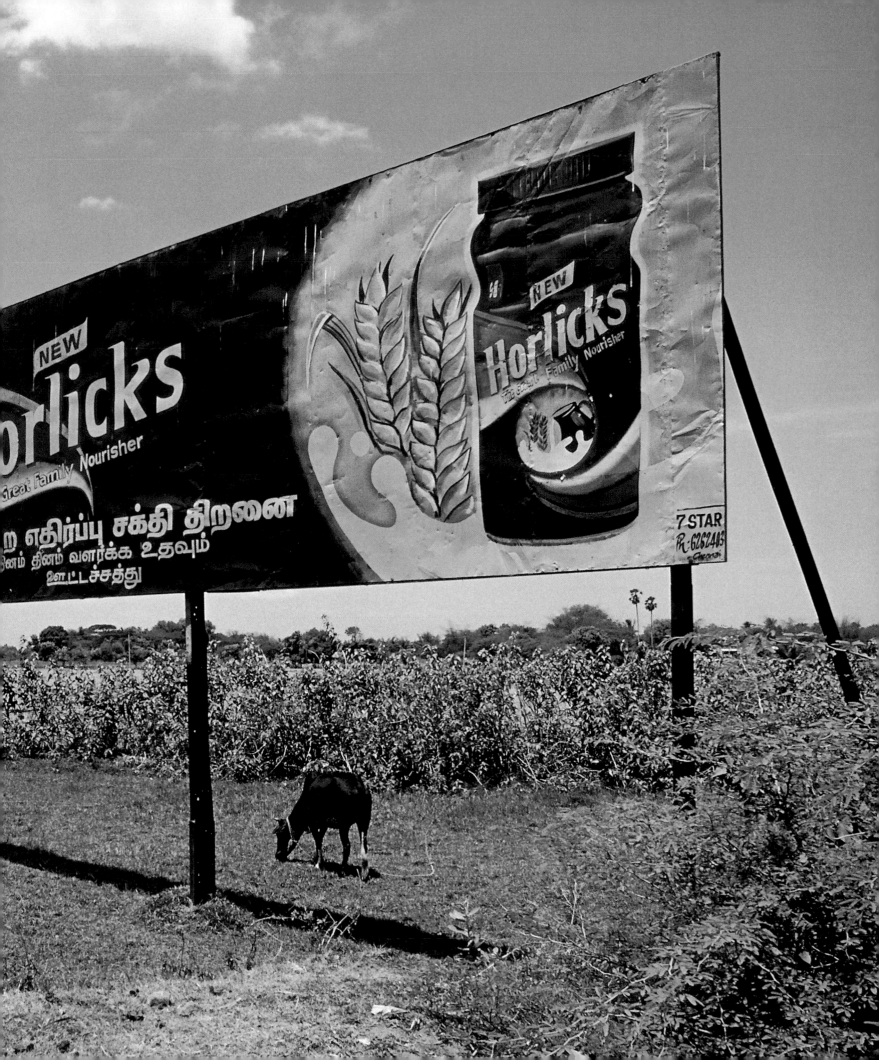

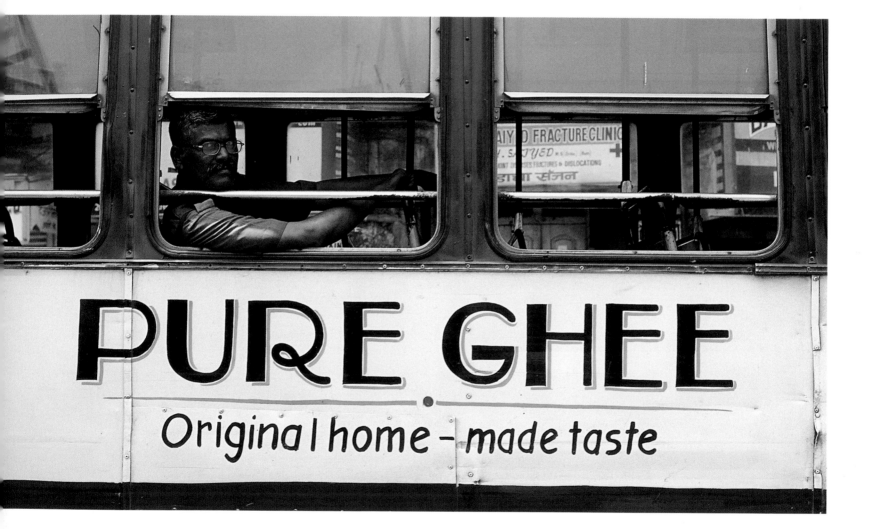

PURE GHEE
Original home-made taste

In the 17th century, India was a popular destination for European travellers – Italian, Dutch, French and British. The trading companies, chartered by their respective governments, followed closely on the heels of the adventurers and missionaries. Their primary interest was Indian textiles – silk and cotton. Other merchandise soon became part of the accelerated international trade. By the late 17th century, the foreign trading companies that had set up in India found themselves in fierce competition, and by the next century the British had established their dominance. The administrative enterprise of Warren Hastings and the military campaigns of Robert Clive had significantly contributed to establishing Britain as the dominant power.

The threat presented by the East India Company only became apparent to Indians when the British policy of divide and rule was already in practice. Trade was key. The East India Company, though merely a commercial enterprise, began to govern India. Almost two centuries of British rule challenged Indian culture and changed the political, economic and religious structure of the country. Machiavellian strategies and governance loosely disguised under the banner of Foreign Policy were used to collect taxes and to commercially exploit natural resources and native labour. By the beginning of the 19th century the British government and British

ABOVE An off-duty policeman commutes by bus through Mumbai's busy traffic. Ghee is a clarified butter used for cooking.
TOP LEFT A street vendor's cramped display of some of India's favourite snacks.
TOP RIGHT The Tiger logo on the side of a delivery van. Tiger biscuits are manufactured by Britannia, whose catchphrase is 'Eat Healthy, Think Better'.
FACING On the road: multi-panelled metal hoardings buckle in the heat of the midday sun.

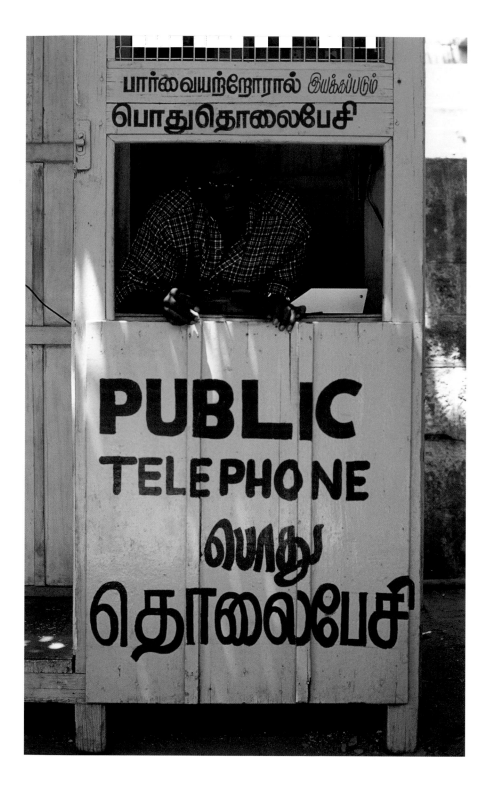

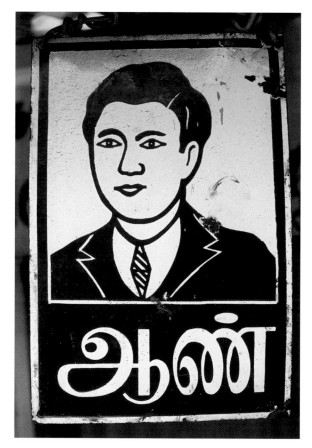

ABOVE LEFT Public telephone: a blind
man provides assistance.
ABOVE Public convenience: an enamel
sign written in Tamil directs
potential users to the Gents.
FACING Public service: a busy road
junction on the outskirts of Chennai
is watched over by officers in a
faux-brick police station.

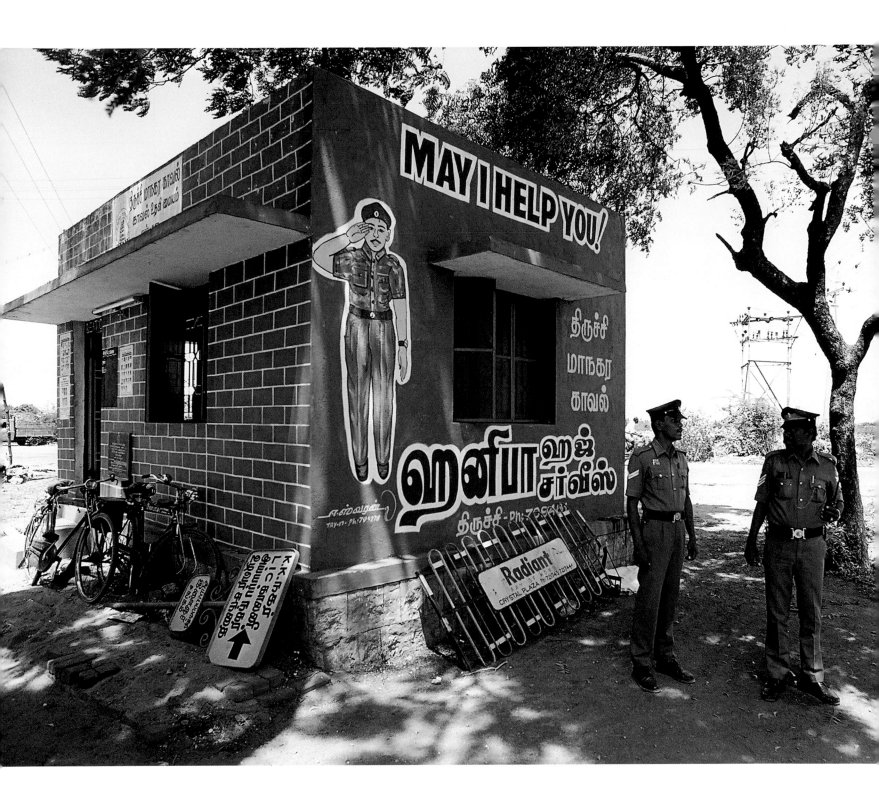

trading companies had united to intensify their authority across India. There were exceptions in the form of a few well-intentioned Governor-Generals who tried to initiate social reforms, but by the middle of the 19th century the arrogance of the foreign administration would jeopardize the status quo. After the bloody Indian Mutiny of 1857, the East India Company was abolished and control of India was transferred directly to the British crown. The subjugated Indians recognized the contradictions in the system imposed by the British and yearned for liberty. The age of national social and religious independence had begun and several decades of violent and bloody struggle for freedom ensued. A truly national movement culminated in 1915 in the arrival on the political scene of Mohandas K. Gandhi, who as the leader of the Indian National Congress adopted a doctrine of non-violent resistance and civil disobedience in his struggle for freedom. In 1947, after laborious and acrimonious negotiations, the British rescinded and agreed to transfer power back to the Indian people. With freedom came a partition of the country that caused unprecedented devastation and famine. More than one million refugees died in the disorder that ensued as the country was divided into two separate nations of India and Pakistan.

Since independence, despite its diverse ethnicity and due in part to its national characteristic, India's capacity for regeneration has been

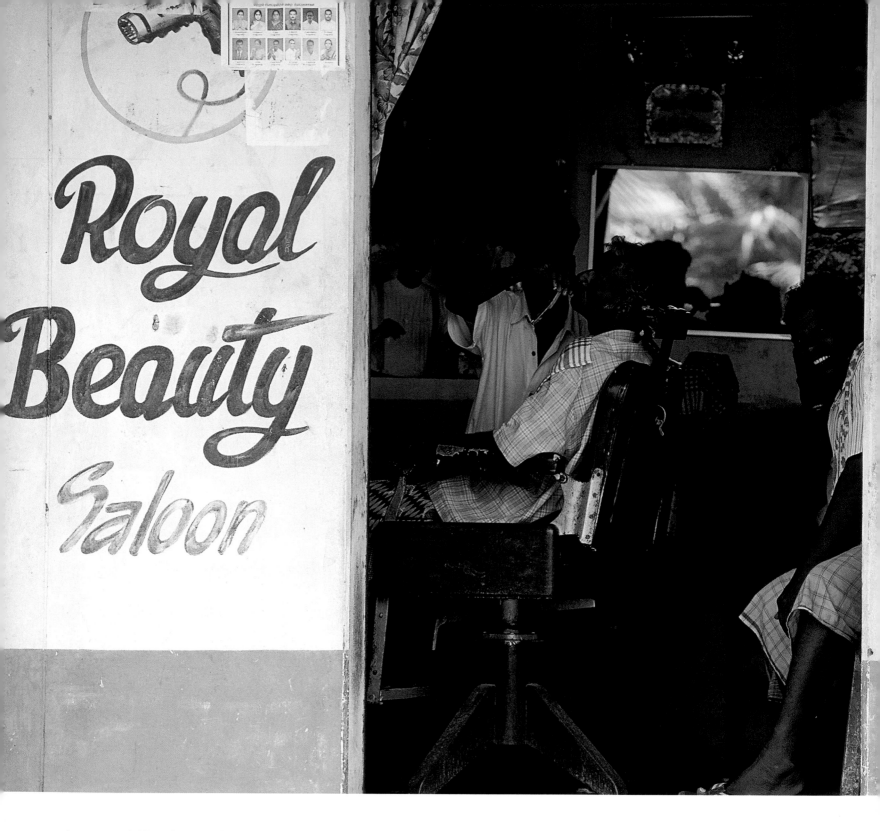

its most remarkable achievement. The country has developed a self-reliant economy and is now an industrial nation that can produce almost everything it needs – and some things it doesn't. The emergence of an authoritative and politically influential entrepreneurial class has secured national and international respect. Meanwhile, the developed international community looks on in judgment: there are fundamental concerns with India's ongoing dispute with Pakistan over Kashmir, with the added tension of the Afghan issue; there is massive overpopulation and extensive poverty, ethnic conflict and environmental degradation. But the tide is turning: India no longer needs to embrace Western culture and ideals in order to prove its role in international society; the West and the rest of the world are readily adopting and adapting Indianness into many aspects of their own social and economic structures, from entertainment to philosophy to communications. The Vedic-Aryan trading culture of 3500 BC has endured and permeates 21st-century India.

India's historical role as transit stop and home for thousands of trading generations has resulted in today's bustling market streets and urban sprawl. India has welcomed consumerism and commercialism, and the archetypal nation of service industries and shopkeepers displays a forthright personality when it comes to advertising its wares – sometimes subtle, but invariably candid. The 'direct approach

ABOVE Gentlemen's barber shops are invariably known as 'beauty saloons'. FACING A three-wheel delivery van advertises a branded Ayurvedic medicine.

16

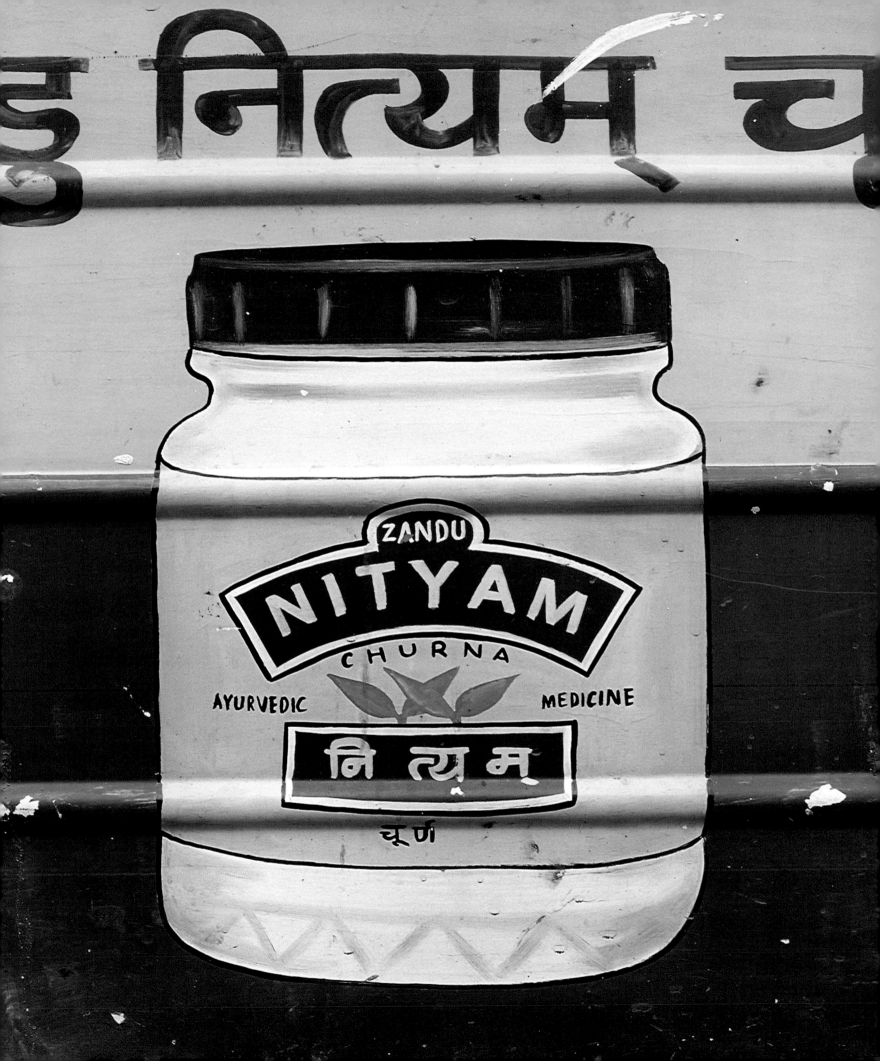

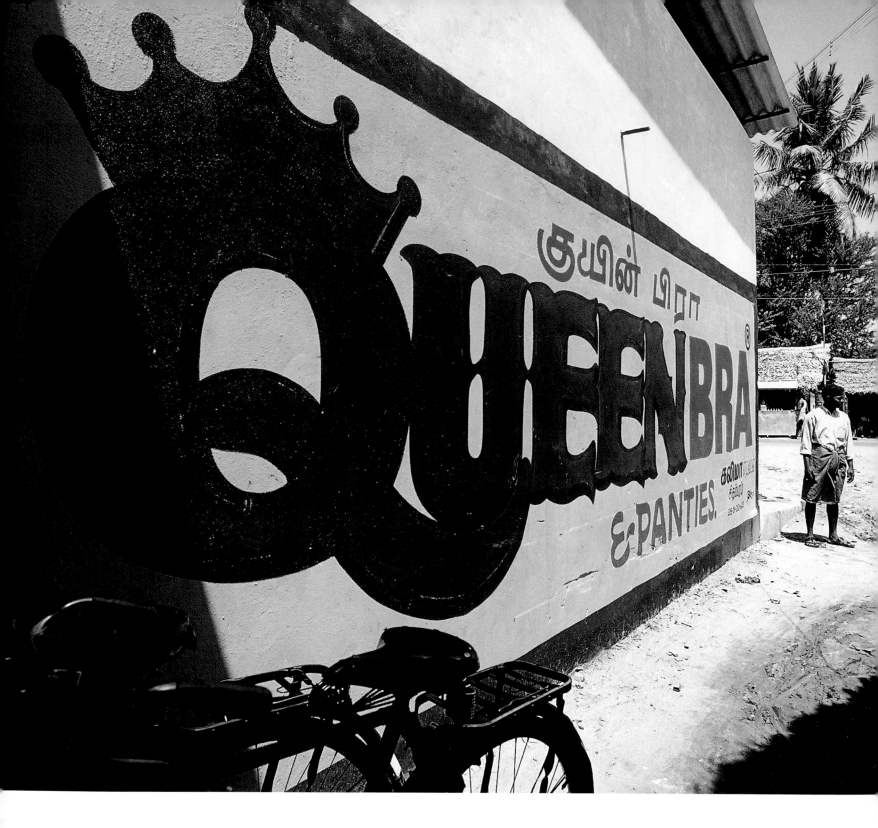

to marketing' is not only apparent in India, but wherever Indians put down their roots: from Singapore to Hong Kong, and from West London to New York City. Legions of Indian and Sri Lankan workers travel back and forth across the Tropic of Cancer on fully booked flights in airbus jets. These migrant workers are involved in every kind of profession from engineering to hotel catering. Past and present generations have brought the Indian shopkeeper culture with them. When my father was posted to Bahrain in 1969, an army of Indian workers were making an invaluable contribution to the infrastructure and administration of this small but very wealthy Arab island. In the late 1960s, commercial ventures were firmly established in the capital city of Manama. Outside our compound-protected home there was a garage run exclusively by Hindus. The garage didn't have a name; instead a simple hand-painted sign hung above the open-fronted building advertising 'Car Denting and Painting'. My father cynically explained: 'You take your car there, they bash it all over with small claw hammers and then paint it – then give you a bill.' The garage's homemade sign did explain the process more directly than the more traditional description of 'Panel Beating'. That is part of the genius of the Indian shopkeeper-copywriter – the message is clear. There is no need to guess as to what service or commodity might be on offer behind the retailer's façade.

ABOVE The incongruous positioning of some promotional publicity is illustrated by the location of this Queen Bra & Panties advertisement next to a metalwork and welding shop.
FACING A little extra revenue can be earned from allowing advertising to be painted on one's house.

18

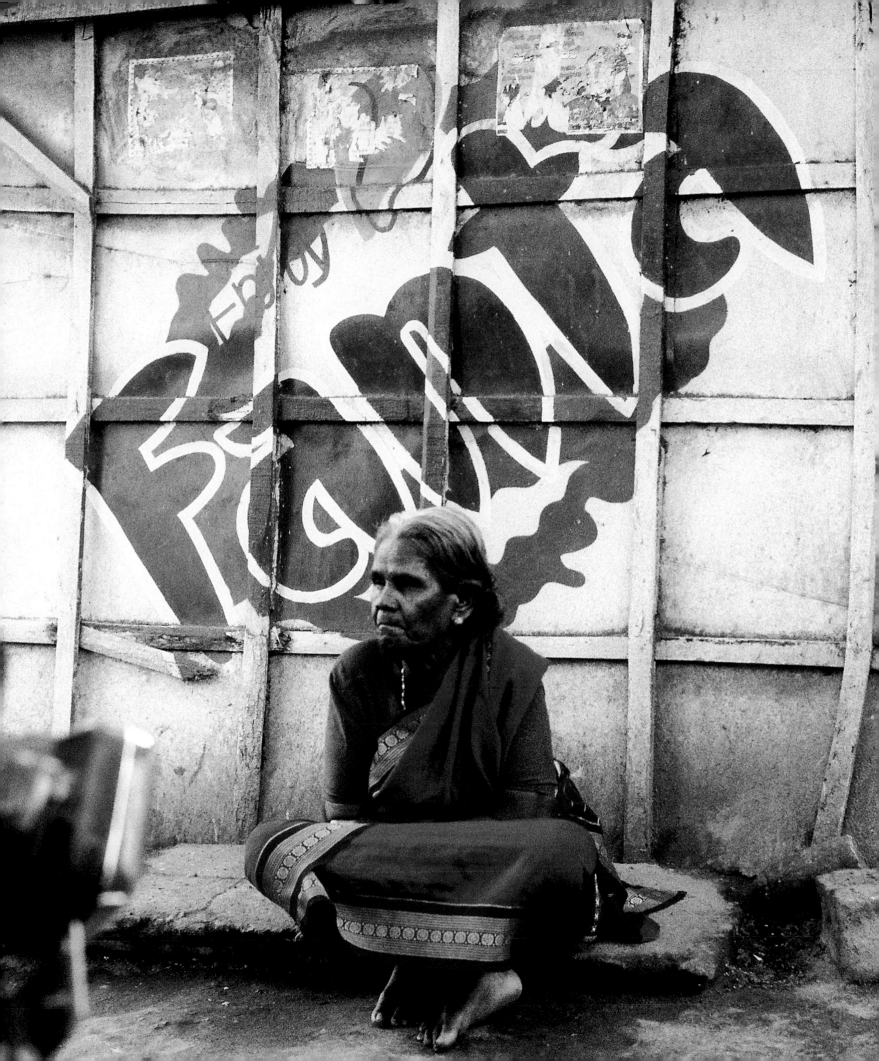

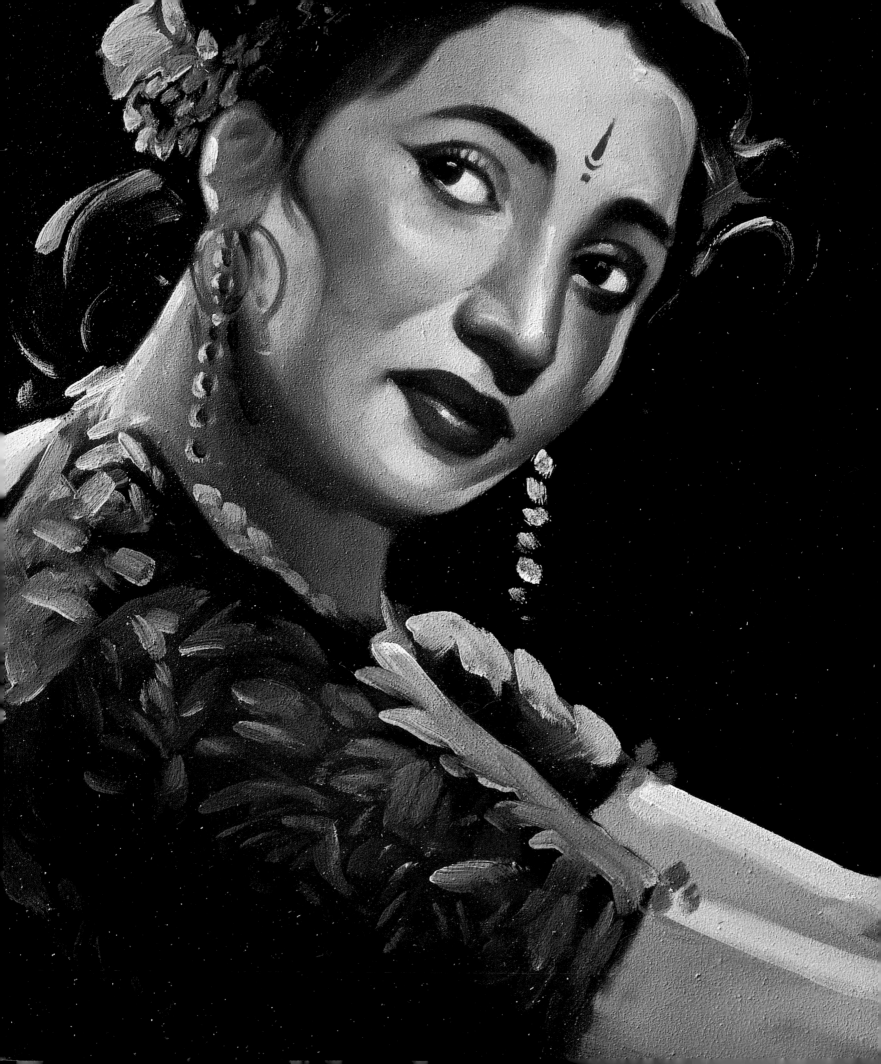

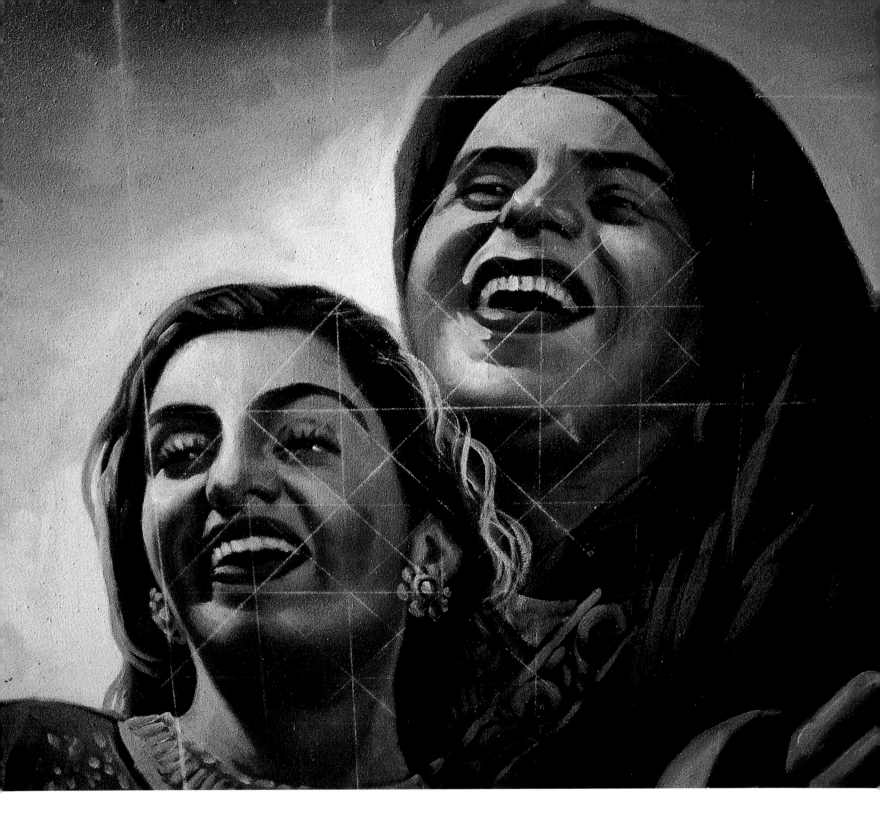

PREVIOUS PAGES A detail of a hoarding painting shows the texture of oil paint on canvas.
FACING Highlights and lowlights: the confident brushstrokes of the experienced hoarding painter animate the heroine's features.
ABOVE A taut string is immersed in a tin of blue chalk dust, stretched across the canvas and plucked to make its mark. The grid then serves as a reference to help the painter enlarge images from postcard-sized photographs. In this case the poster has been returned to the painting studio for amendments.

The hoarding painter

Not many living artists can claim to have exhibited at the Tate and the Victoria & Albert Museum in London, as well as other prestigious venues in Vienna, Florence and Zurich. For Balkrishna Vaidya, who lives and works in Mumbai (Bombay), trips abroad are becoming increasingly regular. He is usually accompanied by his son, Ujjwal, who helps him with translation and technical demonstrations. The West, it seems, now regards Indian cinema poster painting as a bona-fide art form and will dedicate important exhibition space to its unique and vibrant style.

Balkrishna is a Maharashtran – these are the ancestral fishing folk of the state of Maharashtra of which Mumbai is the state capital. In 1952, he started his apprenticeship at the Modern Arts hoarding-painting studio and spent three years sketching in charcoal before advancing to the paint brush. He now runs Balkrishna Arts, one of the few remaining film poster painting studios. His studio in northwest Mumbai is tucked away in a relatively quiet alley, away from the bustling commercial traffic of Ranade Road. It is difficult to imagine how the enormous hoardings can be produced in such a small space. Most film hoardings are about 8 by 16 feet. The largest

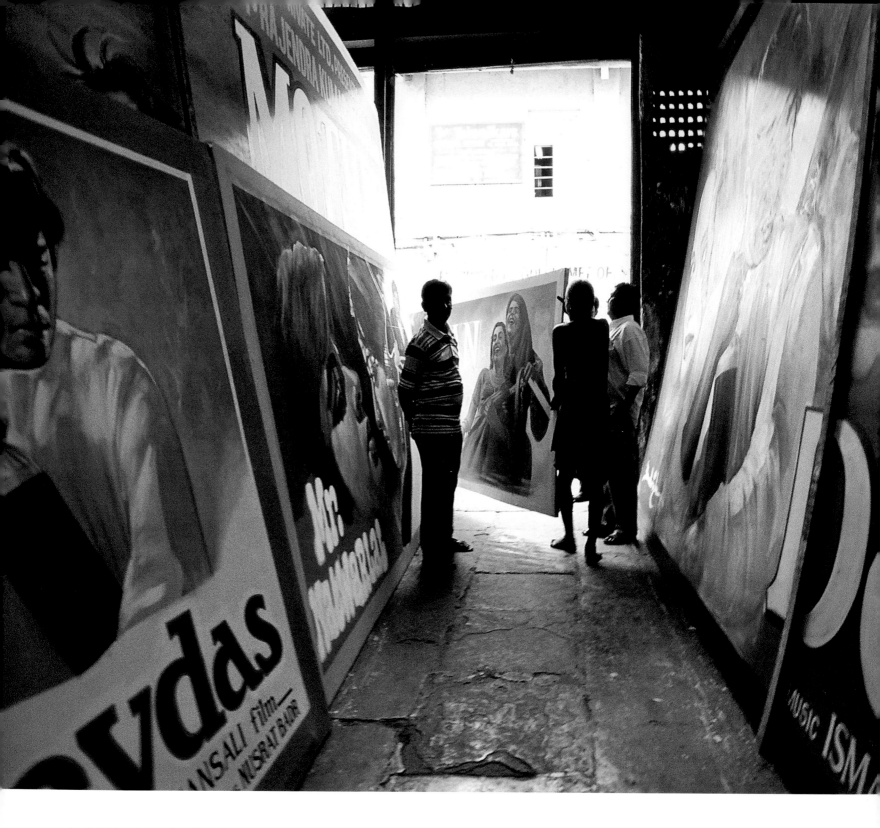

that Balkrishna has produced is 60 by 40 feet, which his team made in six pieces. His studio consists of two open-fronted spaces, each of about 200 square feet with a 15-foot-high ceiling. A ladder ascends into the darkness at the back of one of the rooms into a space that is off-limits to everyone except Balkrishna. Canvases stretched over recycled wood frames are stacked on either side of the ground-floor spaces – some are finished posters and others are works-in-progress. The smell of oil paint offers a welcome respite after the traffic fumes of the busy streets. At the back of the studio, Dexion shelves provide storage for dozens of tins of oil and acrylic paint. Years of spillage have left an amalgam of multi-coloured, solidified globules on the floor that resemble the candle-wax drippings on an ancient temple altar. Above the desk a picture of a garlanded baba (a kind of guru figure) evokes religious and philosophical devotion.

 The largest of the painted posters promotes the 1957 Oscar-nominated epic *Mother India*. Its strong typography complements the image of the film's courageous protagonist, Radha. She is a young bride whose gruelling trials against both man and nature result in her elevation to the position of esteemed 'Mother' of her village. Her outstretched arm and tortured pose set against a backdrop of fiery sky and distant horizon illustrate her strength and moral resolve and offer an iconic symbol of the power of social tradition. A wiry,

ABOVE The Balkrishna Arts hoarding painting studio in north Mumbai. FACING The embodiment of Indian womanhood and the undisputed queen of Indian cinema for over a decade: actress Madhuri Dixit as the eternal enchantress Chandramukhi in the 2002 remake of the 1935 and 1955 film *Devdas*.

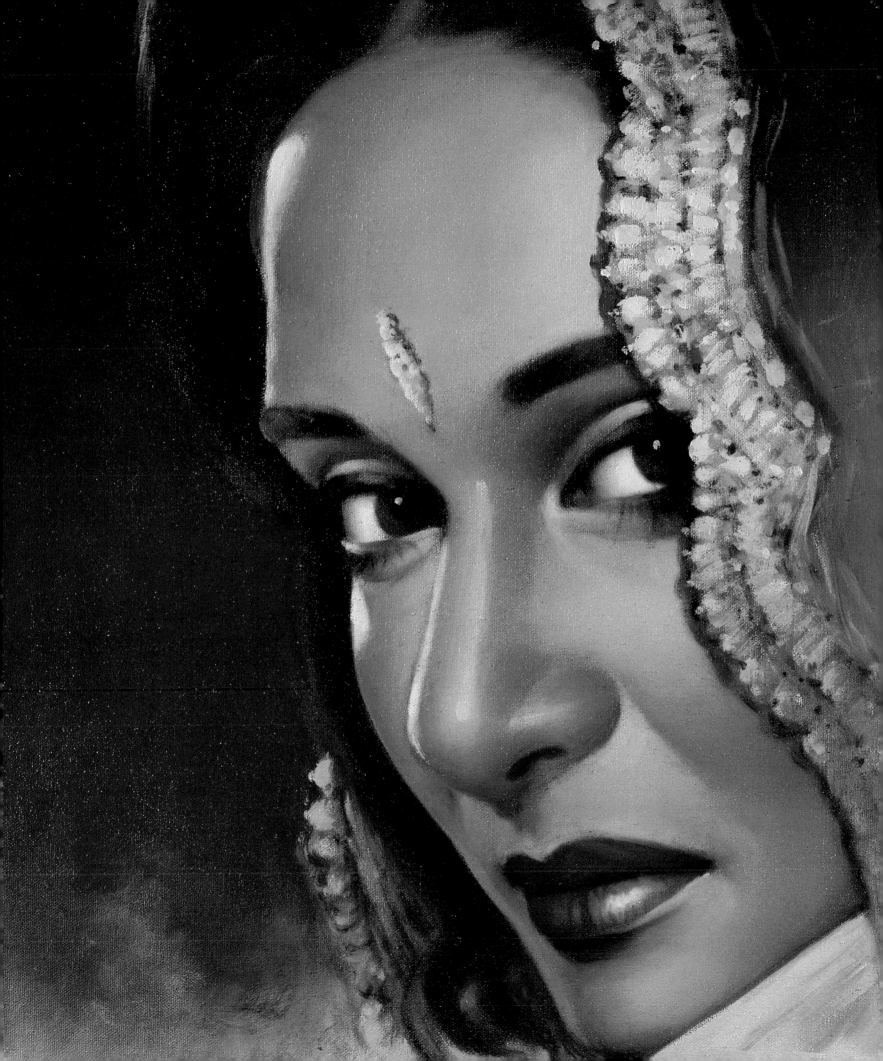

ABOVE Detail from a painted hoarding promoting the film *Aan*. Poster designers consider 'eye contact' an important element in capturing the public's attention.

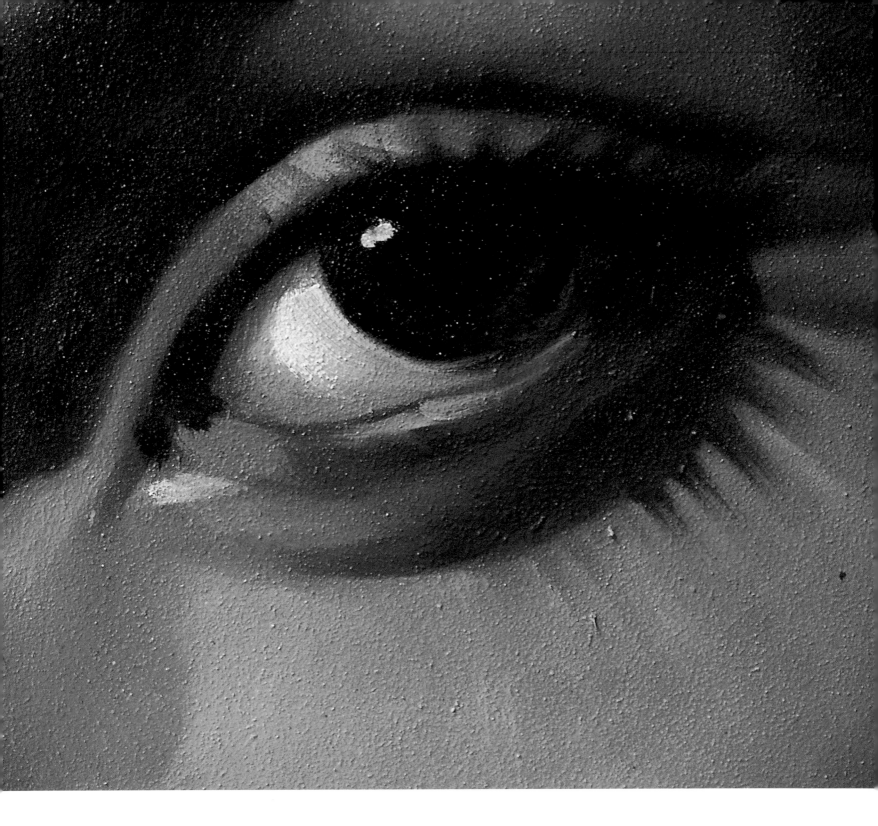

white-haired studiowallah and his young apprentice are instructed to move the *Mother India* poster so that I can see a smaller canvas promoting the 2002 remake of the 1935 and 1955 film *Devdas*. The tragic story is taken from Saratchandra Chatterjee's novel of the same name, published in 1917. The painting features the three main characters played by Miss Universe-winner turned actress Aishwaraya Rai, heart-throb Shah Rukh Khan, and the undisputed queen of Indian cinema for over a decade, Madhuri Dixit, as the eternal enchantress Chandramukhi. The rendering of Dixit's classically beautiful face is exceptional, vividly capturing the spirit of this 'embodiment of Indian womanhood', as she is considered to be by millions of adoring fans. The oil-paint portrait is at least three times lifesize and has been copied from a small photographic postcard pinned to Balkrishna's cupboard. The process begins with a horizontal, vertical and diagonal grid being applied to the virgin canvas. In bricklayer fashion, a taut string has been immersed in a tin of blue chalk dust, stretched across the canvas and plucked to make its mark. When the grid is complete, an enlarged freehand charcoal line drawing is made from the miniature postcard. Meanwhile, another studiowallah prepares a large, translucent acrylic palette on a table top and lays out the brushes in ascending order of size. Large, fist-sized blobs of oil or acrylic paint are spooned onto the palette and Balkrishna is

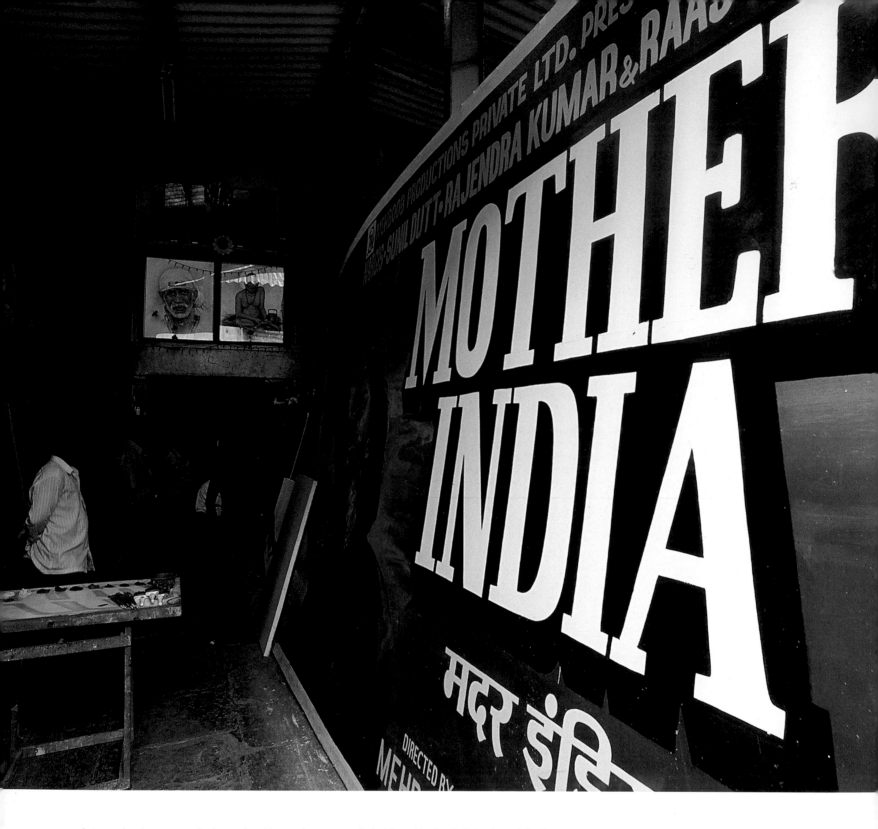

ready to put brush to canvas. Background and base colours are applied with a wide four-inch brush, and the famous faces, dramatic landscapes and bold typography take shape with a confidence that comes from decades of practice. Acrylic paint is used more often these days; vinyl is starting to replace canvas as a painting surface but has a tendency to tear. Traditional canvas is Balkrishna's preference.

I sit in the welcome half-light at the back of the studio, sipping hot, sweet tea, the perspiration being dried out of my shirt by a small but noisy desk fan that is fixed to the ceiling. Outside, in the narrow alley, another of Balkrishna's studiowallahs is stretching another fresh canvas over another recycled wood frame in the bright heat of the midday sun. This is low-tech commercial art, and I am revelling in its rawness and the lack of computer hardware and microchip-aided design programmes. The lithographic and laser inkjet-printed hoardings displayed on either side of Mumbai's wide avenues hint at the diminishing role of the film poster hoarding artist in the marketing of India's most profitable entertainment industry. But the painted renditions of the heroes, heroines and villains of Indian cinema exude so much more soul and character than the computer software-retouched photographs of the laser inkjet poster.

ABOVE *Mother India* is an Indian classic. The smell of oil paint in the Balkrishna Arts hoarding painting studio offers a welcome respite from the city's traffic fumes.
FACING Miss Universe-winner turned actress Aishwaraya Rai is represented on this film hoarding.
OVERLEAF A studiowallah lovingly dusts down a hoarding advertising *Mother India*.

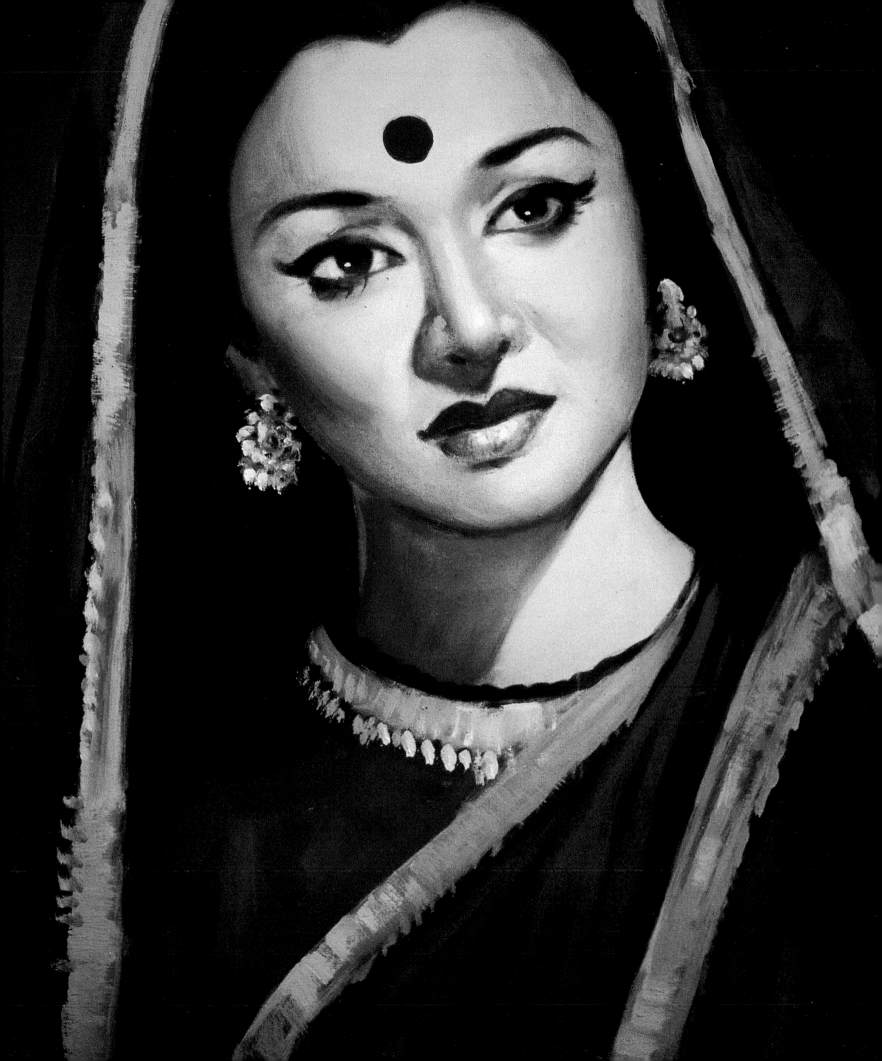

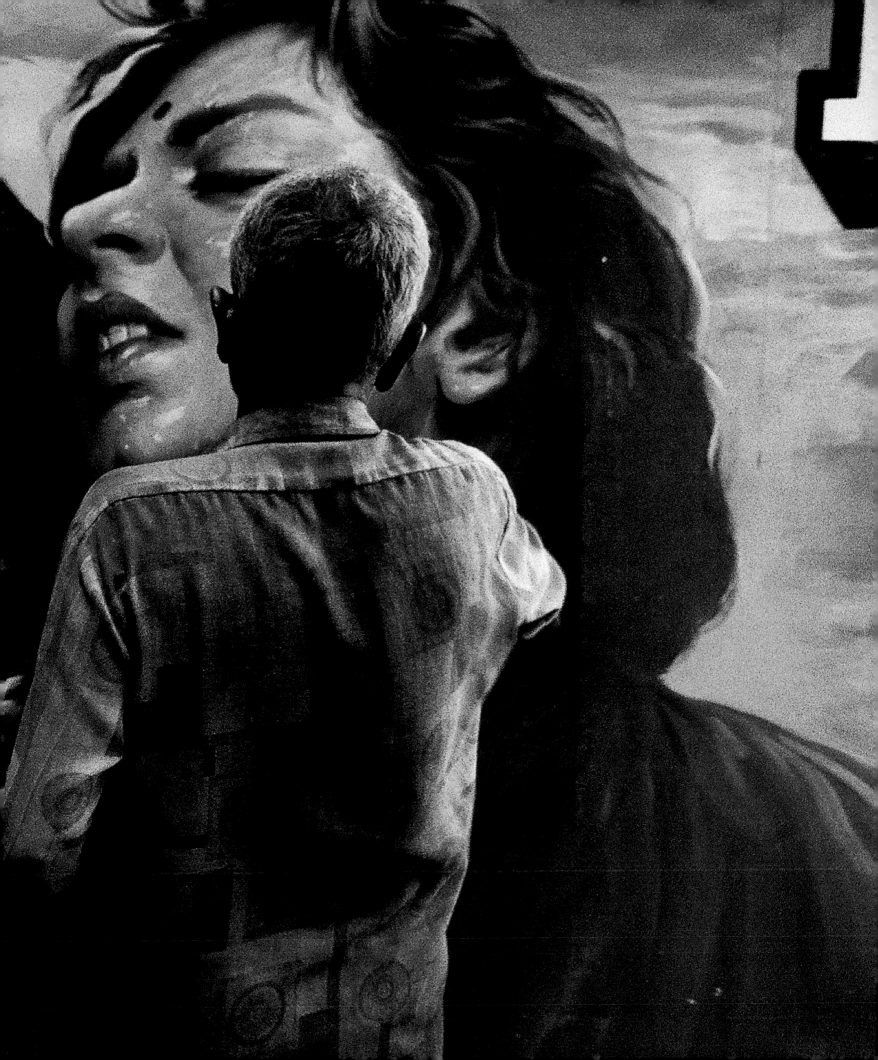

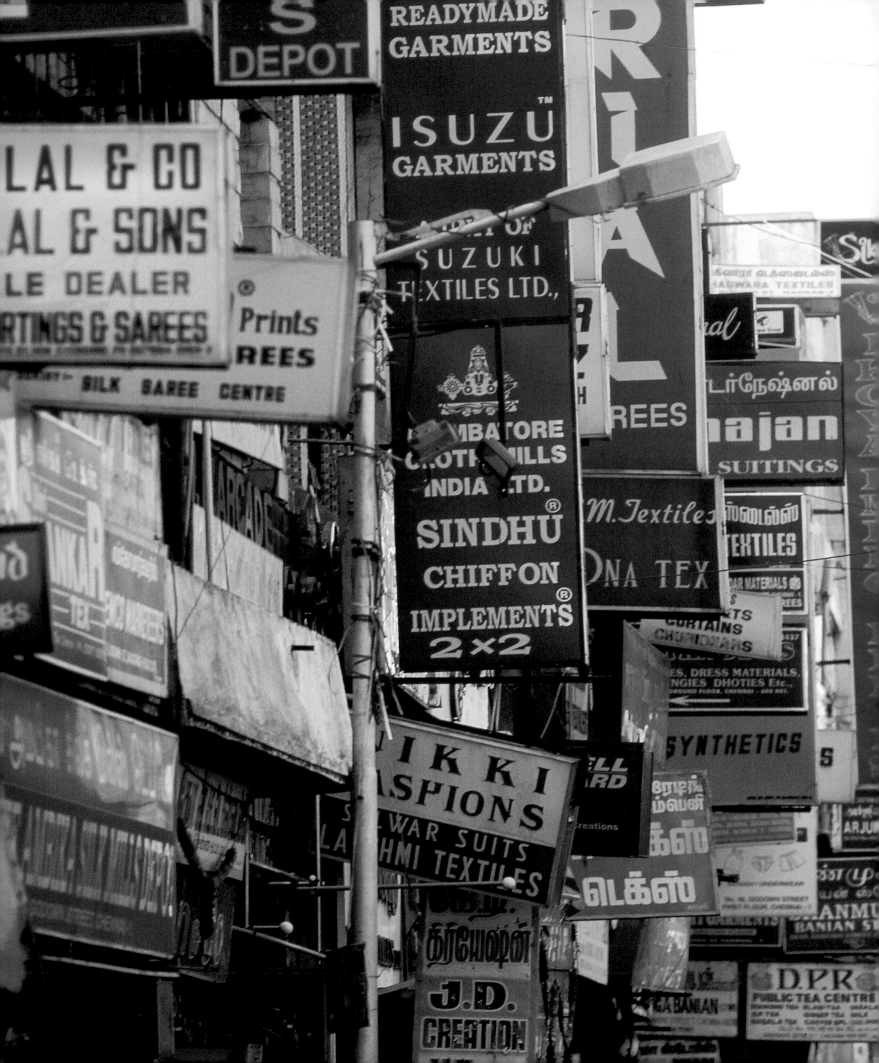

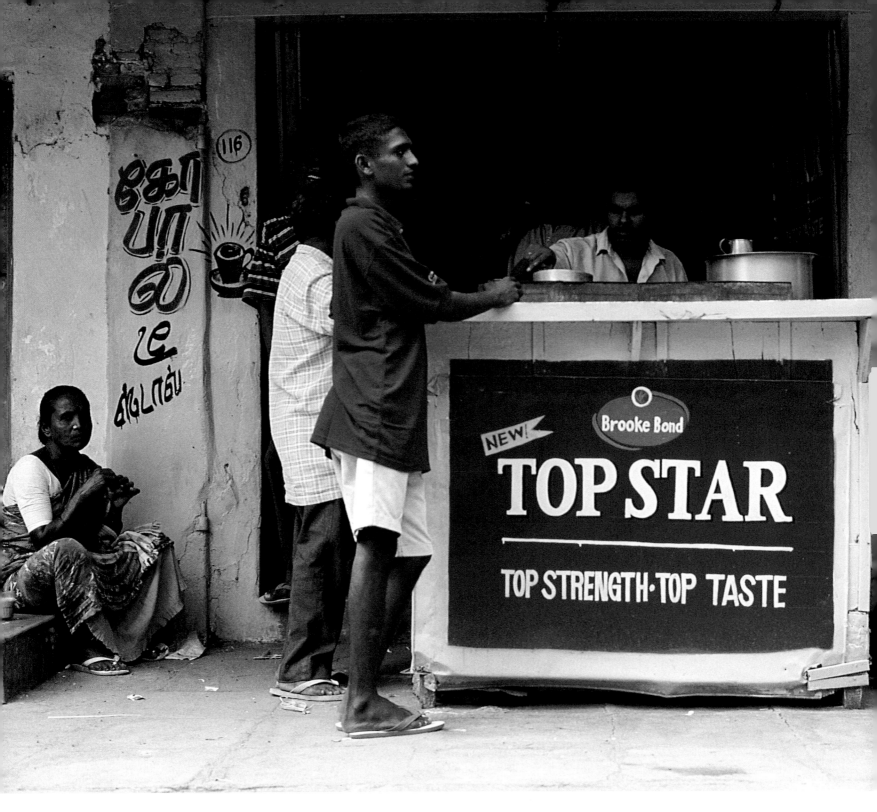

PREVIOUS PAGES Biodegradable
advertising: paper posters do not
last long in the humid climate. When
the peeling starts and accessibilty
allows, the goats step in and eat the
remains.
FACING Shop signs can confuse rather
than aid navigation.
ABOVE The street vendor serves tea
with or without milk but always with
lots of sugar.

Chennai's pyramid-selling

In marked contrast to Mumbai, Chennai's street graphics are more rustic – there's an abundance of hand-rendered visual feasts. Every possible surface that can be glued or painted onto displays advertisements, political posters and signs in profusion. In context, some warning signs deliver a contradictory message. For instance, just above the exhaust pipe of a carbon monoxide-belching corporation bus overpacked with passengers, one sign reads: 'Think! Don't burn plastics. Causes dioxins to be released into the atmosphere which can lead to cancer.' (In another contrast to Mumbai, Chennai's former name of Madras has seemingly been dropped with little nostalgia for heritage or history; the man on the street refers to the city as Chennai. In Mumbai, to the 'regular guy', as middle-class Mumbaikars call the average person, the name of the sprawling metropolis is still Bombay.)

Chennai's George Town market is as noisy aurally as it is visually, and the tiered levels of vendors reflect different social classes. Fruit and vegetable sellers display their wares in perfectly symmetrical piles, at Tarmac level, only a couple of metres from passing auto-rickshaws, cars and buses that move slowly through the low-lying smog. Salt, grapes, mangoes and beans are all arranged in neat pyramidal mounds.

35

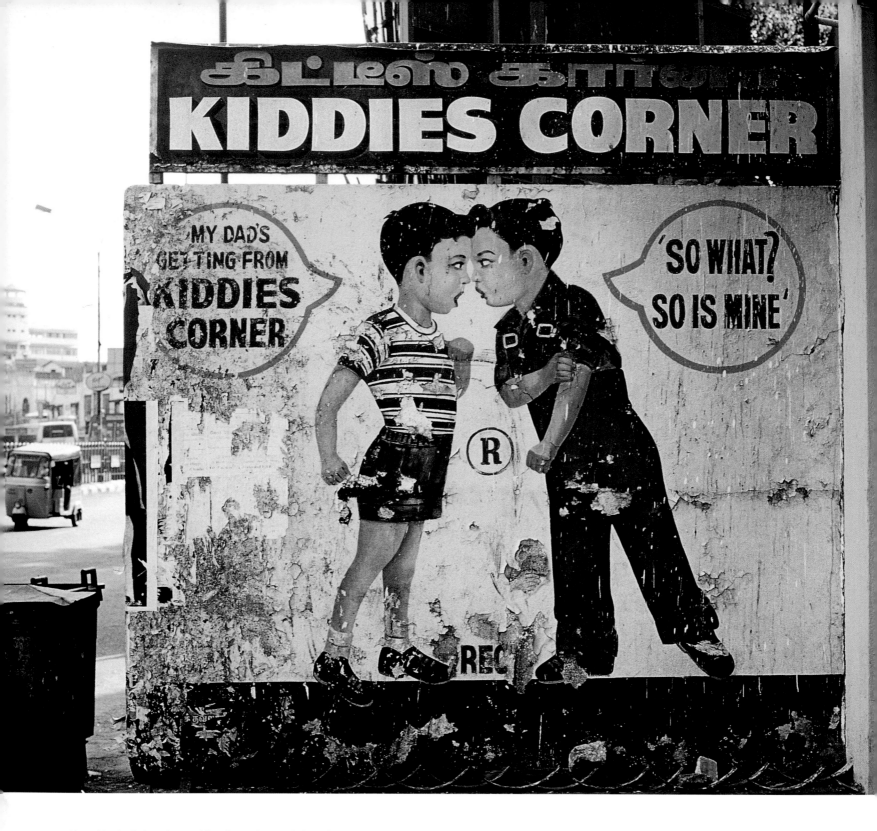

Alongside the fruit and vegetable sellers, others trade in a disparate range of commodities, from plastic rope and bottle tops to quarter-sections of spokeless bicycle wheel rims. The road-level vendors don't require advertising assistance: everything is there for shoppers to see; they either want it or they don't. Further up the retail ladder, at chest height, is the jolly trolley caterer enticing purchasers with the aroma of barbecued corn on the cob and the guarantee of 'freshly crushed' sugarcane for that mid-afternoon energy-boosting glucose drink.

At pavement level, marketing departments of differing sizes have been commissioning graphic designers to exercise their art in profusion. Walls are covered with large, hand-painted Coca-Cola logos, with an accompanying text that appears to endorse the view that Coca-Cola is a completely artificial, chemical drink: 'Contains no fruit! Contains added flavour!' Shop signs confuse rather than aid navigation; telephone boxes, washing lines, livestock and people join the melee of colours and shapes. Shopfronts, shutters and the slim wall spaces between shops adorned with vertical lettering represent the next rung up the commercial ladder, followed by signs above shops and on first, second and third floors. A commercial building with more than three floors may profit from enough advertising revenue to be able to offer the luxury of 'Air-Conditioning When Shopping With Us'.

ABOVE The copywriter opts for a confrontational theme to advertise a children's clothes store.
FACING Sunday afternoon on Chennai's Marina Beach is the occasion for family outings, which results in good business for mobile vendors.

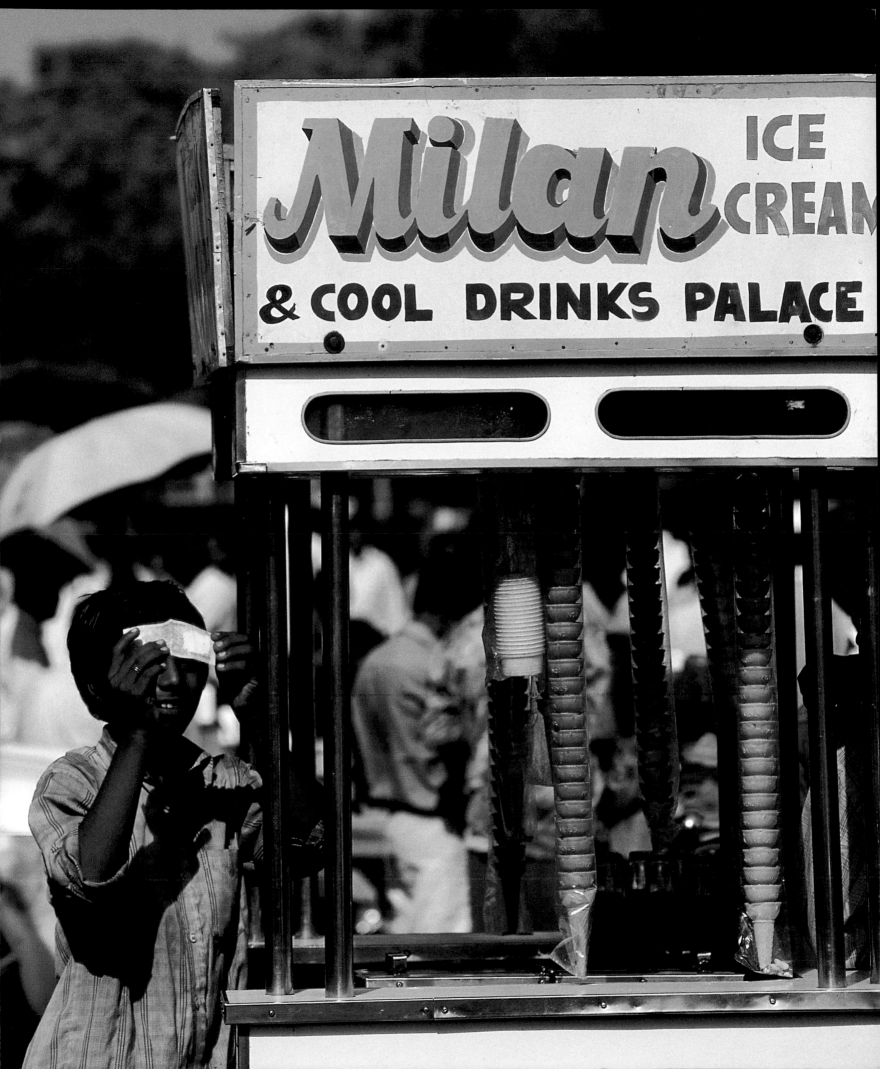

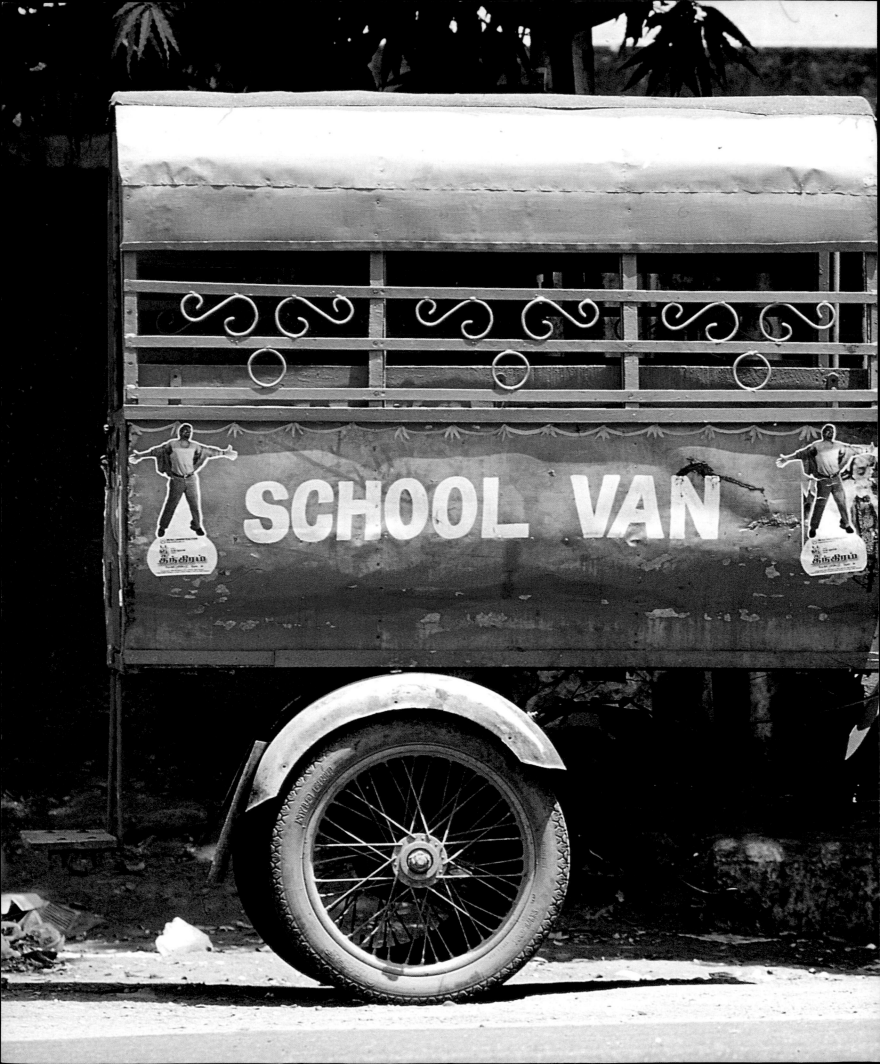

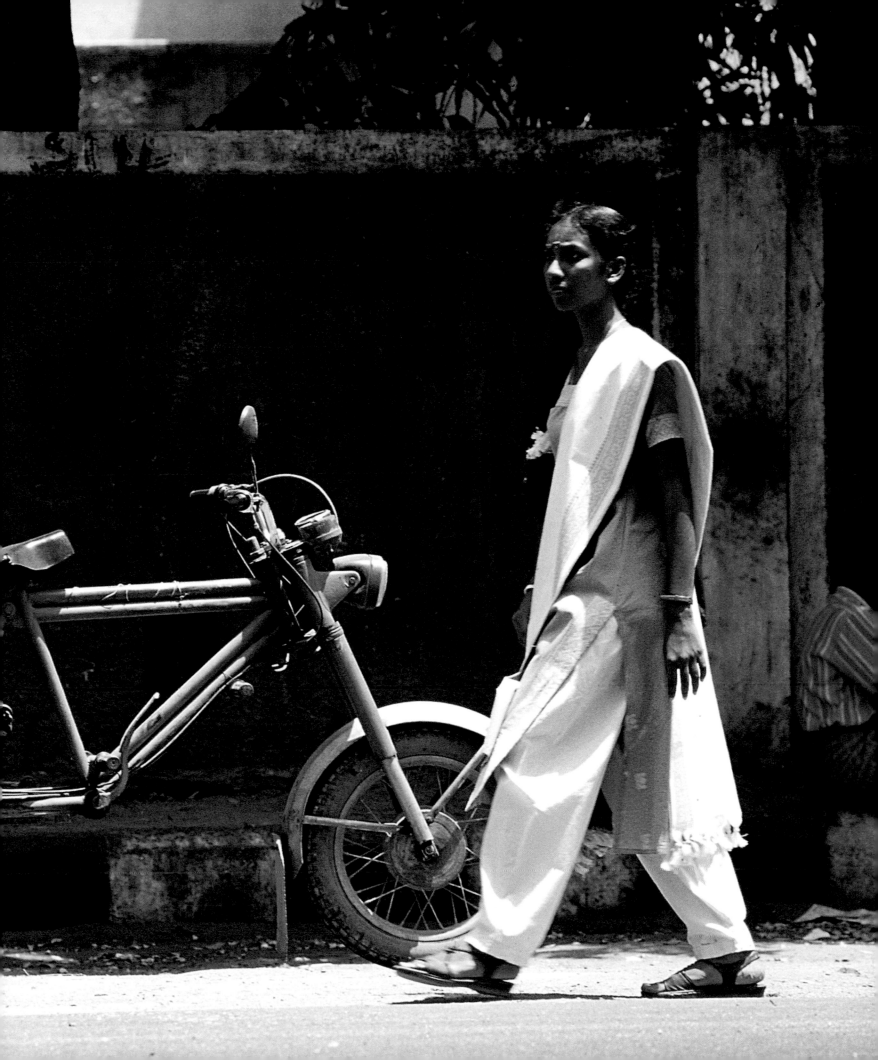

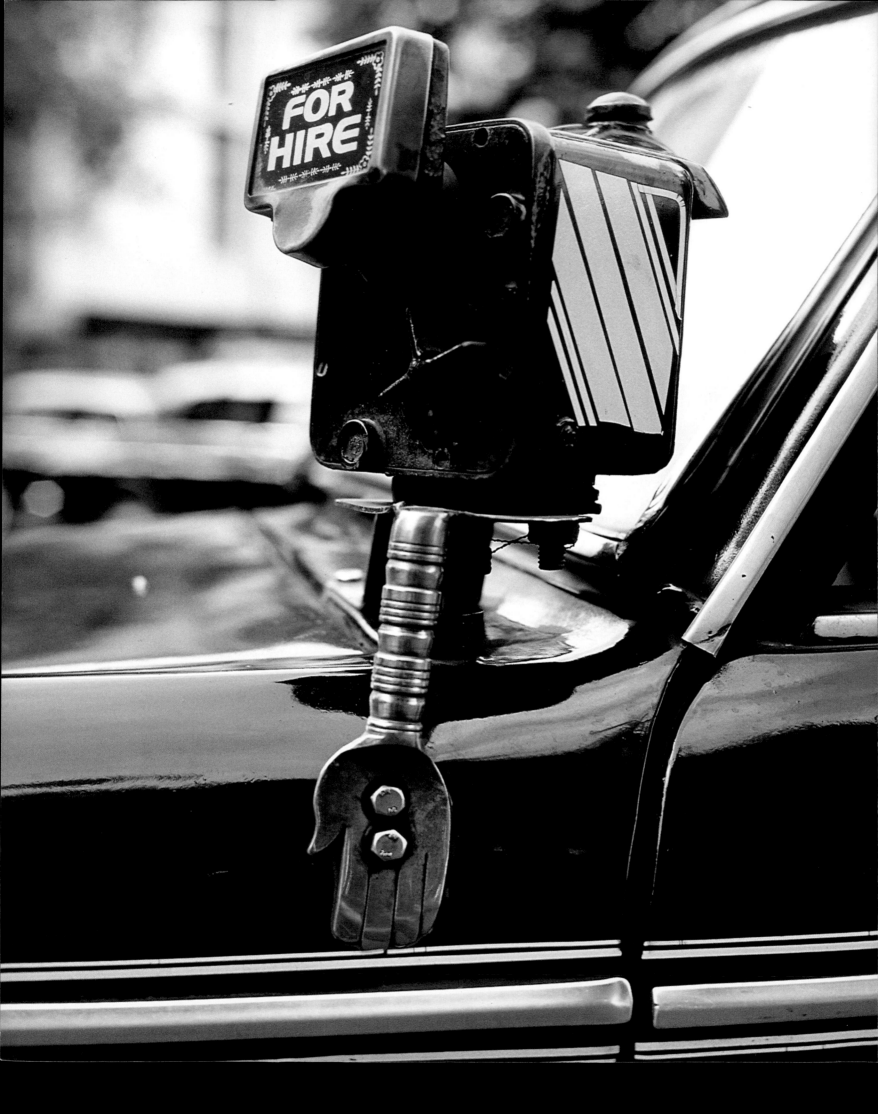

The most redundant sign

The most redundant sign in India must be the 'No Horn' traffic sign. The horn symbol is usually black on a white background, with subtle variations from one area to the next. In the temple town of Tiruchirappalli the sign artist has drawn a dainty bugle silhouette complete with curlicued holding strap. In other areas, the horn is represented simply by an isosceles triangle. Completing the design are a thick circle of red around the graphic horn and an equally thick red oblique line running from 2 to 8 o'clock over the bugle drawing – an internationally recognized symbol prohibiting horn use. In India, however, the 'No Horn' sign is the best example of ignored information graphics. Even the 'No Spitting or Urinating' sign commands more respect. But while every driver may ignore the 'No Horn' notices, the police don't. It is quite common to see a small band of traffic-division officers pointing stiff-fingeredly at guilty commuters and stopping them so that they can question and fine them. Either policemen are very adept at picking out the offending driver, or a randomly pointed finger makes all drivers feel guilty because all drivers *are* guilty. The redundancy of this particular information graphic may be due to the 'No Horn' sign's opposite, the 'OK Horn Please' sign. This blithe message is usually painted on the tailgate of three-tonne

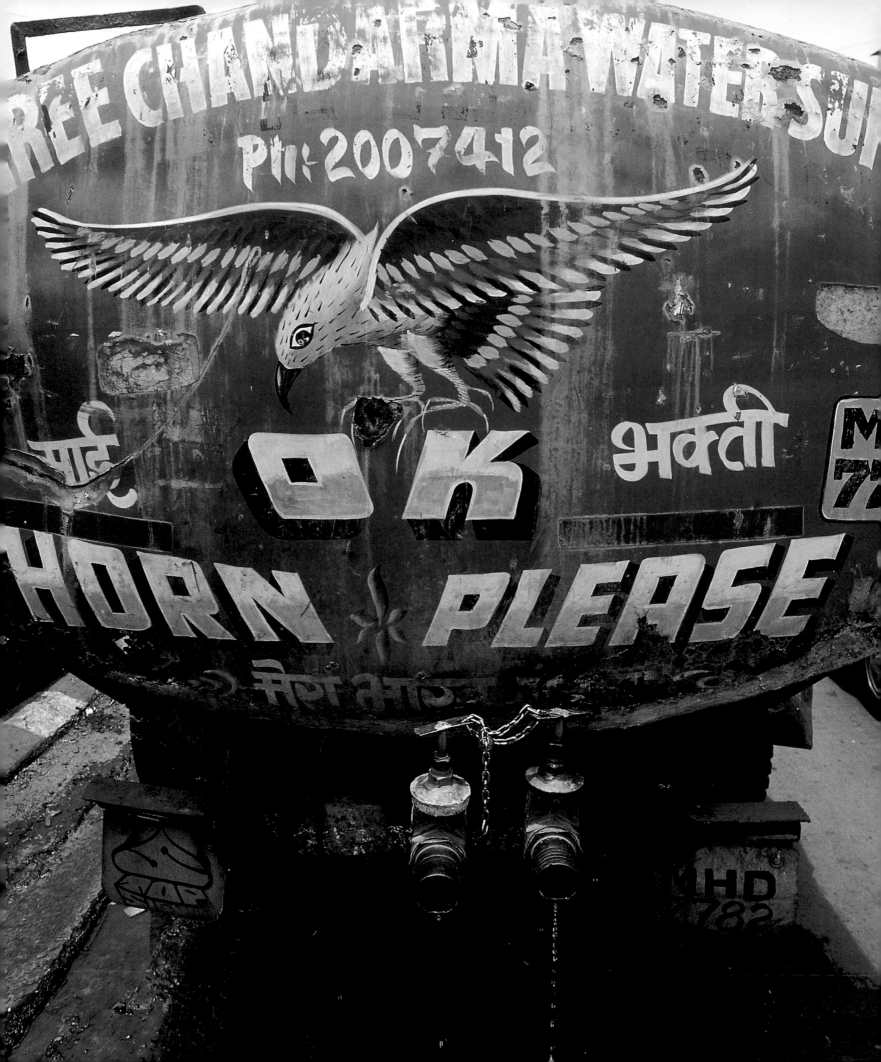

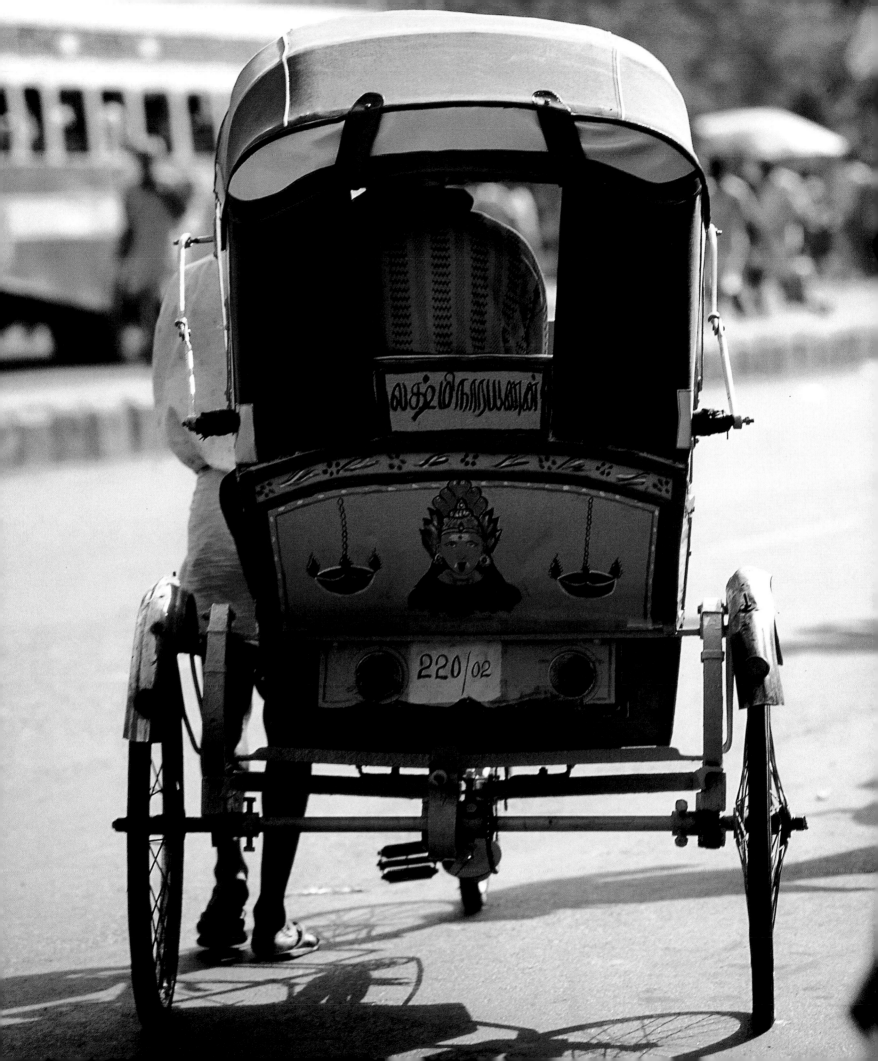

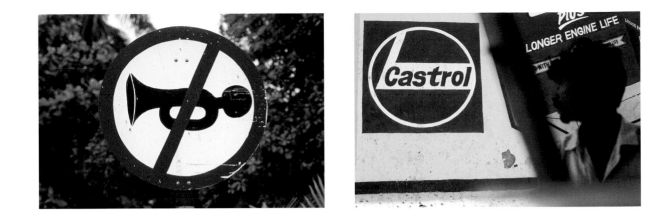

TATA trucks. A jolly typeface may be accompanied by a garish painting of the devil's face – sound your horn or face the consequences. The consequences are numerous, as are the chances of hitting or being hit by something on the highways of India. The most disconcerting part of being a passenger in India is the non-existence of single-file traffic. While you are between lanes on a two-lane road the questions run around your head as if on a tape loop: 'Is that double-decker bus with people hanging onto the open platform at the back going to collide with that overladen TATA truck, which is getting closer to that bullock cart, which is being overtaken by that family of four on a scooter… ?'

Roads in India are used by everyone and everything, from articulated leviathans to small children and chickens. They are used for getting about and getting things about, while the Tarmac also serves for drying and threshing crops under the wheels of passing traffic. Hand-carts and pedestrians are the most popular recipients of horn scorn. Hand-carts also appear as illustrations on road signs. They are listed with other vehicles including bullock carts, horse-drawn carriages and the original human-powered cycle rickshaws in a unique banner-style 'No Way' sign.

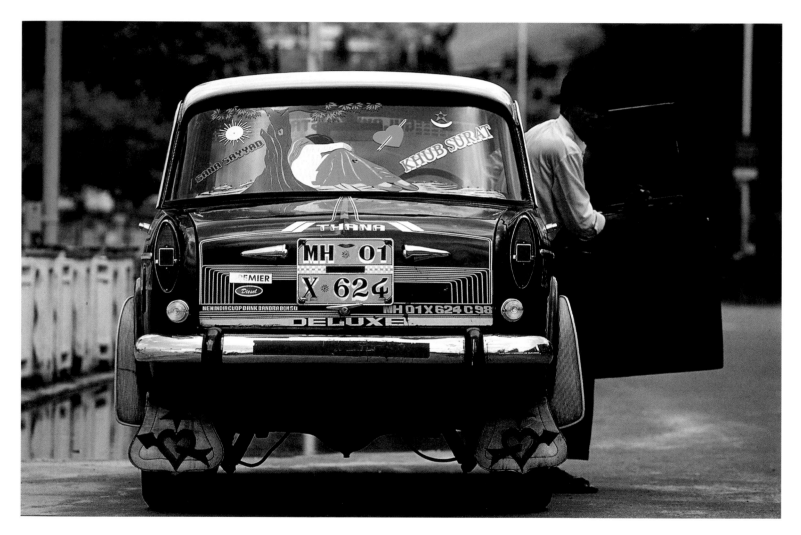

A popular subject of debate in the media and among the chattering classes alike is India's growing traffic problems. There are plenty of associated concerns to keep editors busy and dinner-party chat continuing into the small hours. In Delhi, the rickshaw is being hotly defended – the Supreme Court of India is at risk of destroying one of the first ozone-friendly forms of urban transport by introducing licences, permits and heavy fines for ignoring the law. The rickshaw-pullers are seasonal migrants whose families still live in their villages; a high proportion are part of agricultural families with small and shrinking land holdings. The socio-economic defence of persecuted rickshaw-pullers is closely linked to keeping down traffic congestion: if, due to the government restrictions, the migrant workers are not able to earn money to send to their rural families, village life will suffer further and more of the population will begin to migrate to the cities, causing more congestion. Additionally, the demise of the cycle rickshaw will mean greater demand for auto-rickshaws, scooters and other carbon monoxide-producing vehicles. Pollution is also part of the chain of consequences. More congestion leads to higher fuel consumption, which means a greater demand for cheaper and therefore lower-quality fuel, which in turn results in more toxic emissions.

ABOVE Graphic overkill: stickers, transfers and 'cupid' mudguards proudly adorn a Fiat taxi.
TOP Some vehicle registration numbers, particularly on taxis, are hand-painted directly onto the bodywork.
FACING The traffic-restriction signs are vehicle-specific.

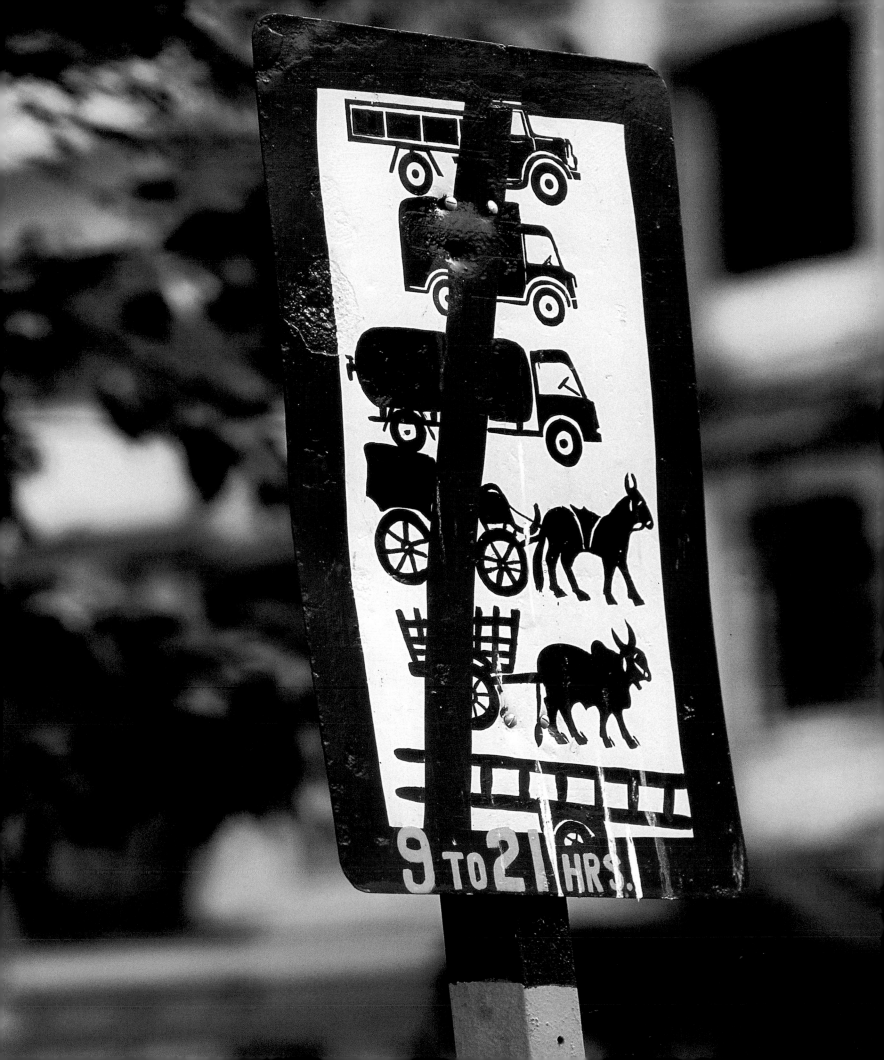

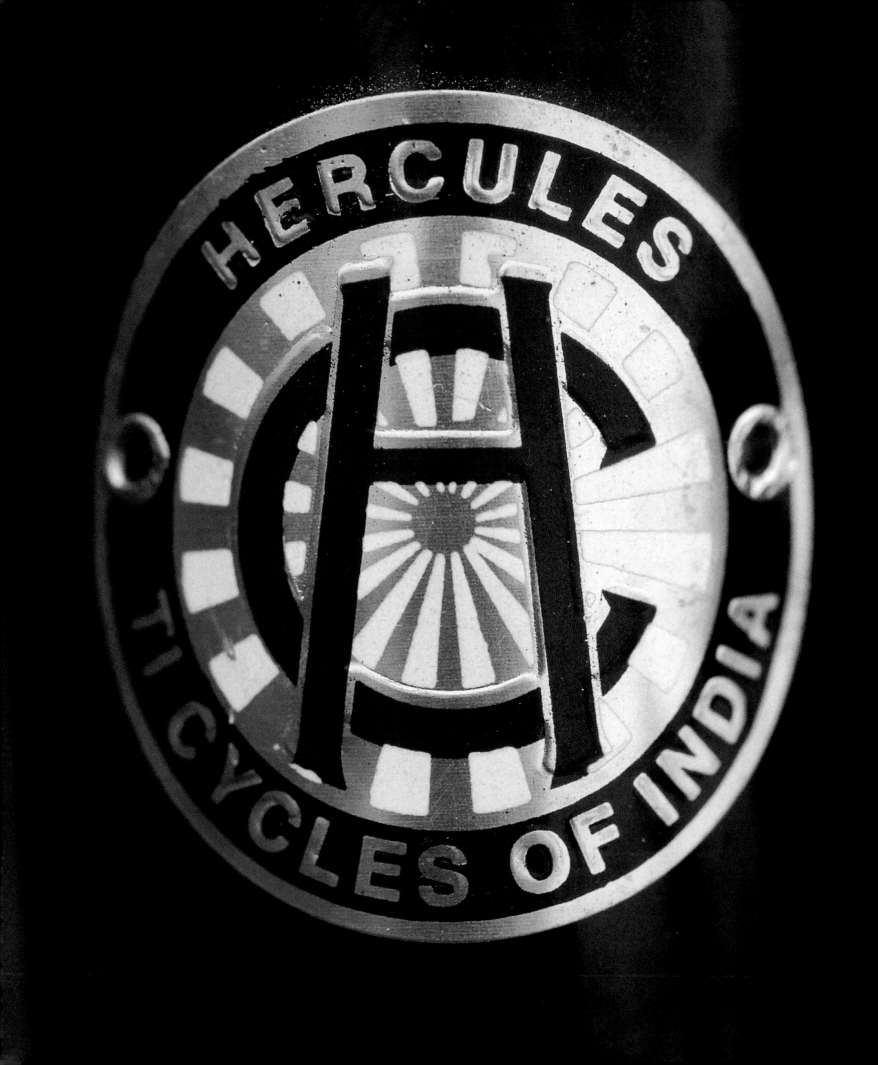

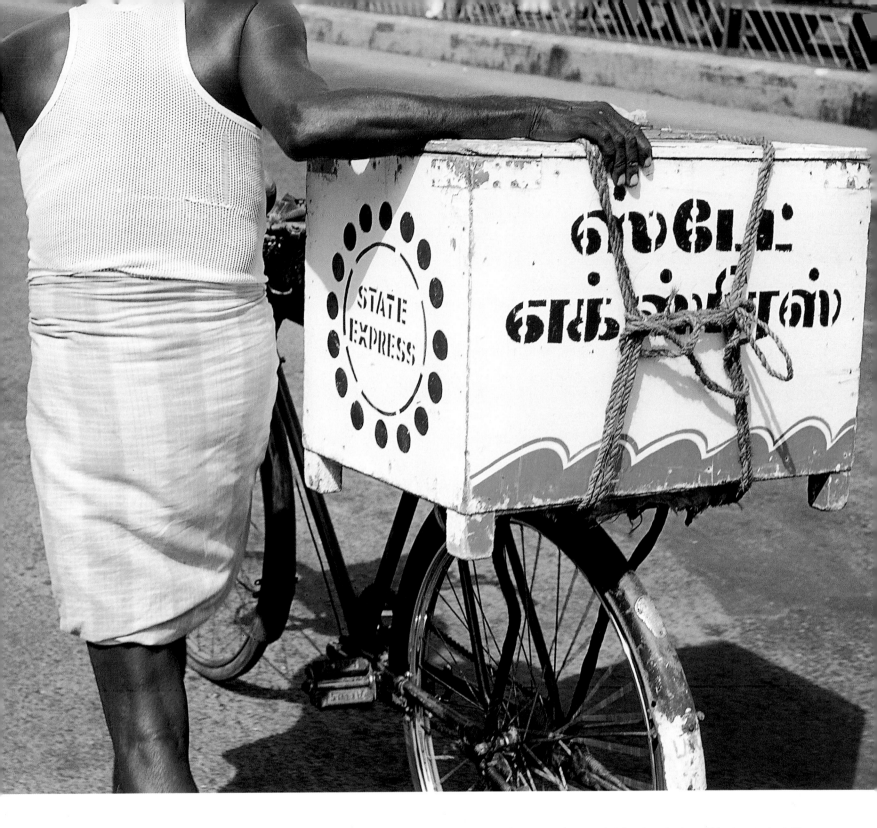

ABOVE AND FACING India's high bicycle-manufacturing output is the result of a combination of an enduring and growing domestic market with increasing international sales. OVERLEAF Chromatic contrasts: the green of a paddy field complements the dominant red background of a wall advertisement.

A faint ray of eco-friendly light glimmers in the gloomy discourse of transport: the annual national production of bicycles stands at 12 million. India is second only to China when it comes to bicycle manufacture. The industry is currently endeavouring to increase exports since the international market is significant. The design of street bicycles in India is loosely based on the sturdy frame of the traditional British Pashley school of product design. A village vicar from a 1940s Ealing comedy would not look amiss astride an Indian bicycle made in 2003. There are millions of heavy-wheeled bicycles with bar brakes, chain guards and integral two-legged stands for that easy 'leave it anywhere' facility. Graphics adorn the cross bar and both diagonals, whether applied by the manufacturer or the owner. Just below the luggage rack, there is a tin badge riveted to the mudguard; in the case of the Hindustan bicycle, the torch bracket is branded with a stencilled H. The embossed graphics on the tin badges are evocative of the homely era of Enid Blyton's *Famous Five* stories and Kipling's summery prose. Whether the bicycle instruction booklet recommends it or not, the luggage rack can be used for carrying people, animals or deftly balanced loads that would make even a Land Rover strain. The Indian bicycle is built to withstand the greatest structural forces; brand names such as Atlas and Hercules reflect this.

49

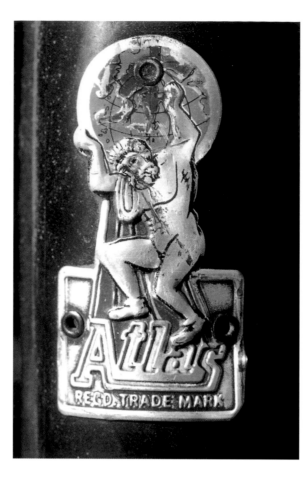

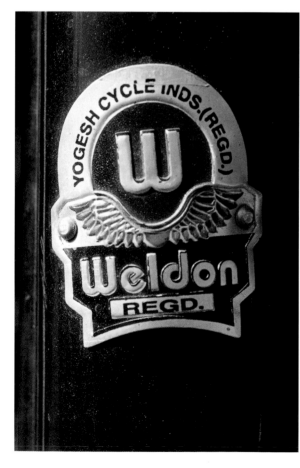

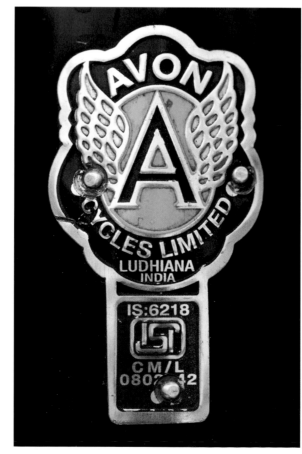

Bicycle manufacturers all make use of the embossed tin badge that is attached to the rear mudguard with rivets. The Indian bicycle is built to withstand the greatest structural forces; brand names and logo designs reflect this.

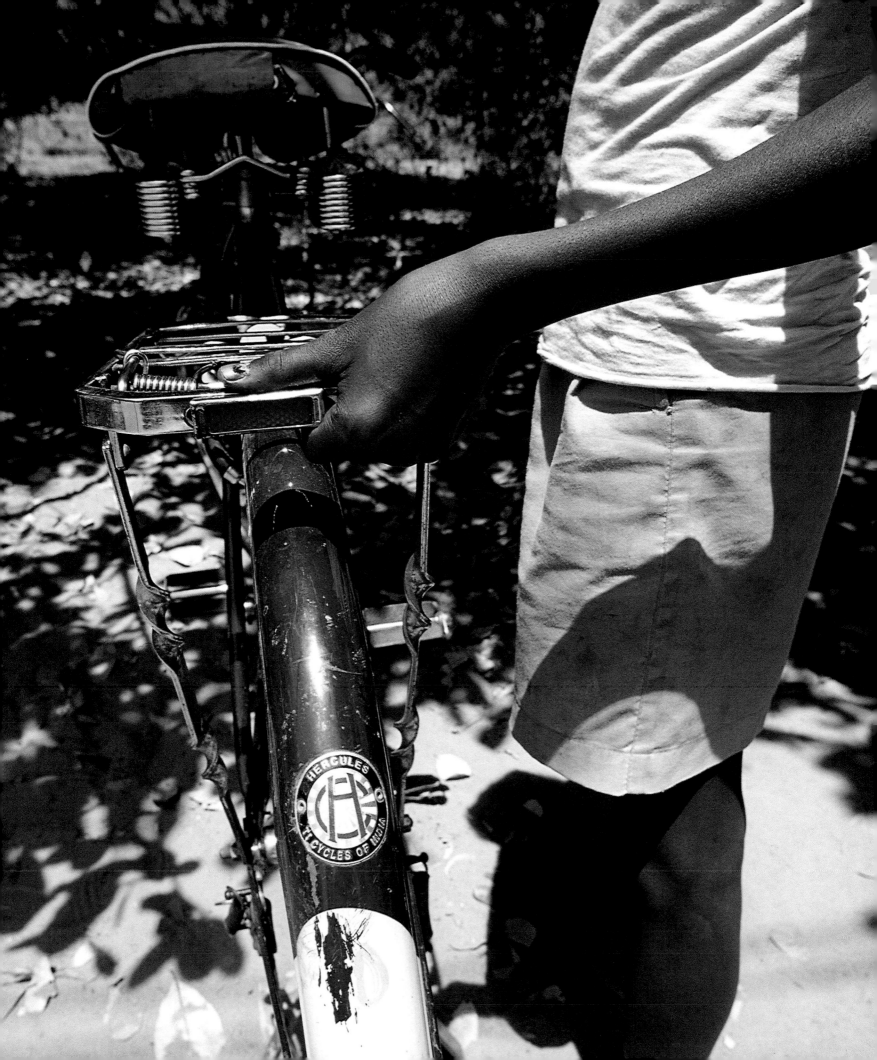

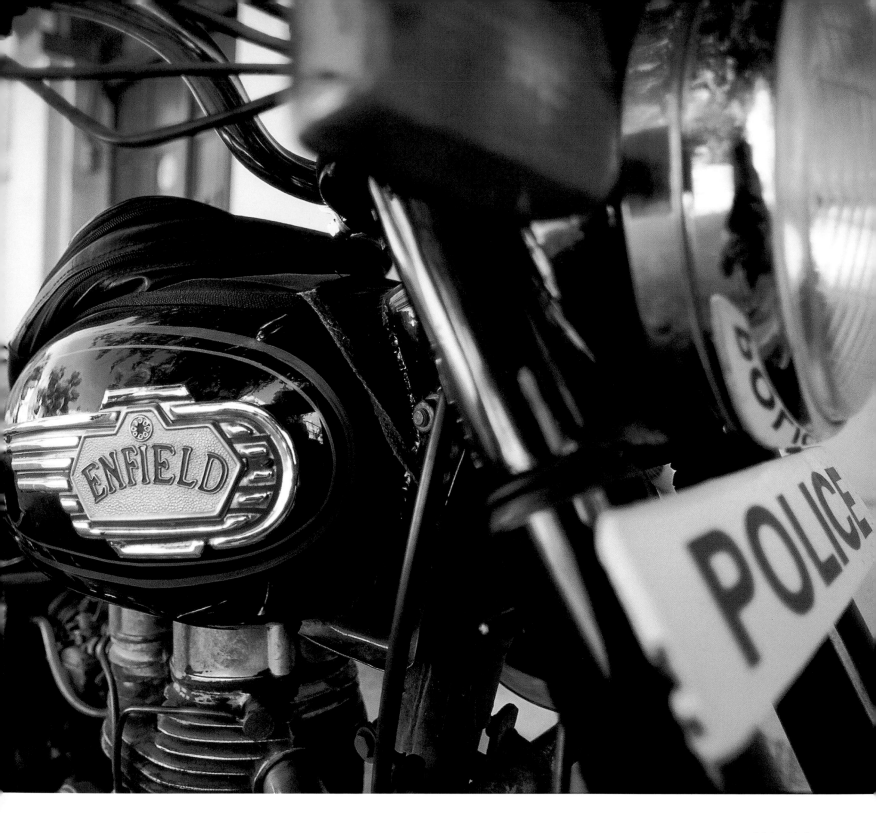

ABOVE AND FACING Enduring style: the Enfield was originally designed and made in the United Kingdom. The British company has closed down, but manufacture continues under the auspices of Enfield India. Production takes place in Chennai.

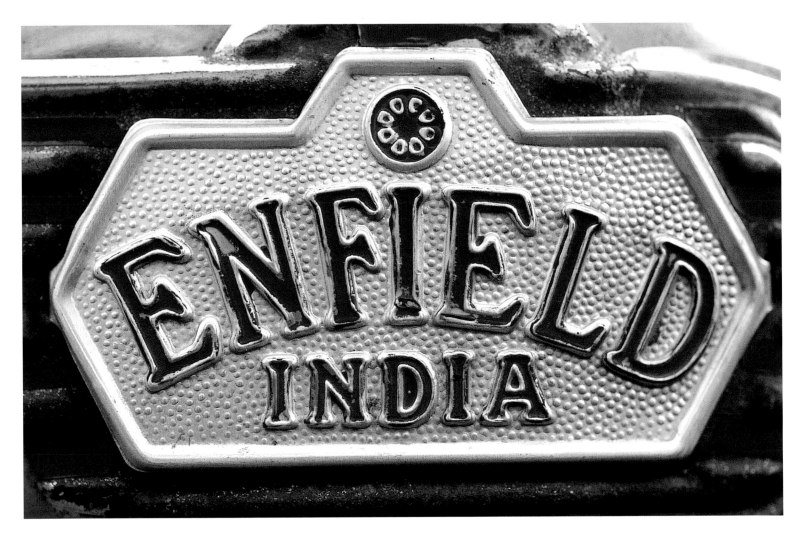

Embossed tin or metal is a popular branding medium and also appears on the petrol tank of the Enfield India motorbike. The styling of the Enfield and its graphics haven't changed much since the Indian government ordered 800 of the 350cc models in 1954. The British Royal Enfield was deemed a solid and reliable motorcycle for the Indian police and army, and the Bullet 350 was suitable for patrolling the rugged border highways. In 1955, with more orders from India looming, the British company sold its design to a subsidiary company in Chennai. Royal Enfield India started by simply assembling British-supplied kits, but within a couple of years the entire machine was being manufactured on-site. The insignia retains a look suggestive of a whole tradition of British motorcycling that has long since disappeared in its country of origin but that continues to evoke the idea of integrity in its adopted home.

Another timeless vehicle in product-design terms and applied graphics is the beautifully formed Hindustan Ambassador car. The stately and regal contours of the Ambassador are based on the Morris Oxford, which was first sold in the United Kingdom in 1948. Refreshingly, Hindustan hasn't followed the branding dictates of Western marketing departments. There are no go-faster names like 'Probe' or economy/fun/stylish monikers like 'Octavia'. Hindustan Motors has remained true to its genteel legacy and has not been tempted to get

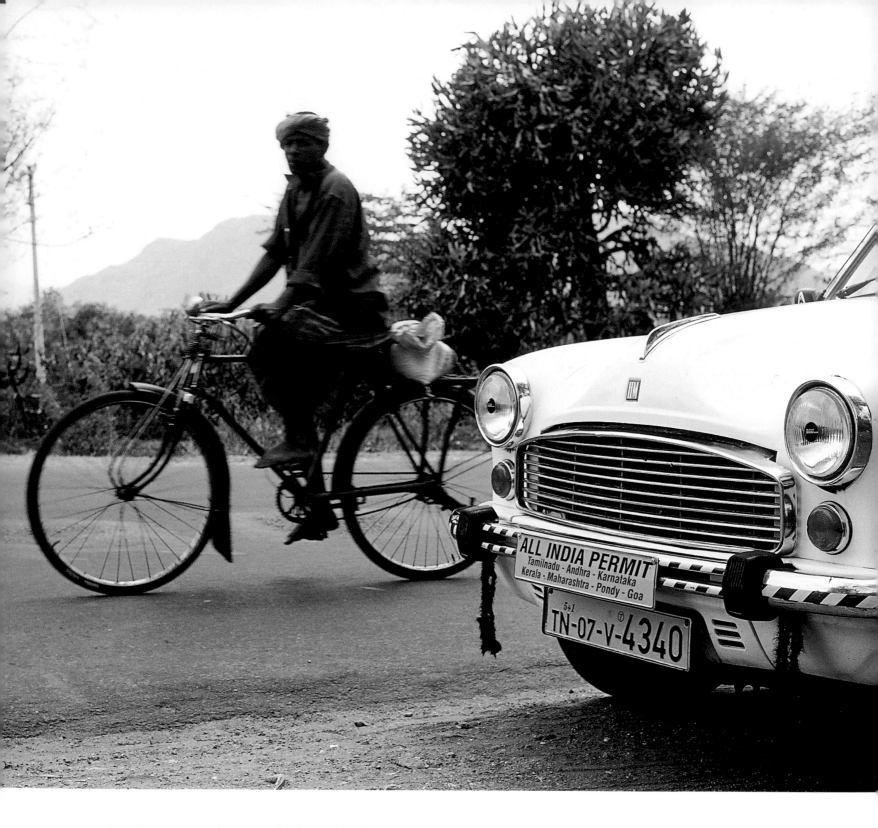

any more innovative than simply adding the word 'Deluxe' in chromium lettering.

India's land mass of over 1.27 million square miles is latticed with almost 39,375 miles of railway track. Over 11,000 trains run every day: Ordinary Passenger Trains, Fast Passenger Trains, Mail/Express Trains, Fast Mail/Express Trains, Super-Fast Trains and Suburban Local Trains. In addition, special narrow-gauge routes to up-country stations such as Coonoor in the Nilgiri Hills and Shimla in Himchal Pradesh serve rural locals' and tourists' needs. Other special trains include the Palace on Wheels, which consists of 14 coaches each named after former Rajput states: Jaipur, Bikaner, Kishangarh, etc. 'Each coach is richly furnished with carpets flowing into every corner and sparkling chandeliers making shafts of light dance on crystal,' explains the railway marketing department. The Bhavnagar state coach, built in 1929, retains a striking original feature: a verandah on one side of the coach still has all its solid brass safety pillars intact. Dining cars and a saloon make the seven-day journey a luxurious week's holiday.

India's 11 million daily passengers experience the hard reality of train travel: chaotic queues, overcrowding, discomfort and accidents. Alighting from a homeward-bound local commuter train in Mumbai is literally an uplifting experience; you can avoid stumbling off the

ABOVE AND FACING Classic style: the Hindustan Ambassador retains its 1940s shape and is built to withstand India's variable road surfaces.

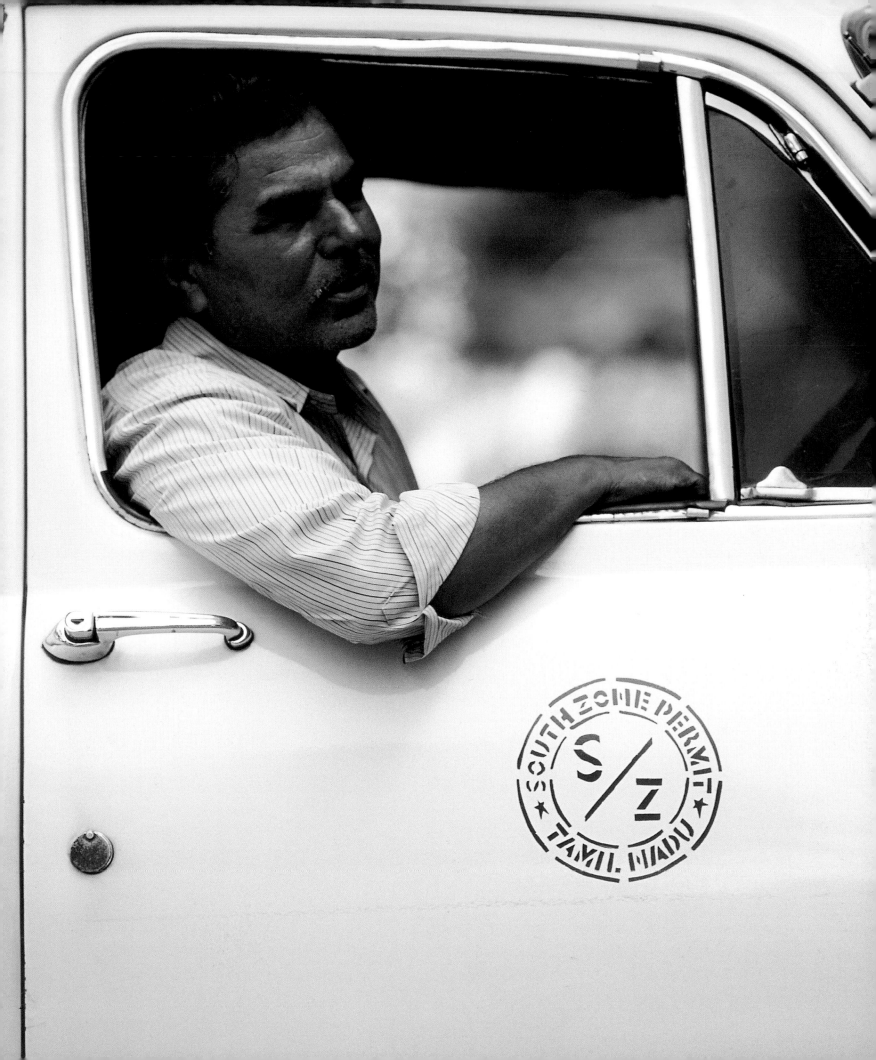

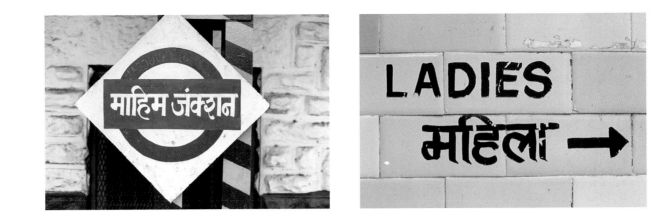

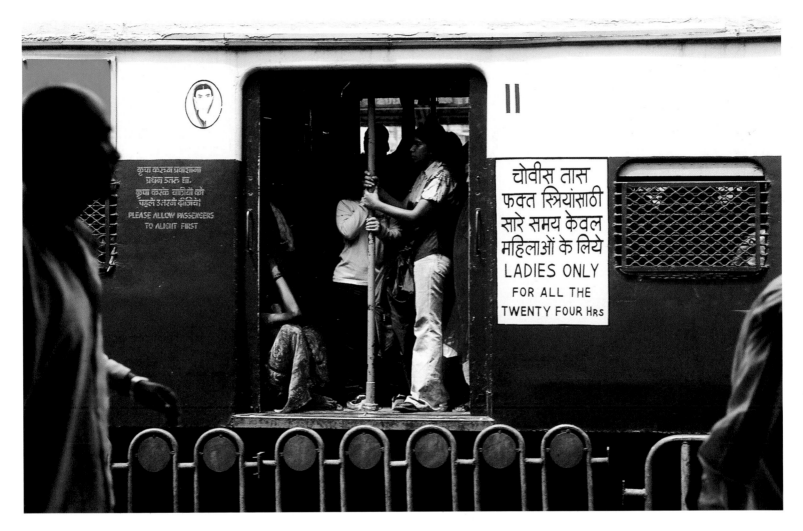

train with other passengers at your appointed stop by simply not walking – the tightly huddled crowd will lift and move anything that is stationary, so rucksack, tripod and foreigner pass from train to platform without touching the ground. In any city on earth local commuters always look as though they know where they are going, but in India everyone is in an almost trance-like state as they embark and disembark. The information signs seem redundant as passengers file past in oblivious recognition. With the added dimension of a widespread failure to implement signage systems' first rule of corporate design identity – consistency – Indian railway signs assume an artistic personality of their own. Is the clip-art representation of the station master on the yellow acrylic swing sign actually meant to resemble the man behind the freshly painted door with a discreet 'Please Knock' rendered on it in freestyle italic? Is the big 'Platform 1' sign in bright-red gloss painted on white plywood hanging over this platform or the one opposite?

Earlier in the day the local train from West Dadar to Mahim is relatively empty. As we approach Mahim railway station, a sprawling encampment of dwellings stretches into the hazy distance. This is the edge of Dharavi, dubbed the largest slum in Asia. Over half of Mumbai's population lives in slums or on the street amidst discomfort, squalor and fear of disease. Dharavi has over three-quarters of a

നിലയ അധികാരി
ஸ்டேஷன் மாஸ்டர்
STATION MASTER
സ്റ്റേഷൻ മാസ്റ്റർ
നിലയാധികാരി
ನಿಲಯದಅಧಿಕಾರಿ
സ്റ്റേഷൻ അധികാരി
ಸ್ಟೇ ಷನ ಮ್ಯನಿಬ
സ്റ്റേഷൻ മാസ്റ്റർ

50 GLORIOUS YEARS

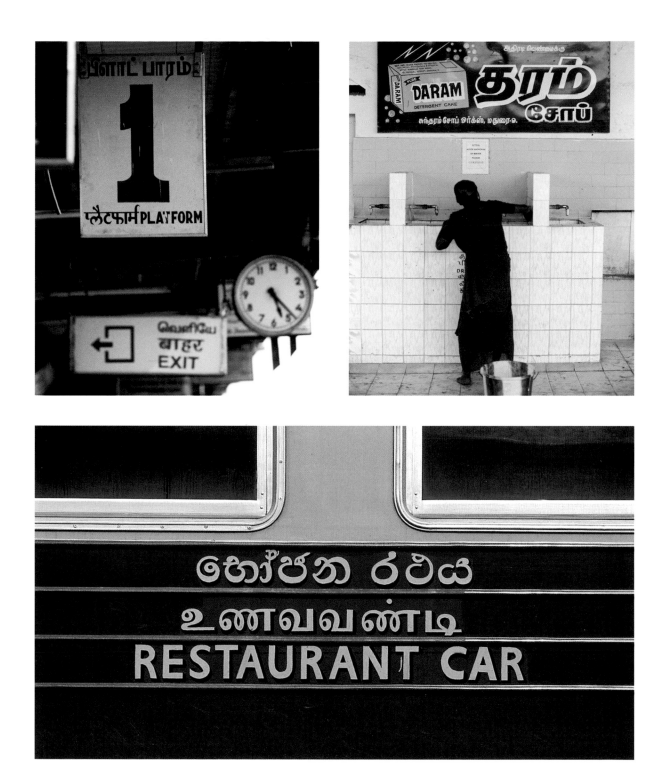

million residents, and they survive with minimal government support. Most of the populace are self-reliant. Dharavi doubles as an industrial estate and produces some of the best leatherwork and furniture in Mumbai. Those who require 'welfare assistance' take to the pavements and railway stations to beg. The limbless and blind line the platform access bridges at Mahim railway station to entreat the benevolent commuter.

Some commuters walk down the sloping ends of the platforms to the railway sidings, and wedge umbrellas and briefcases under their arms as they relieve themselves in the open-air public toilet. Naked children play at the edge of the railway track among human excrement where flies mass. The poor survive on the leftovers of Mumbai's commercial growth, and there is plenty of unwanted material to recycle, from food to building materials. Some homes are no more than tents fashioned from tarpaulins, while others are constructed partly from breeze blocks and corrugated iron. Municipal leftovers are also used in domestic construction: broken pavement slabs create an open hearth for cooking and in one particular case a mother and baby sit on the ground before a low, circular homemade table. The mother moves a cooking pot to reveal a metal 'No Horn' sign – India's most redundant sign has found a use.

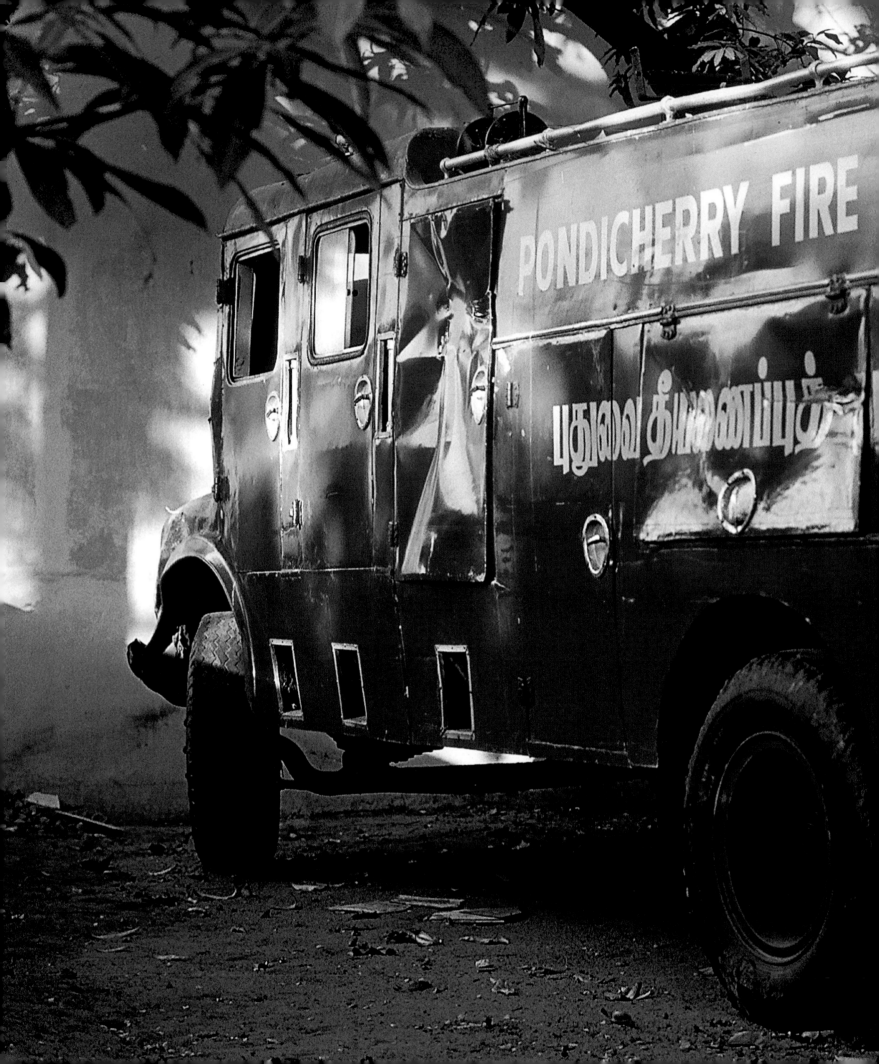

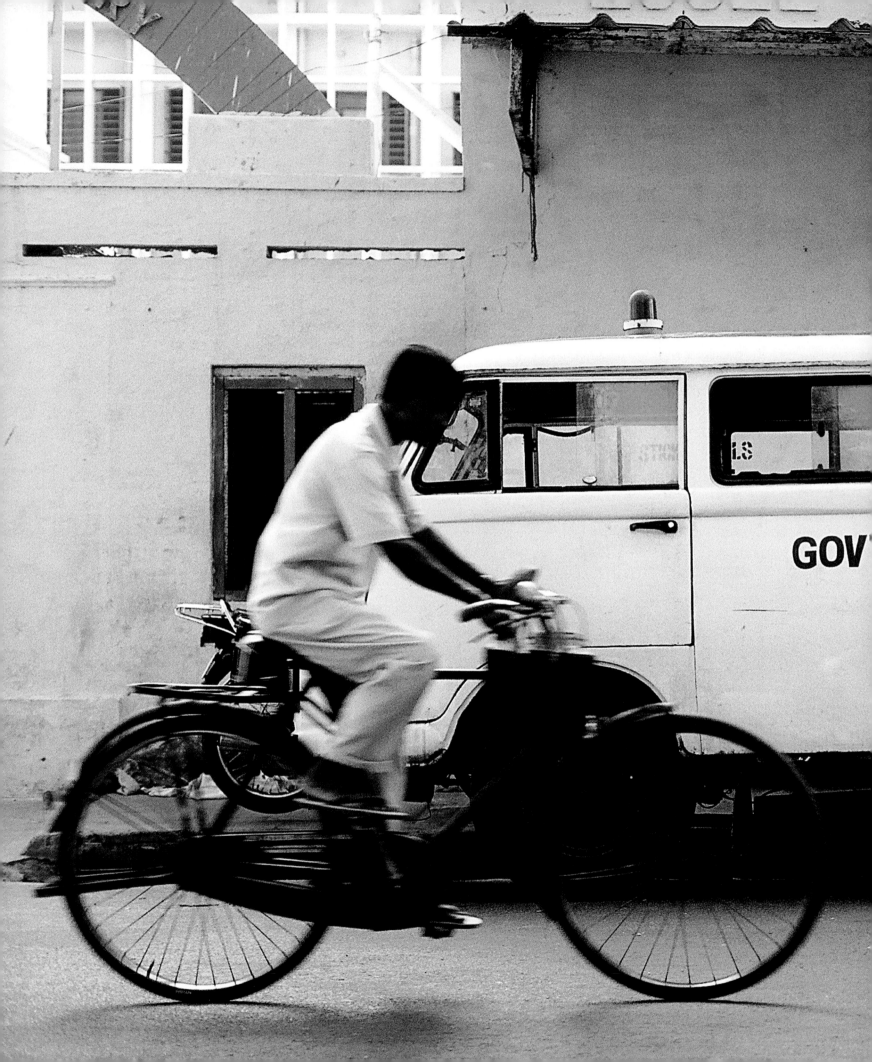

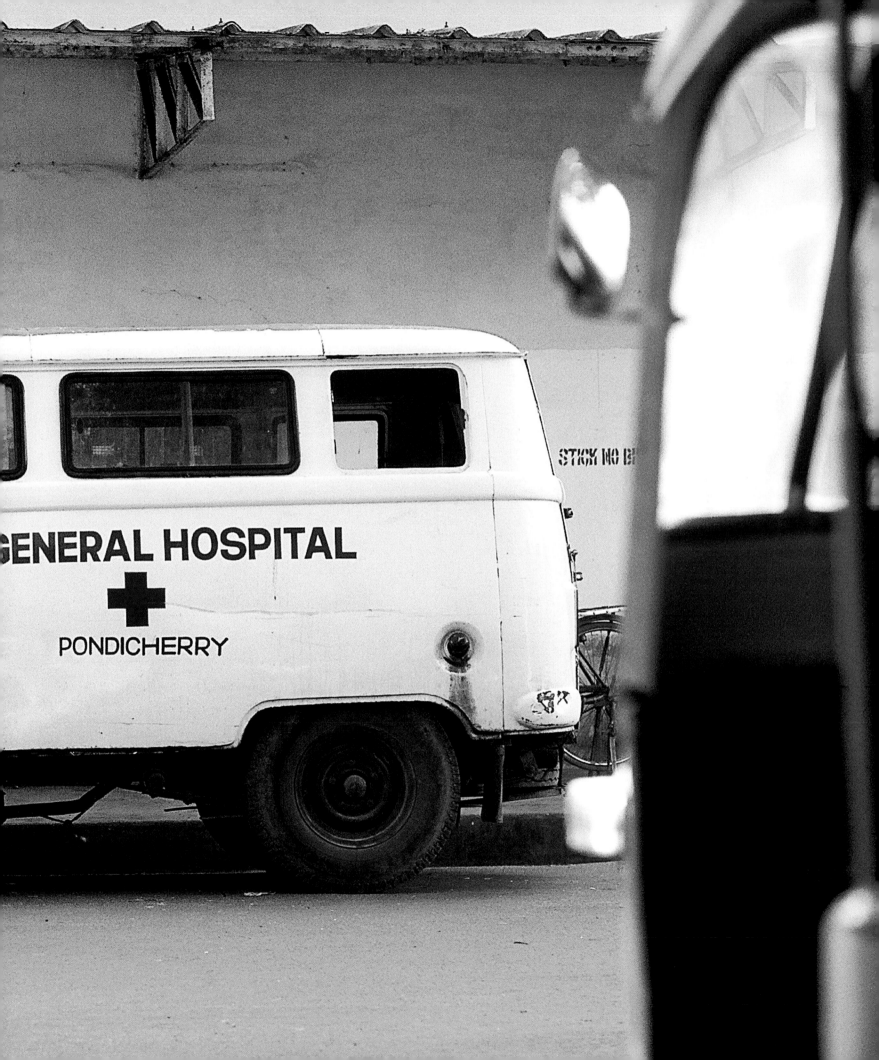

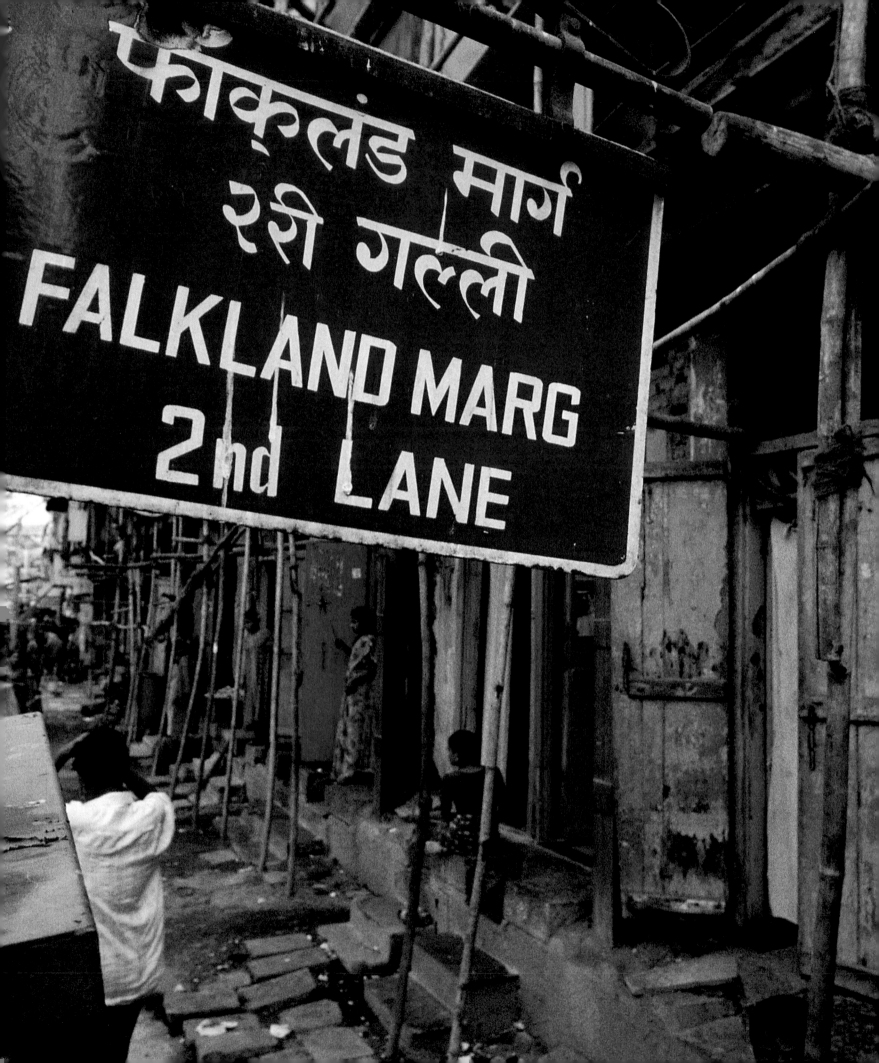

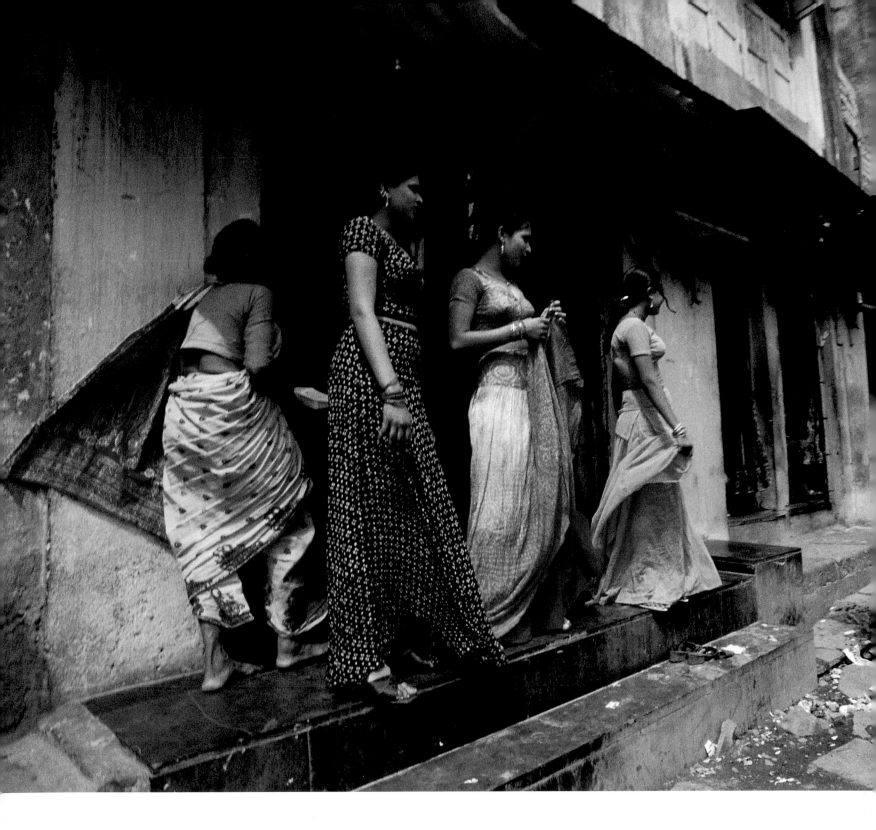

ABOVE Prostitutes and their madams
line the back streets of Kamatipura
vying for business. Mumbai's
prostitutes service an average of 50
clients each per day.
FACING One of the few original
enamel road signs in the Kamatipura
district of Mumbai. *Marg* means
road.

Red lights in Mumbai

The doctors' clinics that display their acrylic, back-lit red-cross signs almost outnumber the prostitutes on Pathe Buparao Marg, formerly known as Falkland Marg (Road). Following a torrential monsoon downpour, the streets turn into a quagmire of rotting detritus. Open channels convey sewage from the side alleys into culverts running down either side of the road. The culverts are covered by slabs of concrete, broken here and there to release the stench emanating from the slow-moving, dark-grey sludge. Touts offer brown acid and hashish and hand out discreet call-girl business cards. In contrast to the naked, large-breasted photo-realism of the brash telephone-box advertisements of the West, the cards of Mumbai's ladies of the night simply feature a head-and-shoulders portrait of a sari-clad woman and a number. The touts follow potential punters, muttering numbers – not vital statistics, but telephone numbers. At night, on arrival in the Kamatipura district, half a mile from Mumbai's central railway station, the streets are lined with standing, stationary women – a rare sight in the city, as most people, especially women, are constantly on the move or, if not walking, are usually either sitting or sleeping on the pavement. Black mould and exhaust fumes cling to the once-white buildings and mud graduates up the walls as

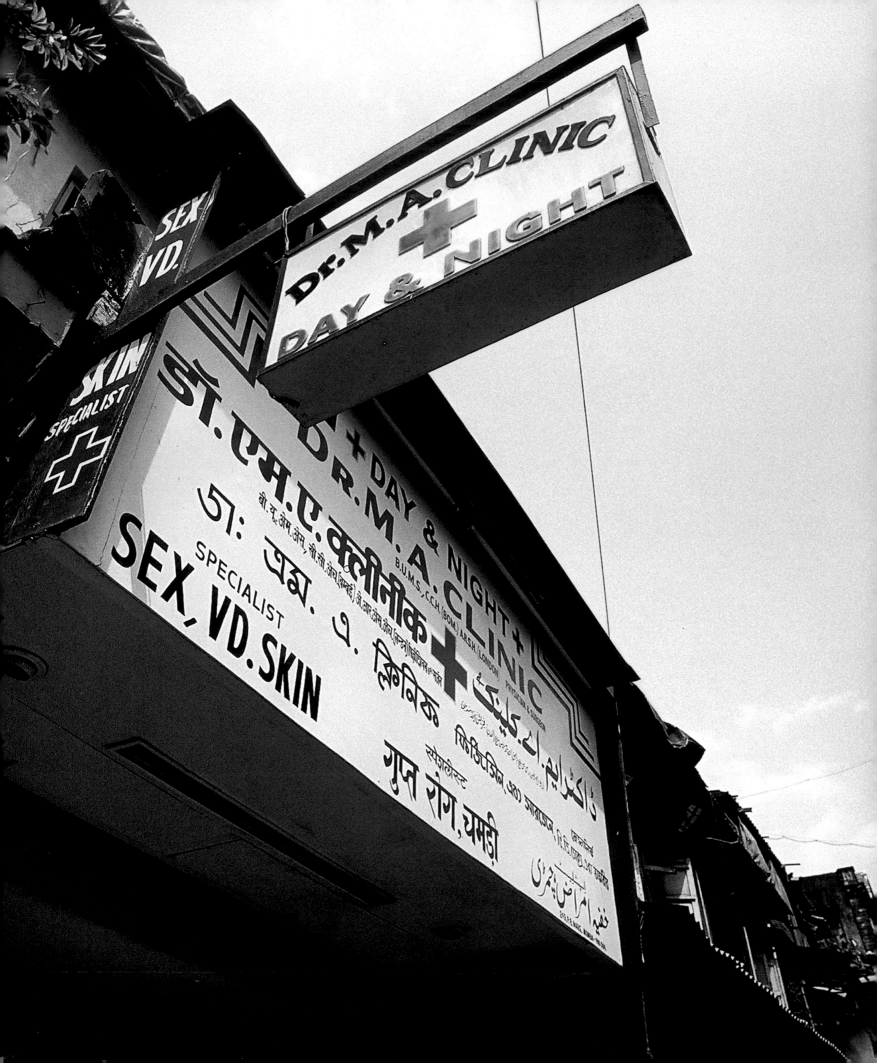

ABOVE Cockroaches, perhaps? A lone sign on a wall bars entry to a pair of insects of dubious provenance.
FACING There is a profusion of red-cross signs in Mumbai's red-light district. This particular sign advertises opening times and specializations in several languages from Urdu to Hindi.

though it has been applied with a brush. The women are dressed in beautiful, spotless saris; for clients in search of a slightly different experience, there are men dressed in beautiful, spotless saris, too. The area is hardly conducive to erotic thought. There are no neon signs promising live shows and no apparent pornography to whet the appetite. The only indication as to the nature of the service industry of the Karnatipura district is provided by the presence of the women, the clinics and the roving pimps. The lack of an A–Z map makes it easy to get lost in Mumbai's back streets, and in our quest to find and photograph one of the few original Falkland Marg enamel road signs remaining, we went into a police *chowk* – an open-sided shelter at the corner of a crossroads housing two benches, a table with a telephone and three immaculately turned-out policemen in khaki uniforms sporting pistols in holsters and .303 rifles. Having been offered a seat and a glass of tea, we requested directions. On learning our nationality, the policemen were keen to discuss the historical role of the British in India – I tried to make light of the subject by suggesting that any personal responsibility lay with my grandfather, who was in the Indian army. The policemen laughed politely and proceeded to give directions, adding a warning as to the possible dangers of the area. As we were about to leave, one of the touts who had been so eager to sell us brown acid and women earlier strolled

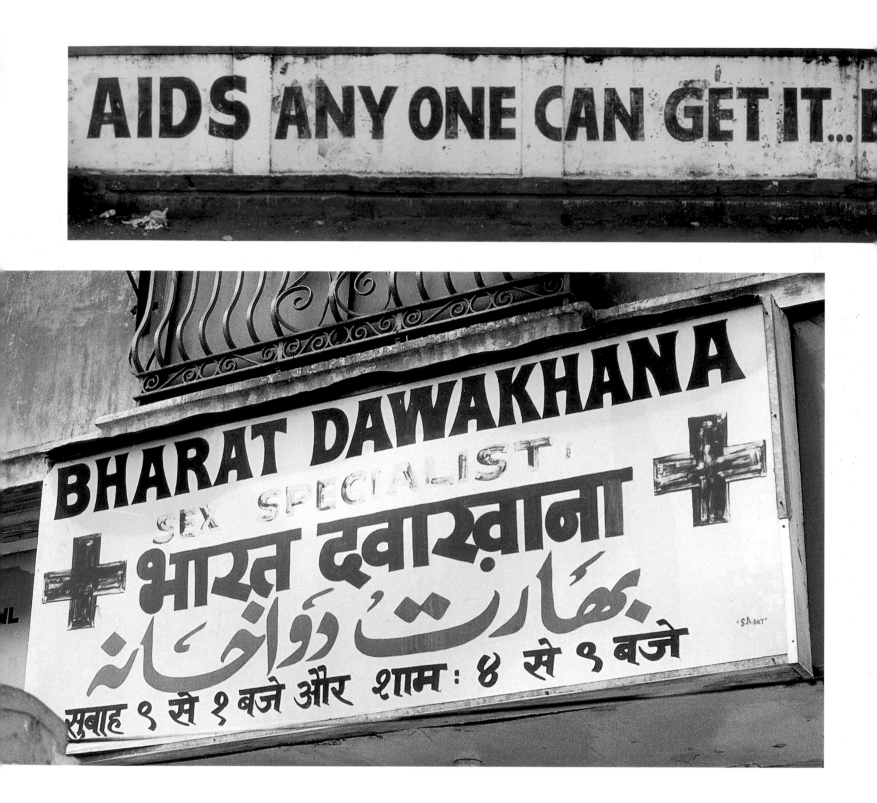

into the *chowk,* pulled up a chair and started chatting and laughing with the officers.

It is difficult for an Indian national to avoid the attentions of a tout; for a Caucasian visitor it is almost impossible. They have a relentless streak and survive on backhanders and percentages. The potential punter may be offered anything from religious icons to currency changing facilities. The encounter begins with a subtle 'best friend' approach that, if rejected, quickly develops into a repetitive verbal battering, particularly in the case of the Kamatipura tout. Saying 'No' is futile. In fact, it indicates that you are willing to communicate, which gives the tout hope – the only way to avoid negative discourse is to pretend that they don't exist.

Not so far from the red-light district is a busy main road used by traffic passing in and out of Mumbai. A hand-painted slogan in large red sans-serif capitals covers most of the surface of a wall that runs for 50 yards or so adjacent to the pavement: 'AIDS: ANY ONE CAN GET IT... BE RESPONSIBLE & PREVENT IT.' Below the English text is a smaller line of Devanagari script that translates the message into Hindi. To photograph it using a standard lens, we need to expose several frames and join them together digitally later. Taking photographs of anything in India creates varying degrees of local interest, and in this case a well-educated man stopped to tell us about

RESPONSIBLE & PREVENT IT

बृहन्मुंबई महानगरपालिका

जगा आणि जगू द्या.
LIVE AND LET LIVE.

TOP The AIDS wall: the municipal message runs for 50 yards or so. India has the highest recorded number of HIV infections in the world – 3.7 million. Unreported cases probably mean this figure is too low.
ABOVE A positive message in Hindi and English.
FACING The 'sex specialist' administers medical aid to sex workers and their clients alike.

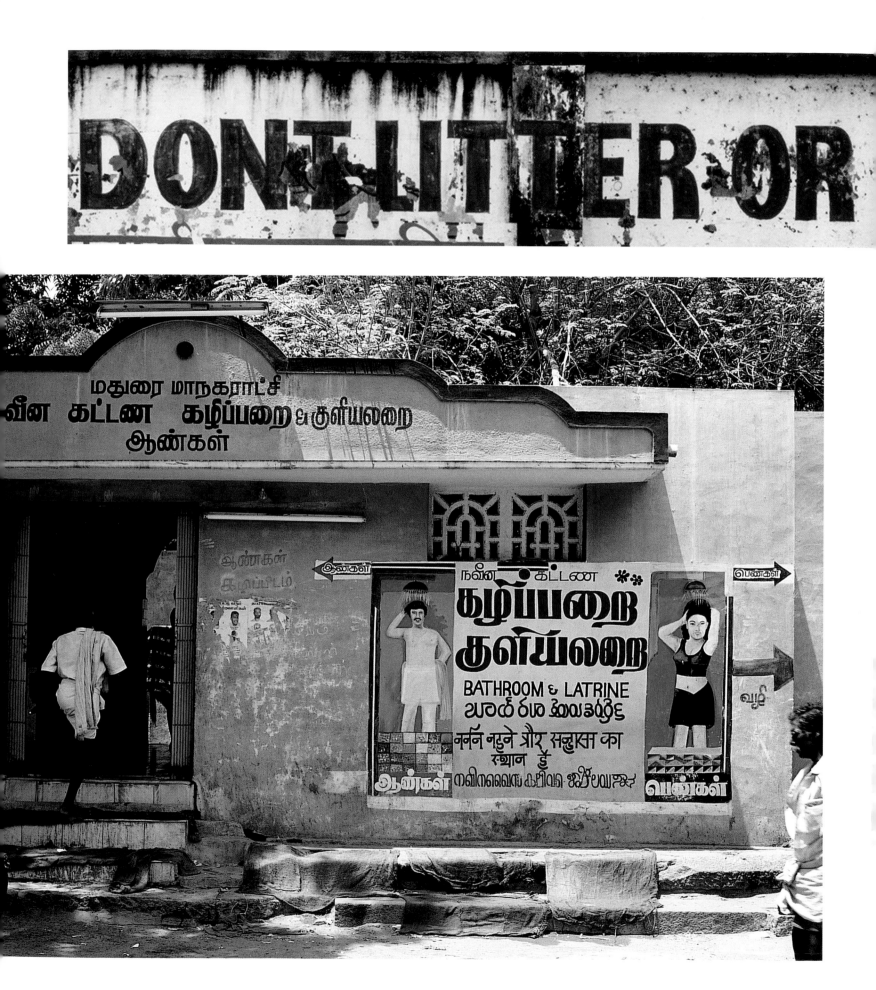

TOP AND ABOVE Municipal signage
urges social responsibility.
FACING The Madurai Corporation
Modern Bathroom has been
refurbished to include a new sign
which is written in Tamil, Hindi and
Telugu as well as English.

'the Indian government's lack of action and complete disregard of the serious implications of the AIDS crisis'. He added that the government were deliberately ignoring the danger as it mostly affected the poor and was a convenient solution to the burgeoning population problem. Having established my nationality, he insisted that I tell the British government of the plight of India's HIV-infected. In 2000, India had the highest recorded number of HIV infections in the world – 3.7 million. Unreported cases, particularly among the poor, probably mean this figure is artificially low. Mumbai has the highest rate of infection and an estimated 72 per cent of the city's sex workers are HIV-positive. Mumbai's prostitutes service an average of 50 clients each per day, and with the growing 'cottage industry' of rural truck-stop brothels it seems likely that the spread of HIV is continuing at pandemic rate.

 The young prostitutes in Pathe Buparao Marg were understandably reluctant to be photographed and threatened us with thick stainless-steel bars, which they presumably keep to hand to brandish at any particularly heavy-handed punters. Among Mumbaikars, the red-light district is known as the black district, and in fact the only red lights visible here are the AIDS clinics' illuminated red-cross signs.

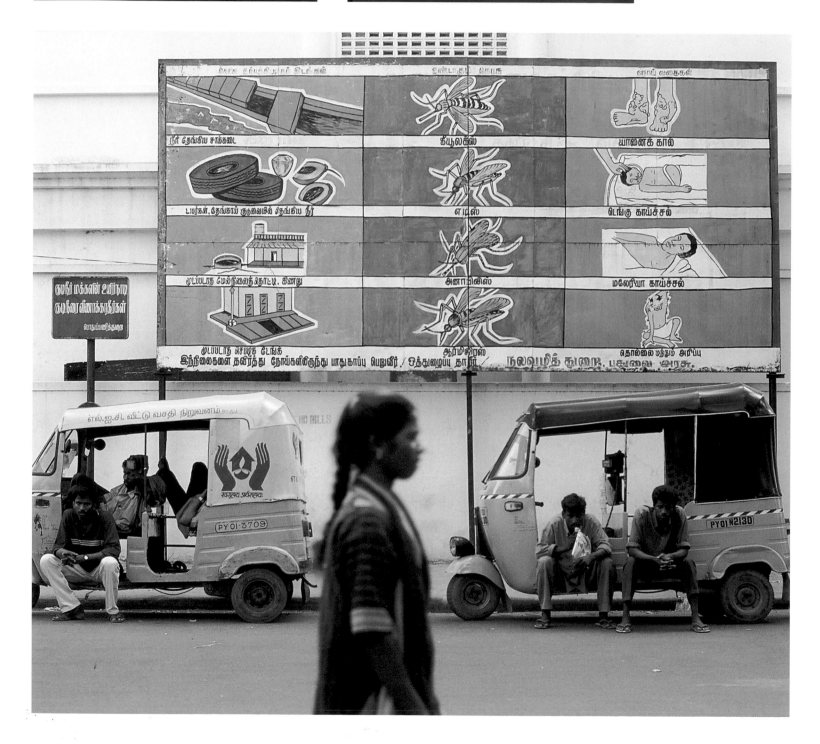

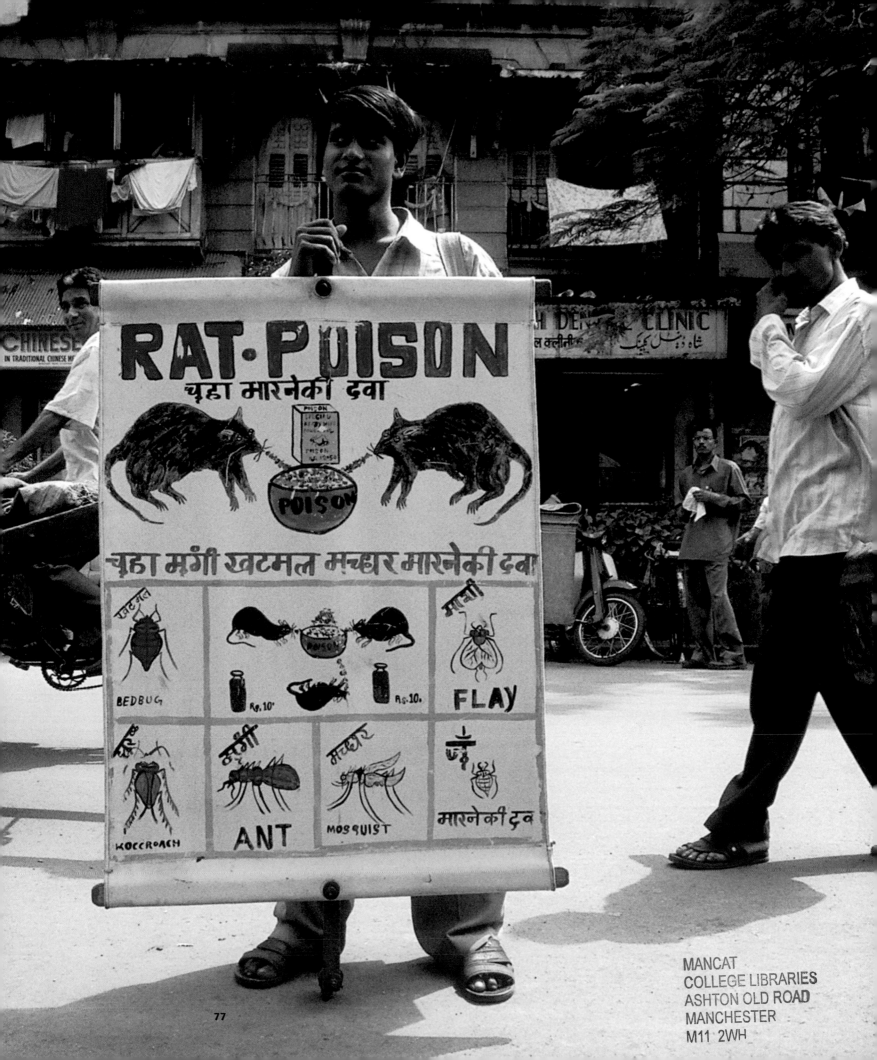

India is a constitutional democracy and the parliament is bicameral: the lower house is known as the Lok Sabha (House of People) and the upper house as the Rajya Sabha (Council of States). A bespectacled politician (top left and facing); the two-leaf symbol of the AIADMK Party (top right); the symbol of the Communist Party of India (above). OVERLEAF Udhav Thakre, a member of the Shiv Sena Party (left) and J. Jayalalitha, Chief Minister of the AIADMK Party (right).

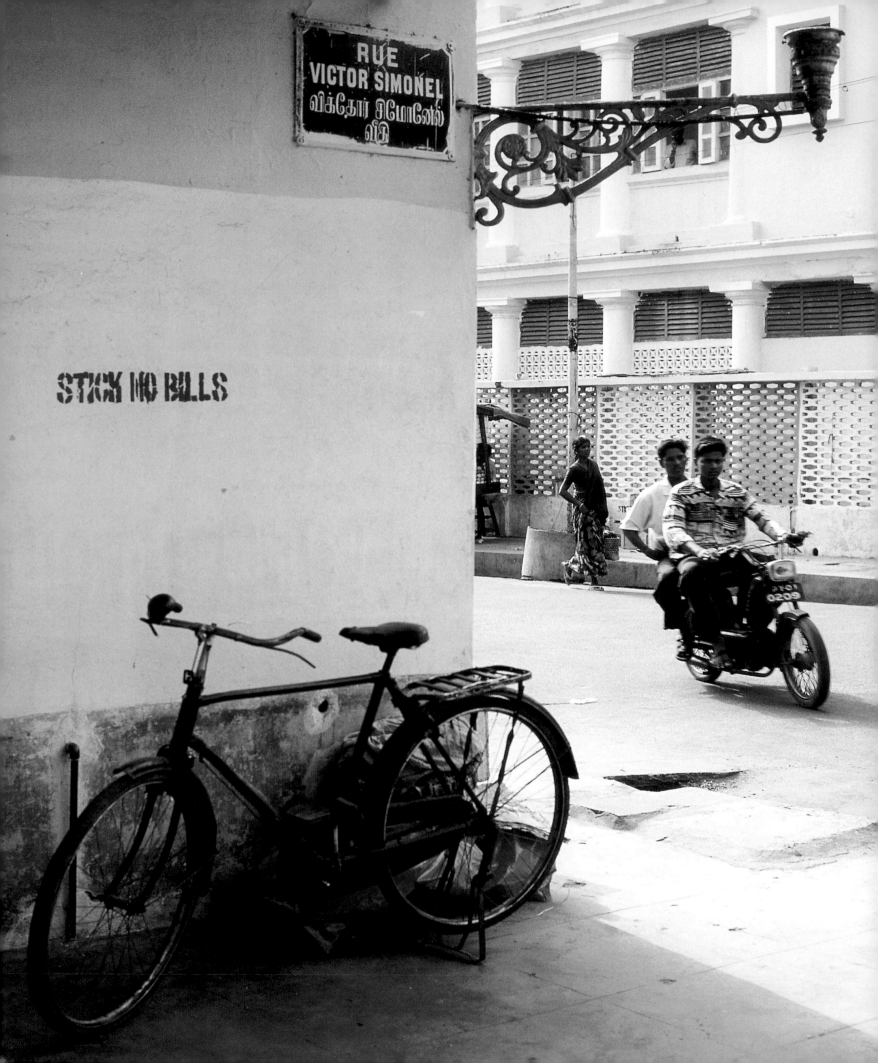

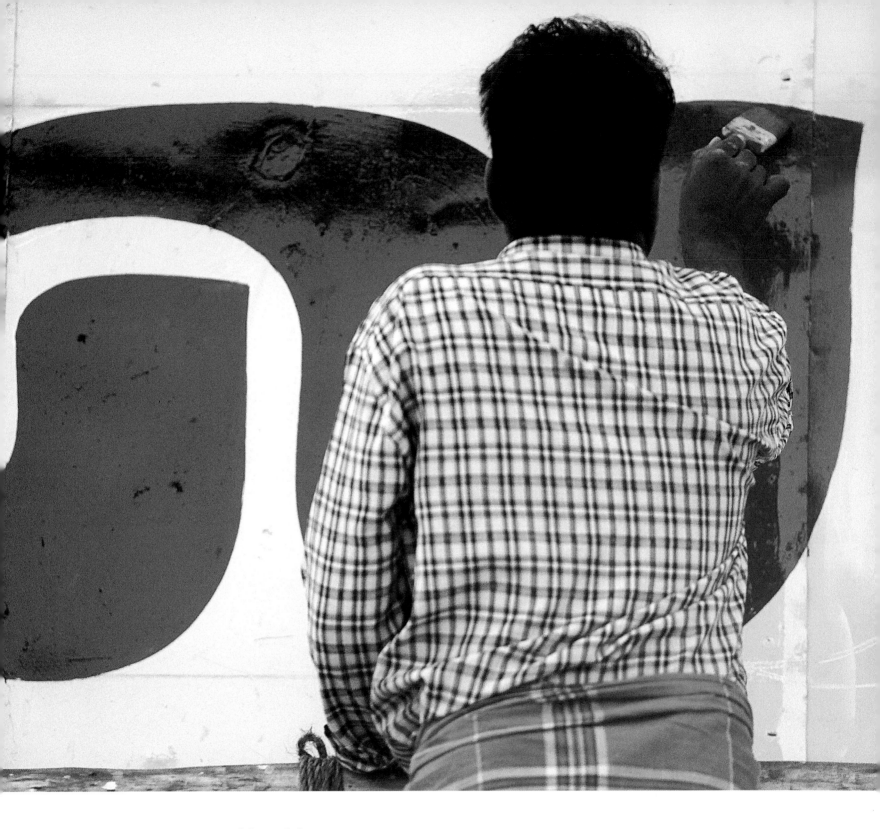

Death in Mumbai

The copywriter's art is much in evidence in India, and the English language plays an important role in selling goods and services. English is widely spoken in towns and cities, and even in quite remote villages it is not difficult to find someone who speaks at least a little English. Other European languages are almost completely unknown, unless you visit such obscure colonial bastions as Pondicherry on the east coast. Colonized by the French, this was voluntarily handed over to the Indian government in 1954 and became the Union Territory of Pondicherry. Many of the half a million inhabitants, particularly the older members of the community, speak French as well as their native Tamil, and street names such as Rue des Bassyins de Richemont reflect the area's colonial past.

Communication in India is not a simple matter of *a* language. Hindi is the national language and has been the official language of the Indian government since 1949. But there are 17 other official regional languages: Punjabi is relatively modern, dating from the 16th century; Assamese and Marathi date from the 13th century, as does Bengali, which is spoken by nearly 200 million people, mostly in what is now Bangladesh. There are state languages such as Gujarati in Gujarat, Kannada in Karntaka, Urdu in Jammu and Kashmir, and Marathi in

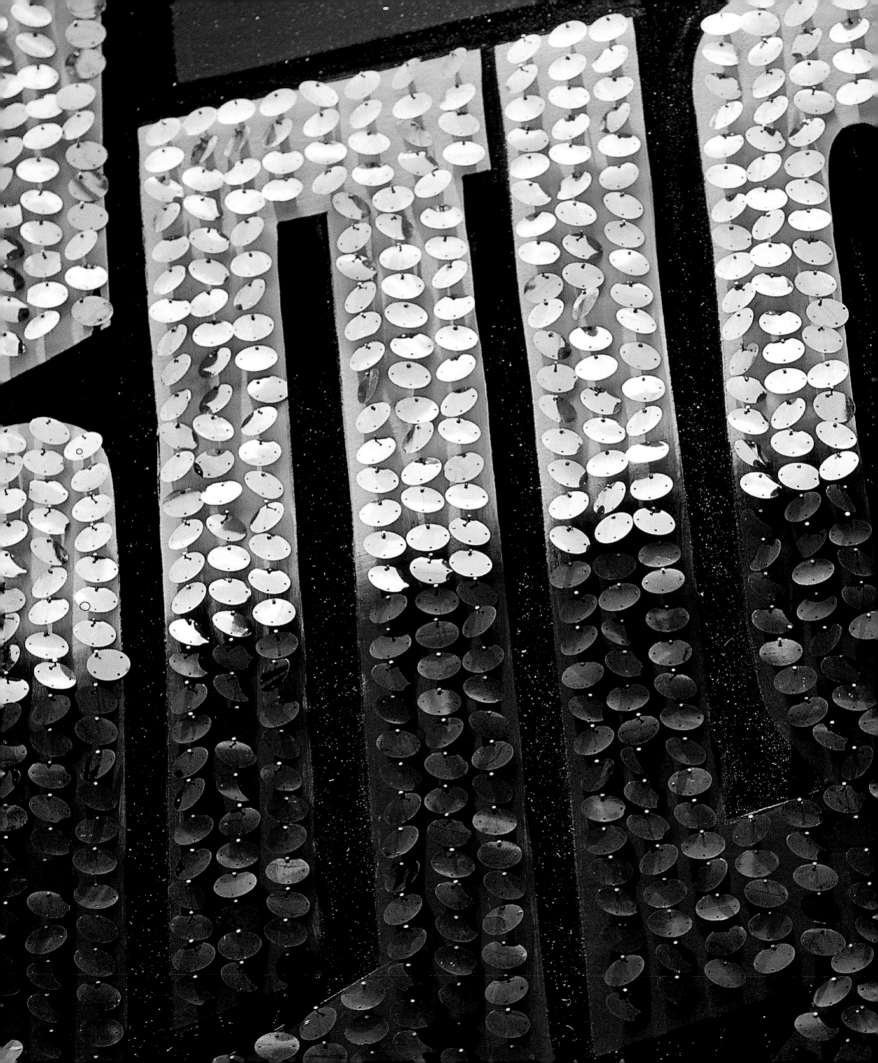

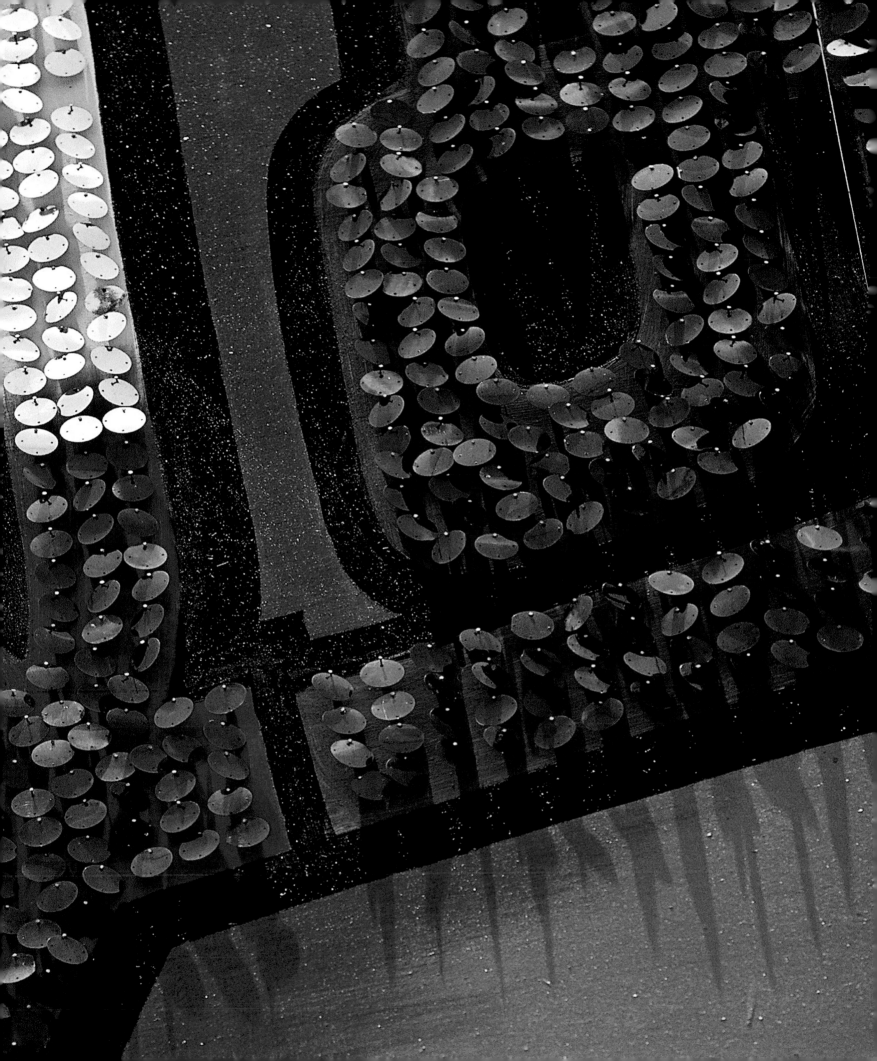

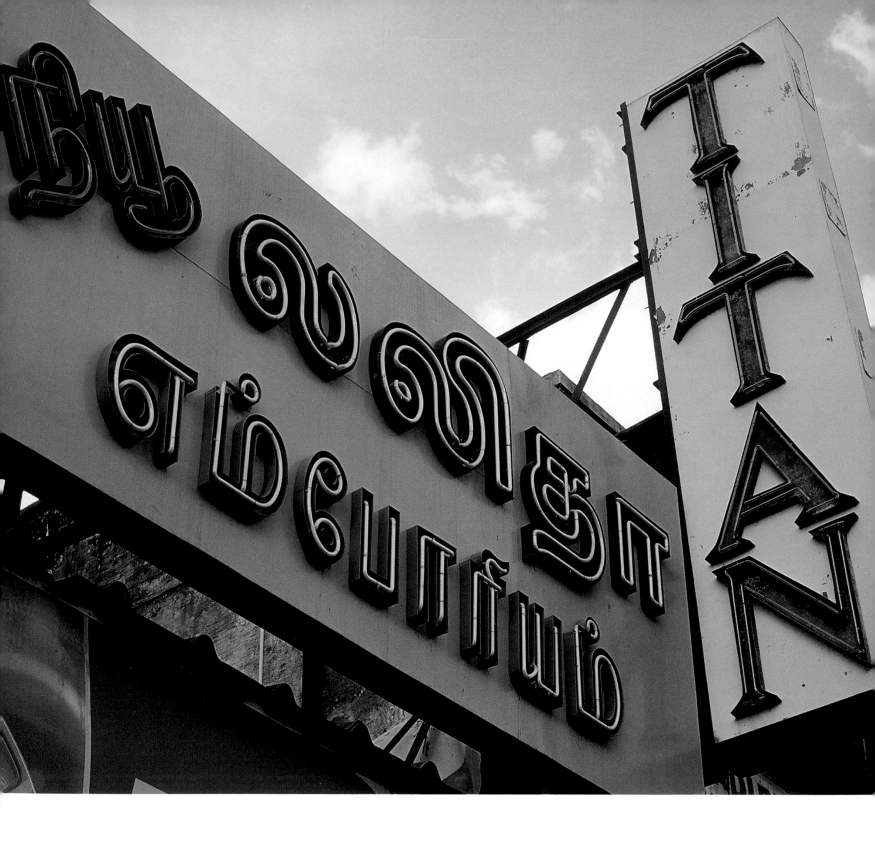

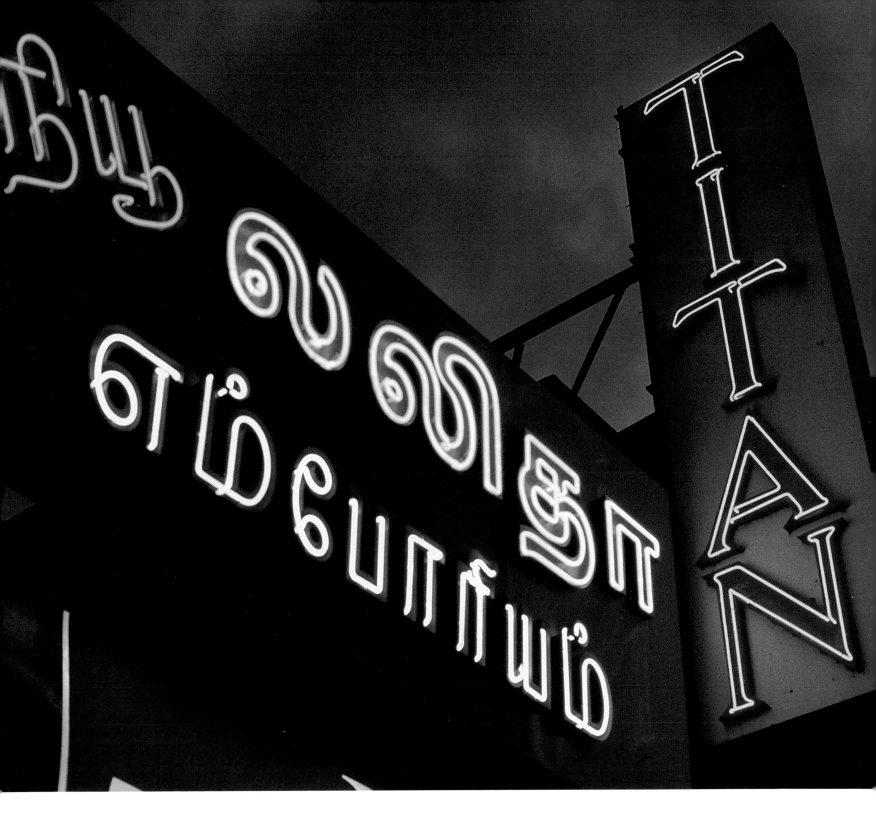

ABOVE AND FACING Night and day comparison of neon signage. Titan is one of India's foremost watch manufacturers.

Maharashtra. The Dravidian languages of Tamil, Telugu, Konkani and Malayalam are spoken in Tamil Nadu, Andhra Pradesh, Goa and Kerala respectively. Tamil is an ancient tongue, at least 2,000 years old, but the Indic language of Sanskrit is one of the oldest in the world. It was spoken in northwest India from 1500 BC and became the classical language of the Hindu scriptures, the Vedas, which comprise hymns, invocations and mantras mostly concerning the sacrificial worship of gods representing various natural forces.

Hindi is a direct descendant of Sanskrit and is the native language of more than a third of India's people. Another 300 million use it as their second language, and there are a further 10 million Hindi speakers outside India. There has been language conflict, which has sometimes led to violent confrontations. Supporters of Hindi as the official language mostly oppose the use of English, whereas speakers of regional tongues often regard English as a preferable language of communication between the Indian states.

In addition to the official languages, there are over 1,000 dialects, making India one of the most linguistically multifarious nations in the world. The language that has been adopted by many of the literate population isn't on the official list, however: Indian English. Many Indian terms have infiltrated the English language as it is spoken throughout the world, too. 'Pyjamas' is Urdu, deriving from a mixture of

Persian and Hindi, for leg and clothing. 'Shampoo' is from the Hindi *champna* meaning 'to press'; and 'verandah' derives from the same Portuguese and Hindi word, *varanda*. 'Curry' is not an Indian word but an Anglicized derivative of the Tamil word for black pepper, and was used by British colonialists as a generic term for any dish that included spices.

 Written non-English can make beautiful shapes and patterns. Most written forms of Indian languages come from an ancient Indian script called Brahmi, early inscriptions in which date back to 322 BC. The scripts of most regional languages run from left to right, but there is no equivalent of capital letters. As opposed to the individual letter system used in the Roman script of European languages, symbols represent whole syllables – a consonant and a vowel. Numerals, however, are the same as the 'Arabic' numerals used in European writing systems – they were in fact originally borrowed by the Arabs from India. The script used for most northern Indian languages such as Hindi and Marathi is closely related to that for Sanskrit: Devanagari. Southern scripts generally have a more rounded shape, probably because they were originally written on palm leaves, and straight, horizontal lines were avoided because they would cut into the fibre of the leaf. The Urdu script is Persian in origin and was introduced by the Afghans and the Turks; it runs from right to left.

TOP Public postbox.
ABOVE AND FACING Abstract letter forms: in addition to the 18 official languages, there are over 1,000 regional dialects.

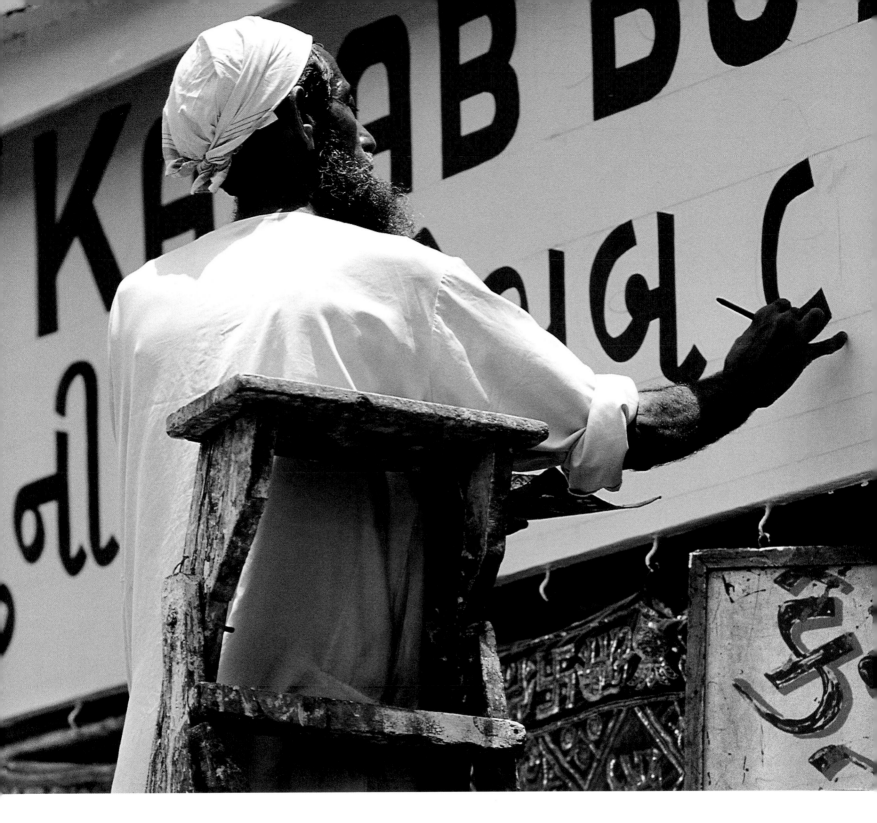

ABOVE AND FACING Freestyle signwriting is a trade that is always in demand. The sign shown above is written in Gujarati as well as English.

English as spoken in India is often so strongly affected by the mother tongue of the speaker that it sounds unusual to the native Briton. The legacy of the Victorian and Edwardian English used by the East India Company, the military and other colonial institutions also continues to influence the modern version spoken and written by Indians. Sometimes referred to as Hinglish, it is a distinctive mix of Hindi and English. The linguistic purist may baulk at such bastardization, but the anthropologist can only be fascinated by the evolution of a language as it is adapted for a different cultural climate – English as used by Americans is another prime example. The Indian press, which contains journalism of a high standard in terms of the incisiveness of its inquiries and the subtlety of its insights, can be a great source of Hinglish. Its grammar is sometimes so unfamiliar that it takes a few reads before one can understand its meaning.

The commercial copywriter is free to explore the nuances of double meaning and word play. Advertising hoardings are a popular canvas for copywriters to show off their skills. On the busy road adjacent to Mumbai's Chowpatty Beach a large advertisement invites passers-by to join the Country Club and make use of its health spa to lose weight by asking them: 'How to burn your fat without sitting on the stove?' A municipal poster sponsored by the Mumbai Traffic Police warns against hurrying across the road without looking. One of the white stripes of

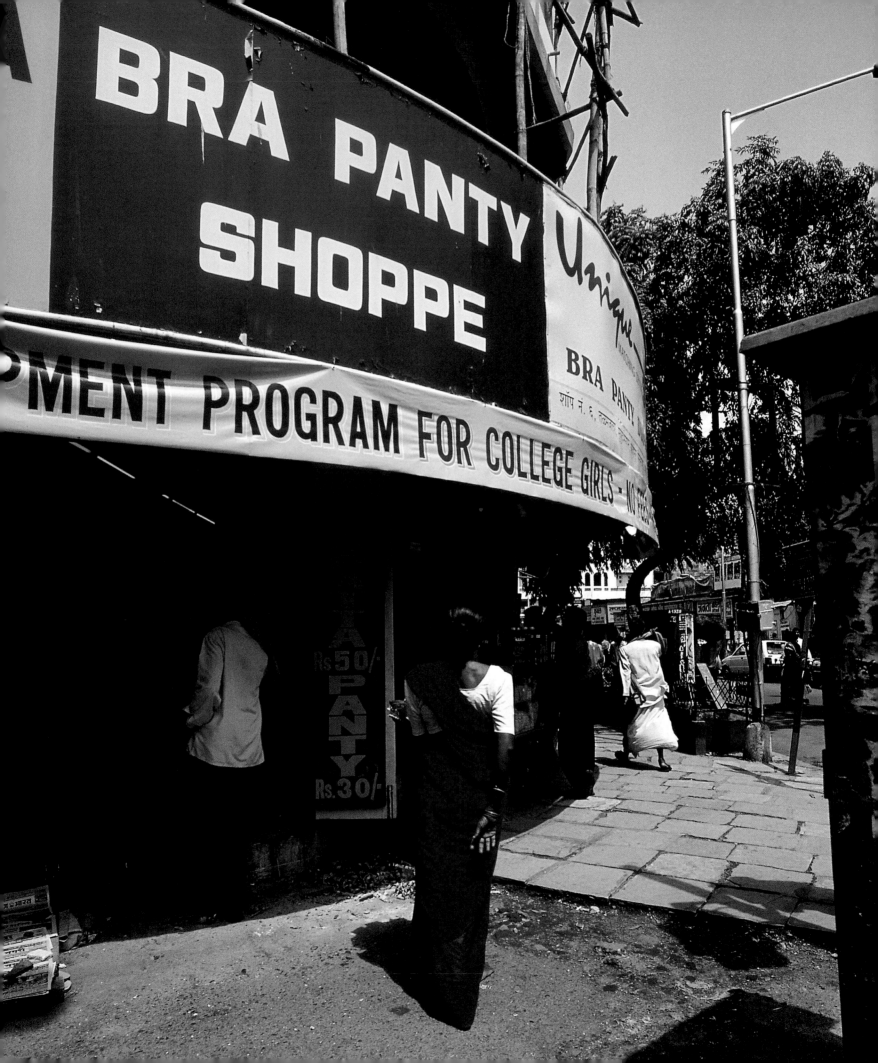

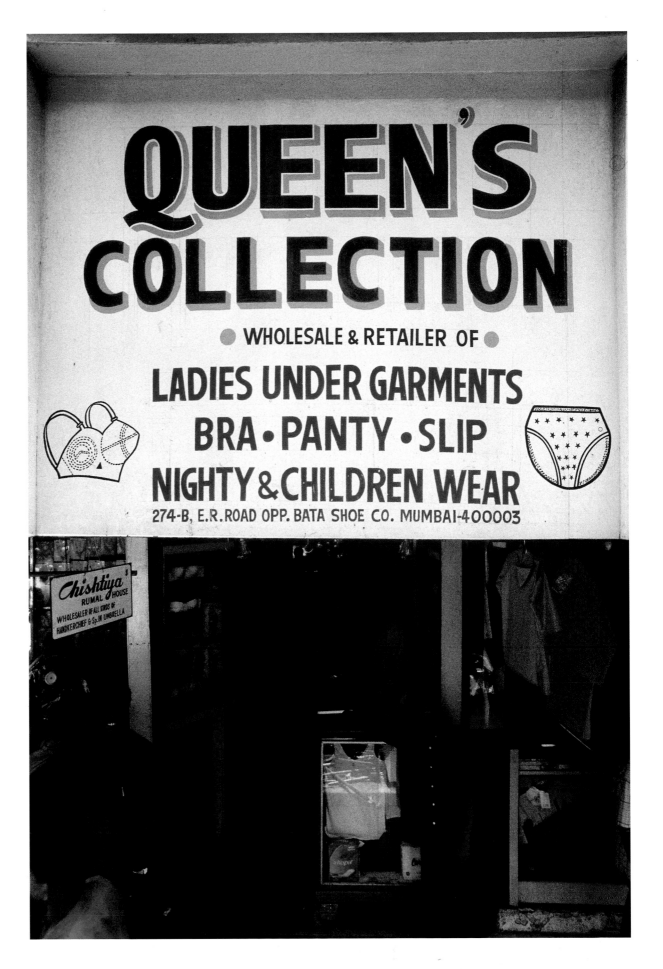

QUEEN'S COLLECTION

● WHOLESALE & RETAILER OF ●

LADIES UNDER GARMENTS
BRA • PANTY • SLIP
NIGHTY & CHILDREN WEAR

274-B, E.R. ROAD OPP. BATA SHOE CO. MUMBAI-400003

Chishtiya
RUMAL HOUSE
WHOLESALER OF ALL KINDS OF
HANDKERCHIEF & Sp.IN UMBRELLA

RIGHT By appointment: the line
illustrations on this shop sign belie
the three-dimensionality of the
human form.
FACING The Bra Panty Shoppe in north
Mumbai publicizes a development
programme for college girls.

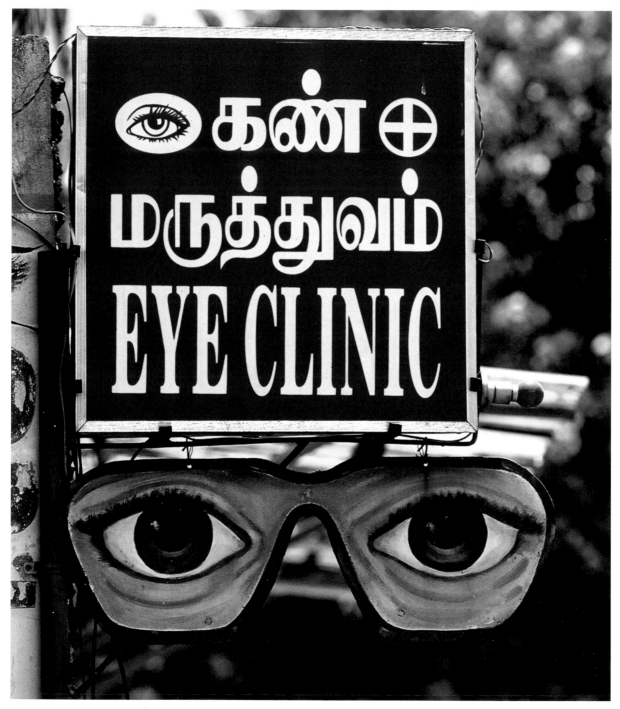

LEFT AND FACING Copywriting can be complex or simple in style. Some shopkeepers and trades create their own slogans, whereas others employ the services of an advertising agency.

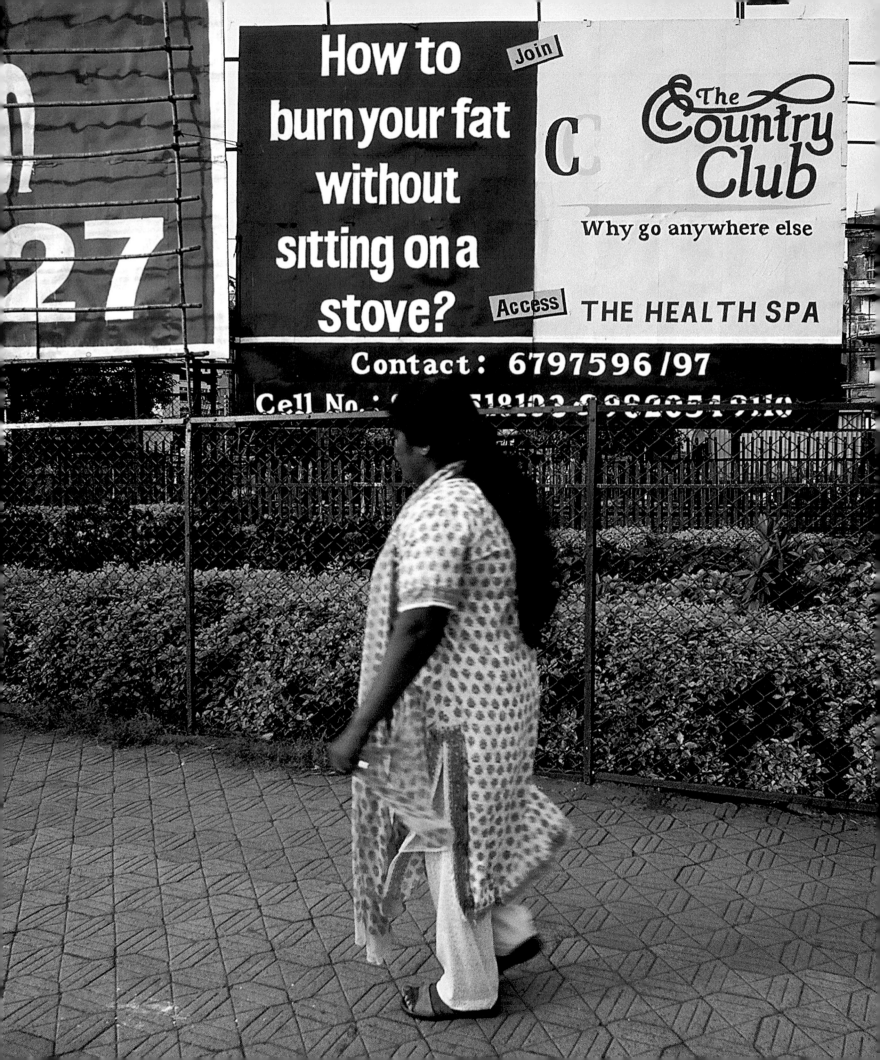

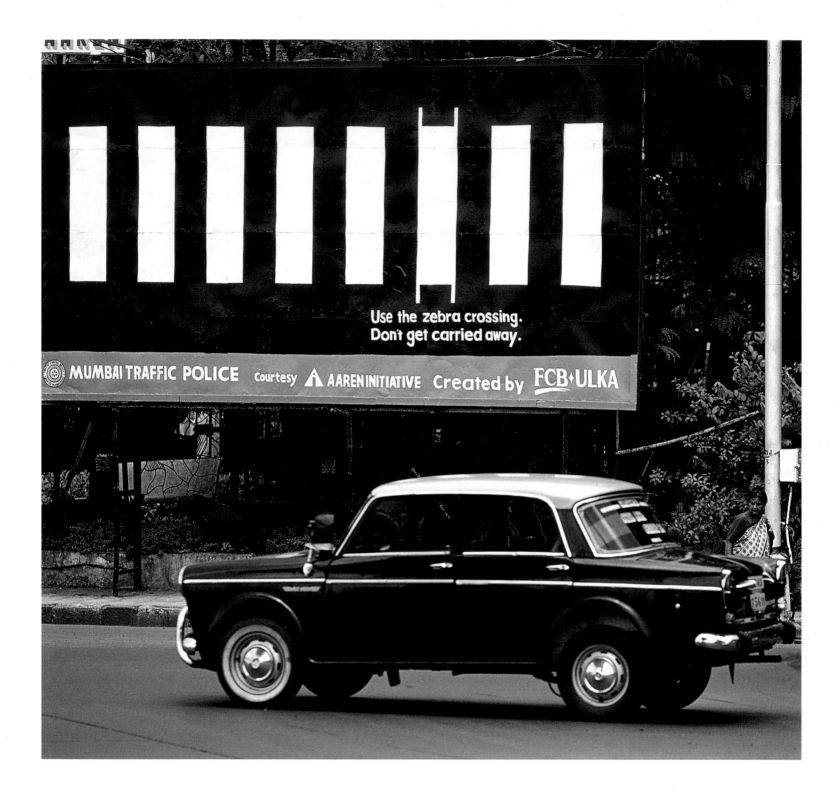

Use the zebra crossing.
Don't get carried away.

MUMBAI TRAFFIC POLICE courtesy ⚠ AAREN INITIATIVE Created by FCB·ULKA

the zebra crossing shown has had four handles added to it to make it look like an ambulance stretcher. The headline reads: 'Use the zebra crossing. Don't get carried away.'

In the Mahim district of north Mumbai a purely typographical treatment catches the eye of passing vehicular and pedestrian traffic. Outside Michael Pinto Funeral Directors is a statement in bold white letters on a black background: 'Remember. We are the last people to let you down.' Michael Pinto's son Danny is now in charge of the day-to-day running of his father's funeral business and is also responsible for writing all the shopfront slogans. He changes the message every few months and laughed loudly as he related one of his earlier nuggets of black humour: 'When you drop dead, drop in.' Danny Pinto offered me a chair in the shade under the shop's awning and proudly reeled off more of his one-liners: 'Hey, smoker! You are the next one coffin it.' Danny lit up another Benson and Hedges, and as I stood to leave I thanked him for his time and told him that if I ever died in Mumbai I would be sure to come to him. 'You will have no choice,' he replied. 'I bury all the English and Americans that die here.'

ABOVE A public safety announcement.
FACING Black humour from a funeral director who writes his own slogans. Others include 'When you drop dead, drop in' and 'Hey, smoker! You are the next one coffin it.'

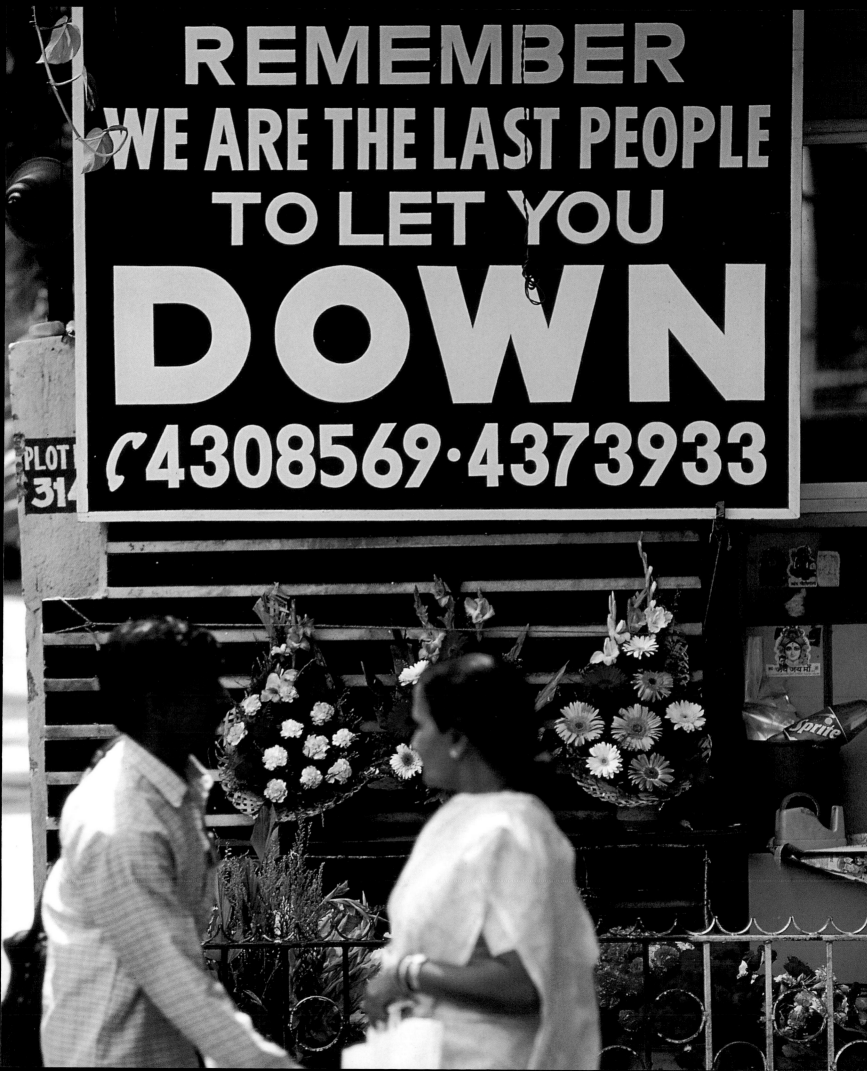

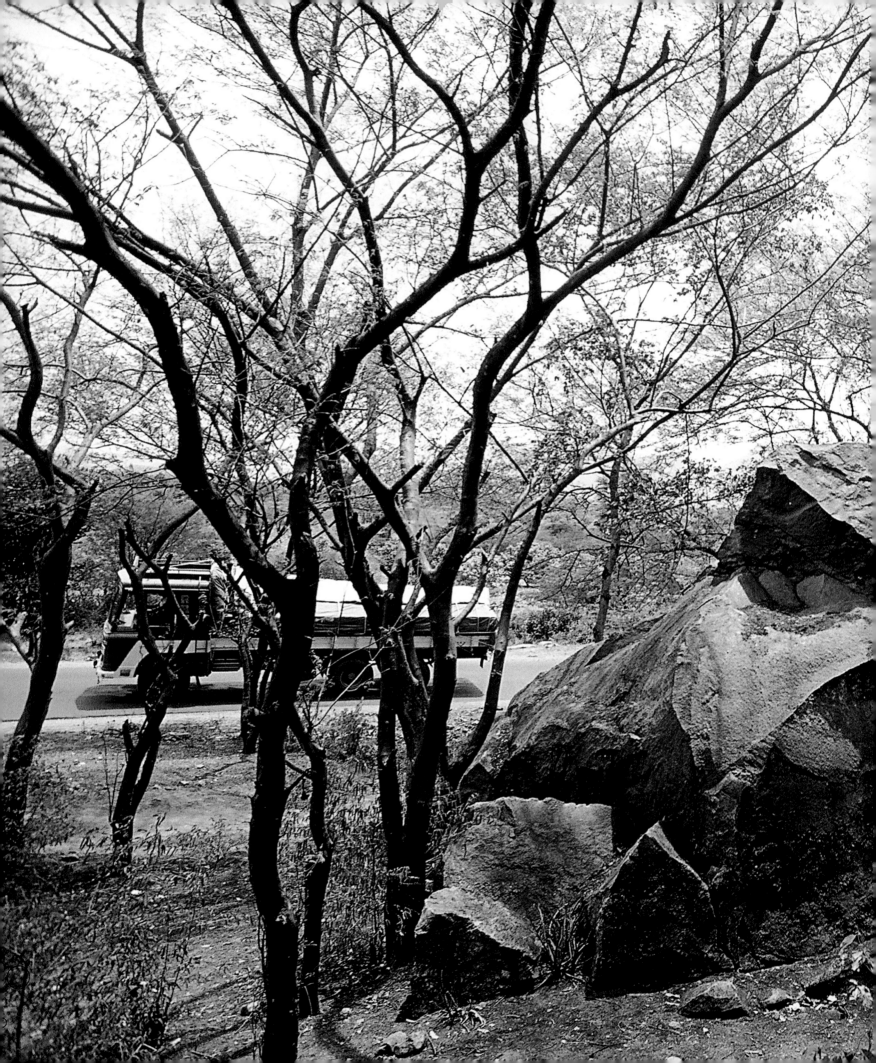

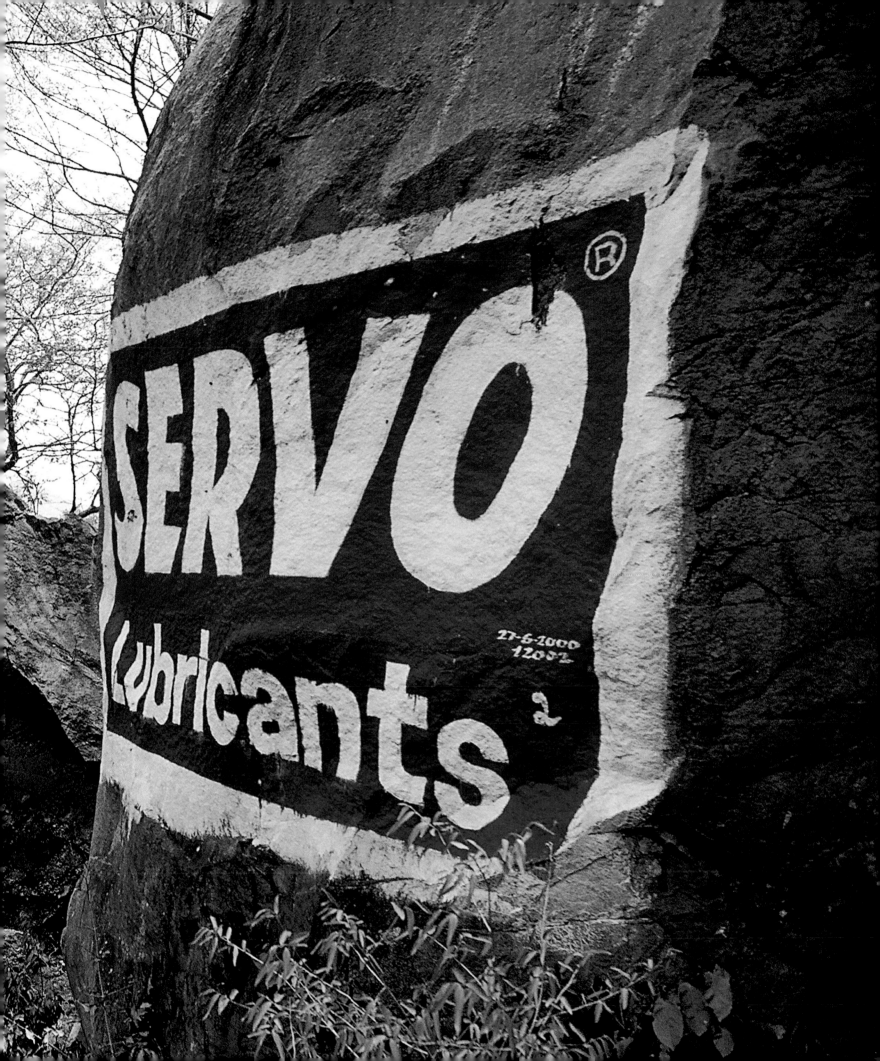

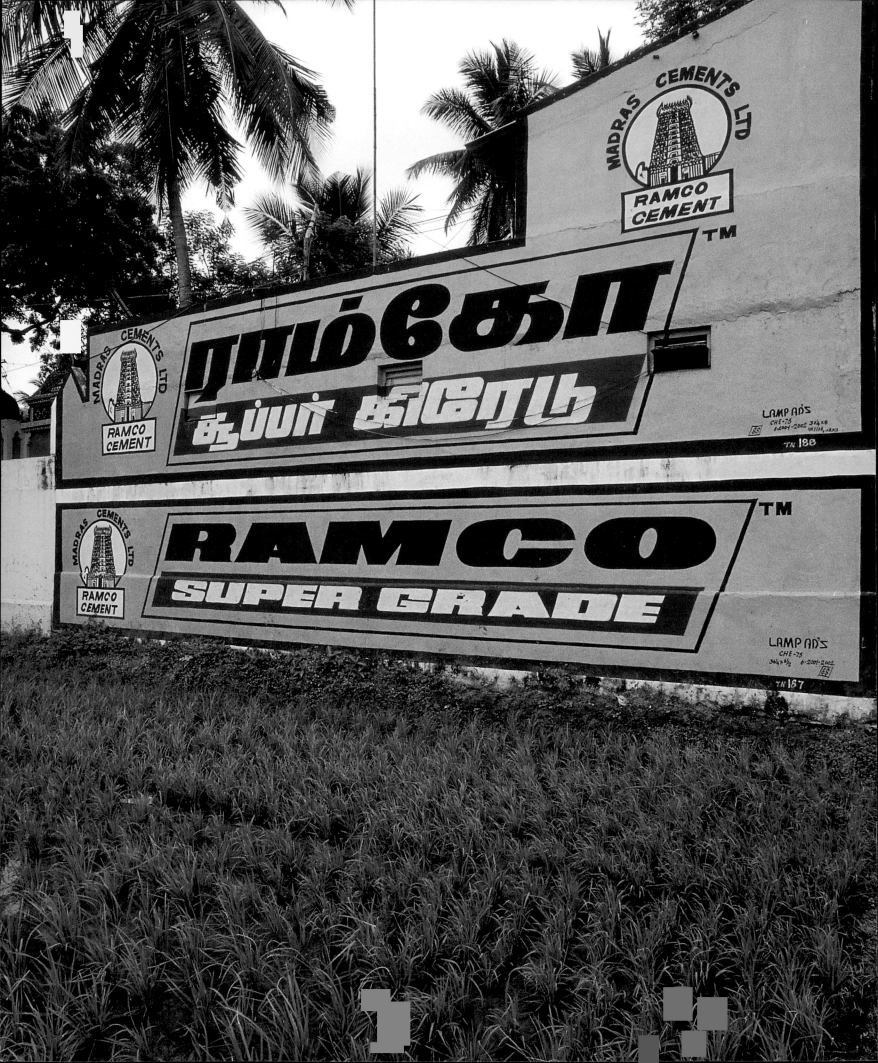

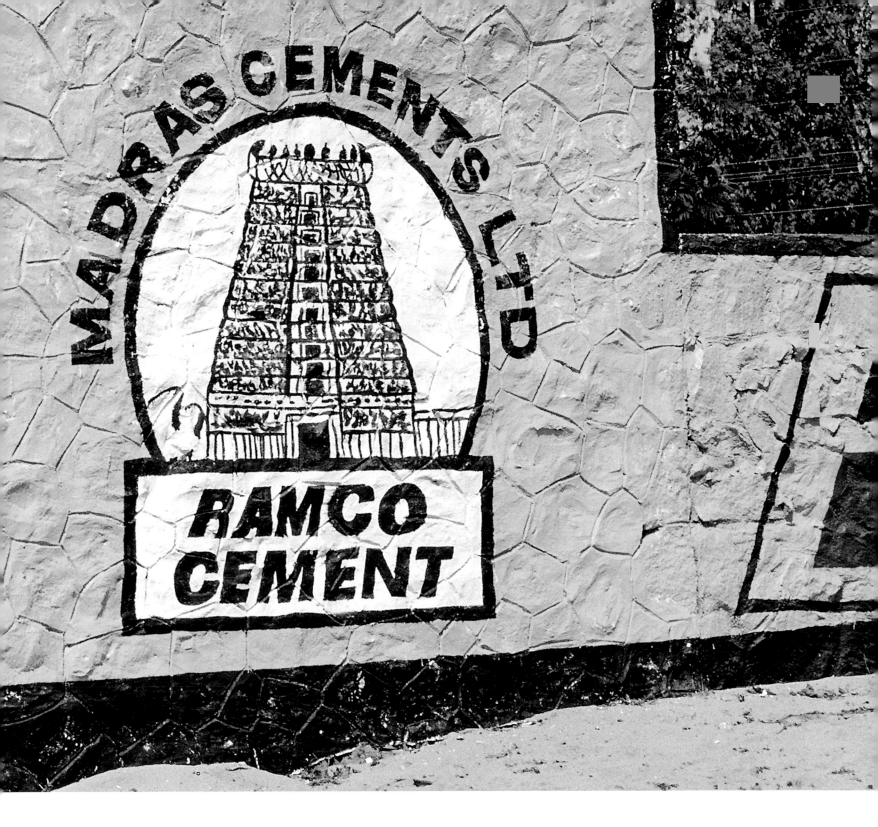

Corporate-identity village

In Tamil Nadu, there are several rural villages scattered along the east-coast road from Chennai to Pondicherry. Some villages are inhabited by agricultural workers, others are home to light-industrial communities. An entire village may dedicate itself to one particular kind of work, like manufacturing coir rope from the husks of coconuts or breaking large blocks of indigenous grey rock into different-sized smaller pieces and grading them into separate piles for use in construction. One thing these villages have in common is Ramco Cement. Not that the houses are necessarily built using Ramco Cement: some are made out of mud rendered over rough brick; others have corrugated iron walls. Rather, Ramco Cement has commandeered the advertising space in the villages to let passing traffic know that Ramco Cement is the only cement worth considering. Homes are emblazoned with the distinctive red and blue lettering on a cadmium-yellow background. The logo itself is a towering gopuram, presumably demonstrating the longevity of Ramco Cement, despite the fact that gopurams (ancient gateways) are constructed in the main from enormous blocks of carved stone. The choice of a gopuram as part of Ramco Cement's corporate identity may not be purely aesthetic. Ramco has long been a supportive presence in the south: its

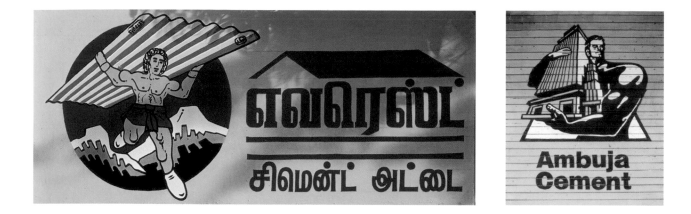

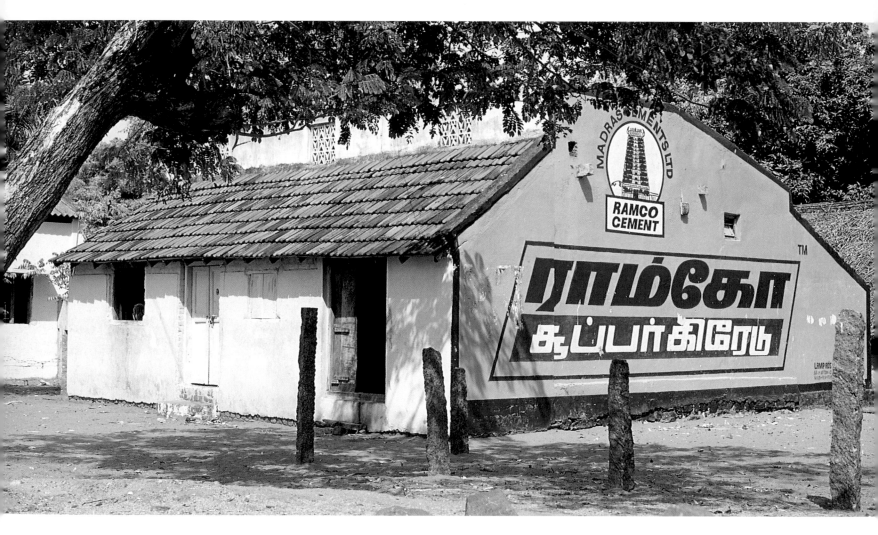

ABOVE AND FACING Home owners and commercial outlets can benefit from a little extra revenue if they allow corporate branding and advertising to appear on their walls and shopfronts.
OVERLEAF Advertising entices the thirsty traveller out of the midday sun.

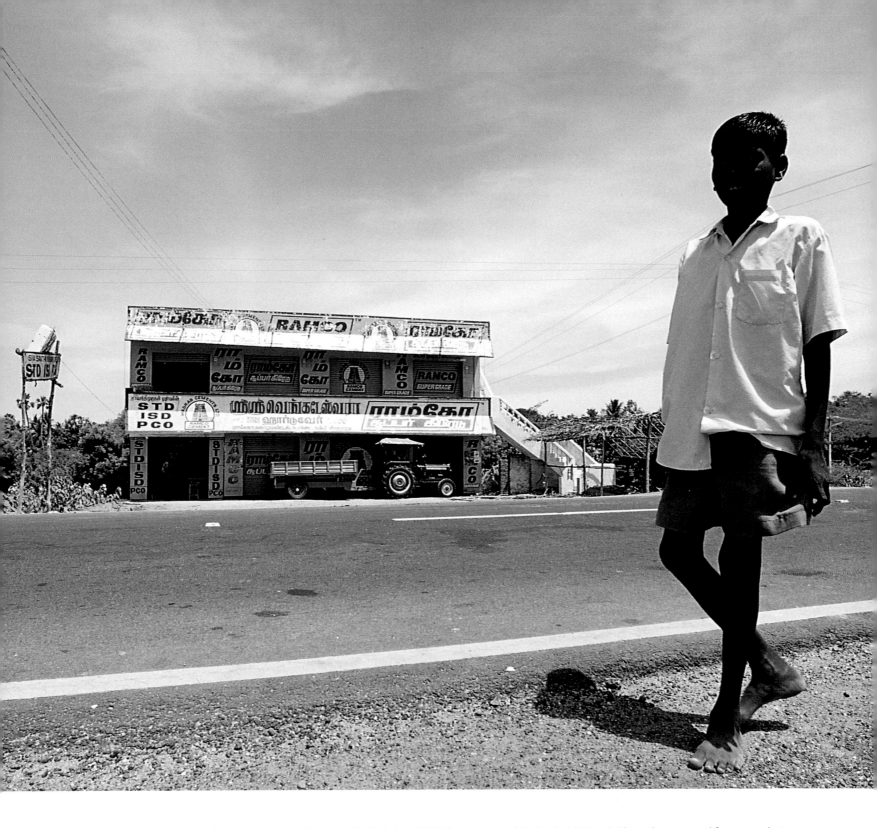

first plant started production in Tamil Nadu in 1961. The gopurams of Madurai's Sri Meenakshi temple are covered from top to bottom with thousands of images of gods and mythical figures. As a result of the temple's location, Madurai became the cultural centre of the Tamil people. The Ramco Cement gopuram evokes a certain spiritually endorsed image that sits well with the Tamil people; to paint your house in Ramco livery is therefore *Serri* – okay.

Further inland, towards Tiruchirappalli, the villages on the main north–south road have been swamped by Servo Lubricants. Huge sans-serif Servo logos adorn the walls alongside paddy fields and in coconut groves. Further south, near Madurai, the relentless monotony of the low, flat plains of Tamil Nadu is broken by enormous outcrops of rock that shimmer in the midday sun. The sight is a welcome respite after the gruelling drive from Chennai. The hump-backed mounds are reminiscent of sacred rocks such as Sigiriya in Sri Lanka and Ayers Rock in Australia. The largest hill is in the far distance. We look through the telephoto lens to cut through the heat haze. At the base of the hill, just above the distant tree line of coconut groves, two words are painted on the majestic buff-coloured rock face: 'Servo Lubricants'.

103

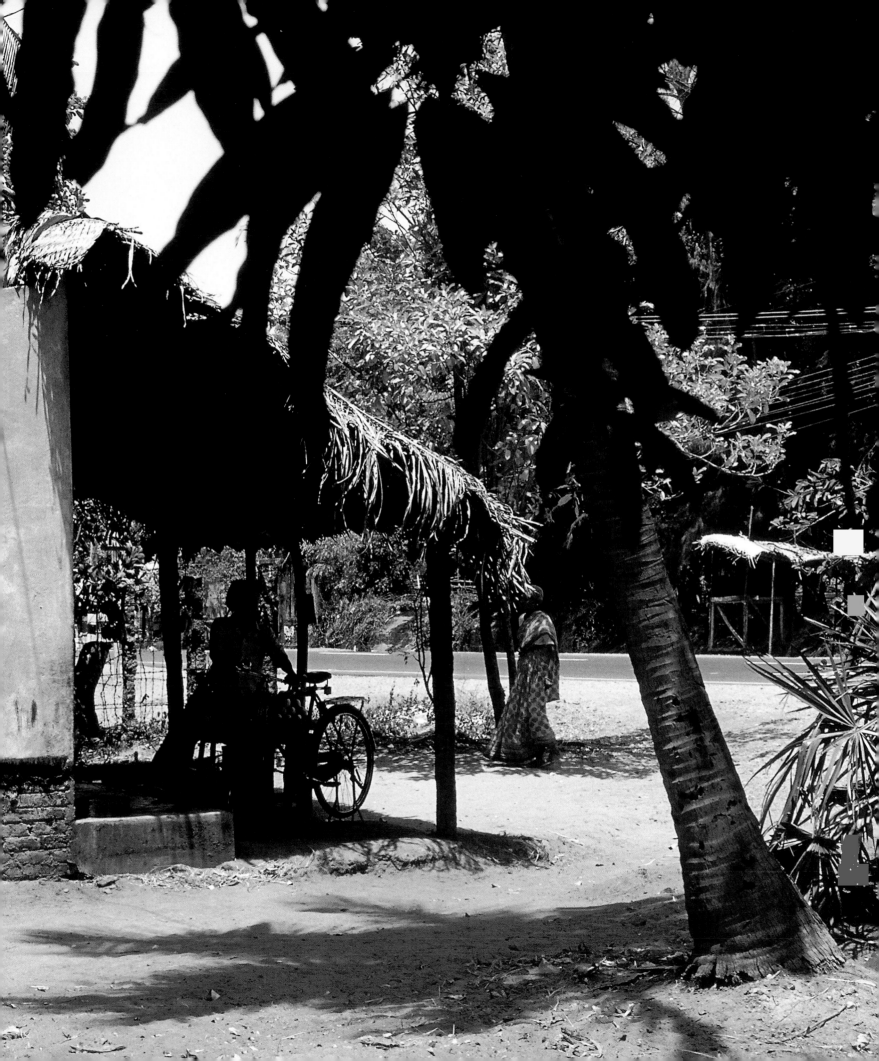

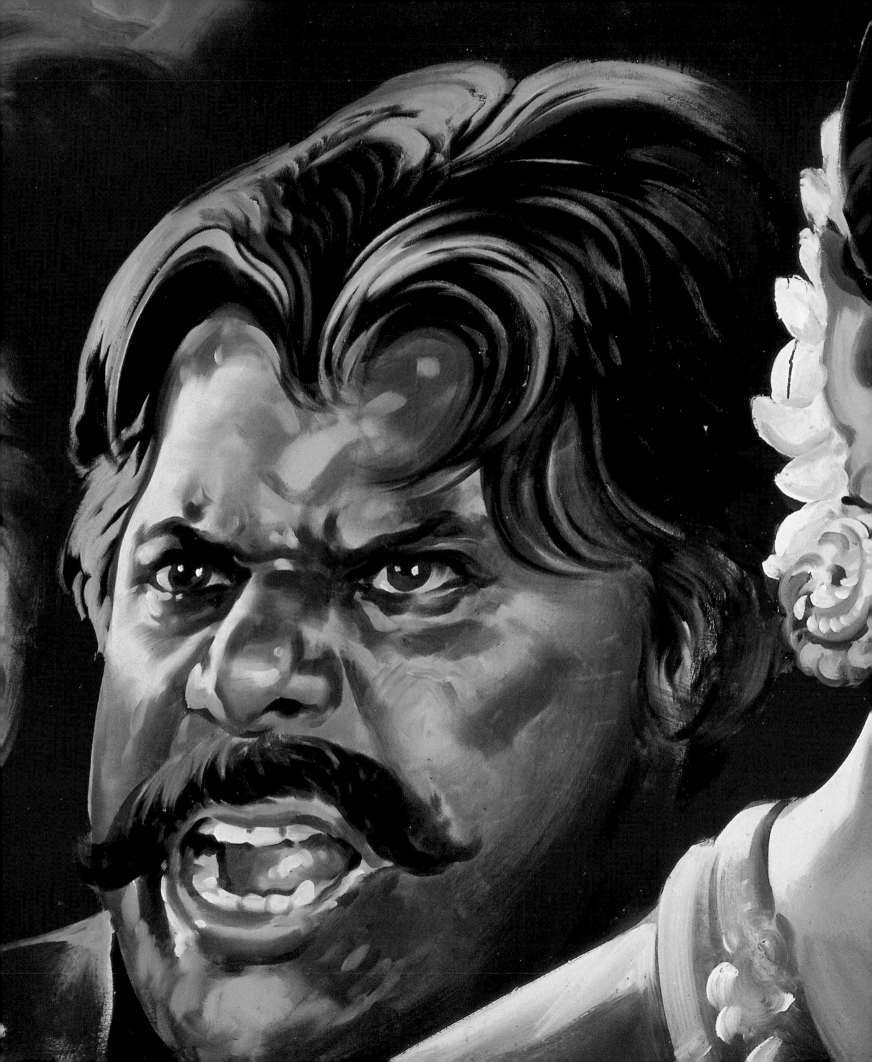

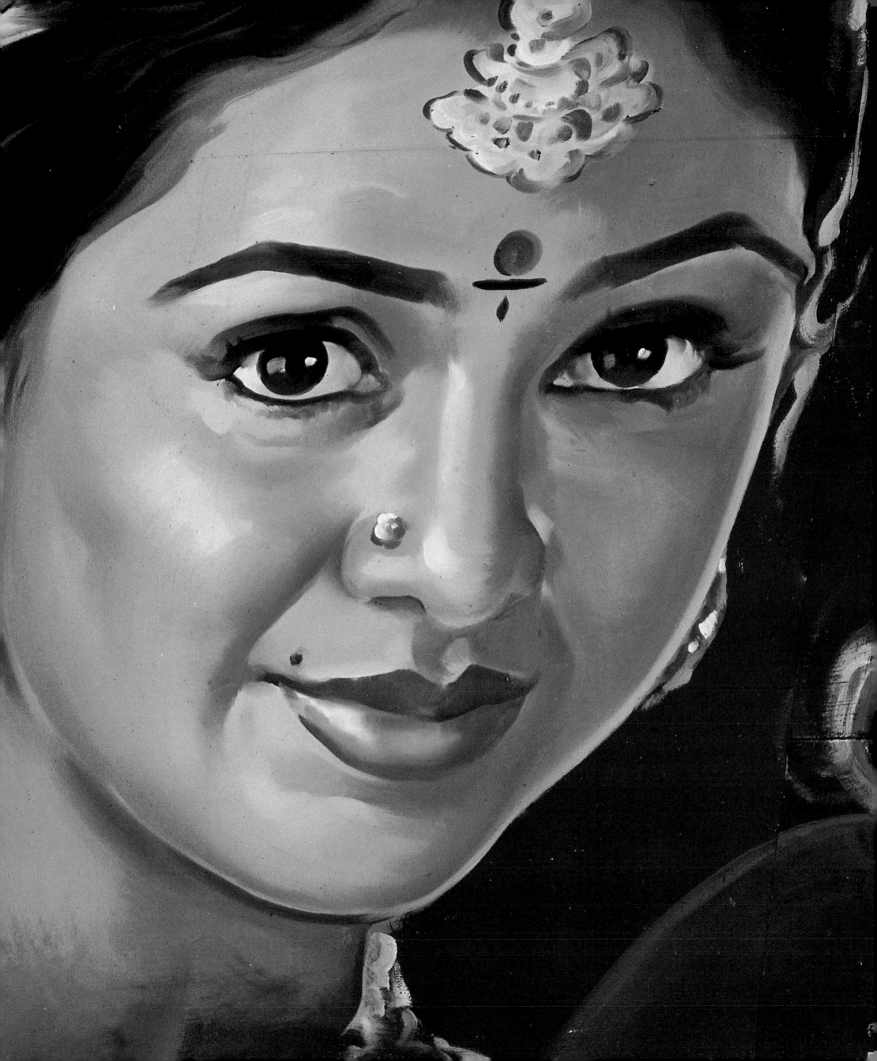

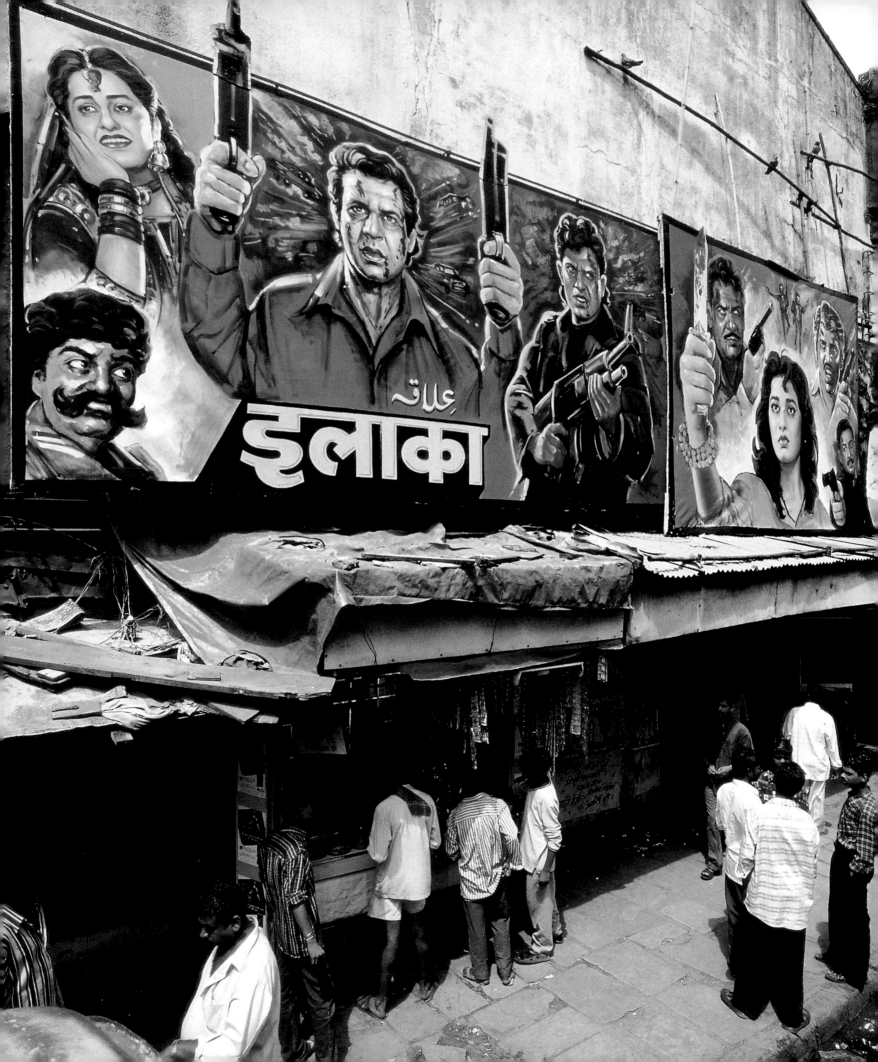

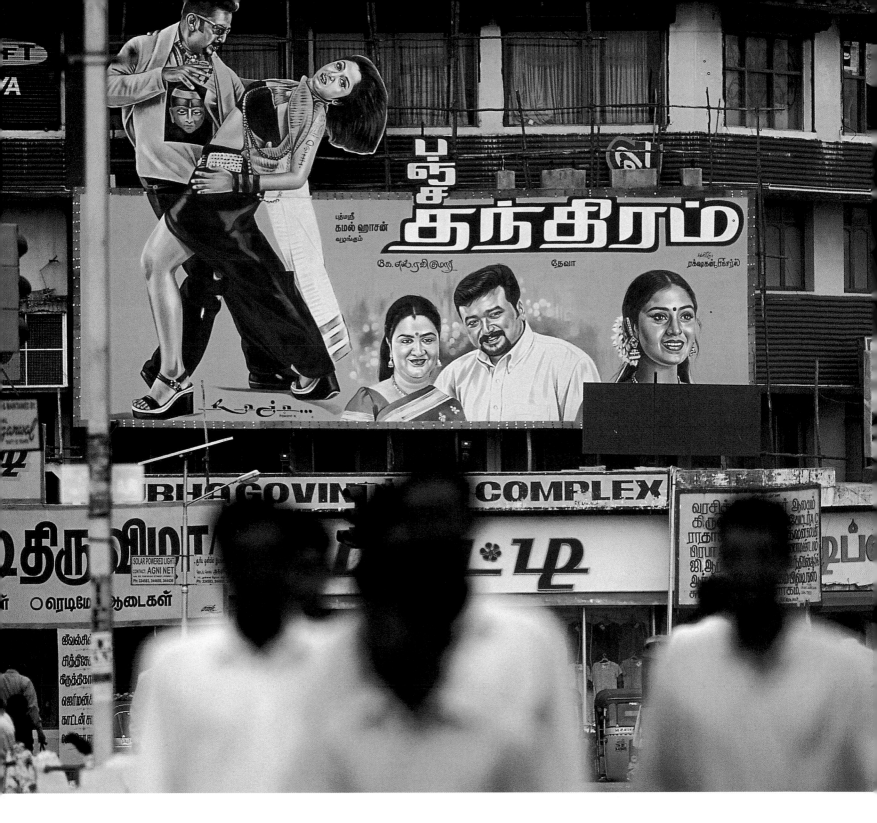

A devoted audience

On one of India's many television stations, I caught the tail end of a late-night showing of a 1970s Indian gangster movie featuring corrupt policemen and hoodlums with thick, moppy hairdos. It was shot on 35mm film stock that could have hailed from Kodak's early Technicolor trials. Pale-blue flared trousers and tight purple shirts speak volumes about the fashion sense of the wardrobe department, while the theatre blood is a particularly bright and unique hue. The hero's punch-up with his numerous enemies in the police station results in liberal use of the viscous crimson liquid. A slight slap to the side of the antagonist's face causes a profuse flow from forehead to chin. The dubbed soundtrack helps the suspension of disbelief as a wide-angle shot of a fist impacting on a septum is accompanied by what sounds suspiciously like a heavy brogue stepping on a rhinoceros beetle. A police guard miraculously turns into a stuffed but floppy mannequin as he is hurled across the cell.

India's film industry is the largest in the world, releasing around 800 films per year. In 1913, *Raja Harishchandra*, India's first feature film, marked the beginning of this home-grown industry that now employs 2.5 million people. Hyderabad, Chennai and Mumbai are the

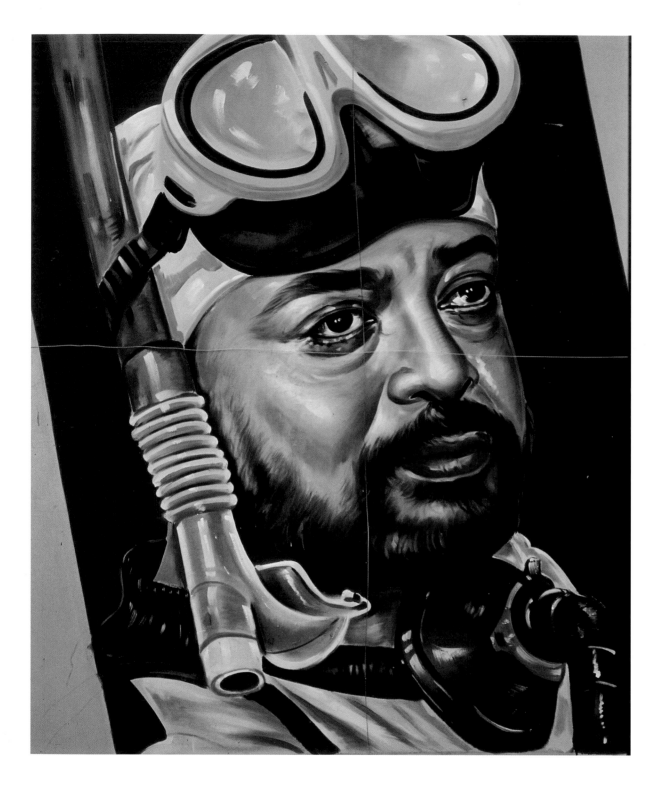

main production centres, delivering most of the popular films to approximately 13,000 cinemas across India. The set designs, production values and quality of cinematography equal those of Hollywood releases. But comparisons may be unfair: the Hollywood actor, after all, does not have to sing, dance and do his own stunts as well as act.

There are three types of Indian movie. Mainstream Hindi films top the bill and have complicated plots and dubbed songs, with inappropriately cued dance sequences set against the lavish backdrop of an Indian wedding or an urban backstreet reminiscent of *West Side Story*. Regional films cater for different cultures and languages; the most significant are the Tamil- or Telugu-language films of southern India. The third category is art-house cinema. As a result of its habit of dealing with social and political issues, it is restricted to a relatively small audience. Historically, art-house cinema mainly appeals to the Bengalis and Keralans.

Although popular Indian cinema often seems over-exuberant, its vitality reflects Indian culture and in turn influences real life. But this is 'reality' that has been sieved, polished and packaged to provide escapist entertainment for the masses and relieve the daily grind. Posters and hoardings advertising the latest releases appear everywhere to set the public pulse racing. Cinematic images reach beyond roadside

ABOVE A film hoarding in Tamil Nadu depicts the protagonist wearing Bond-style accessories.
FACING A cinema ticket can cost the film-goer the equivalent of an average day's wage.

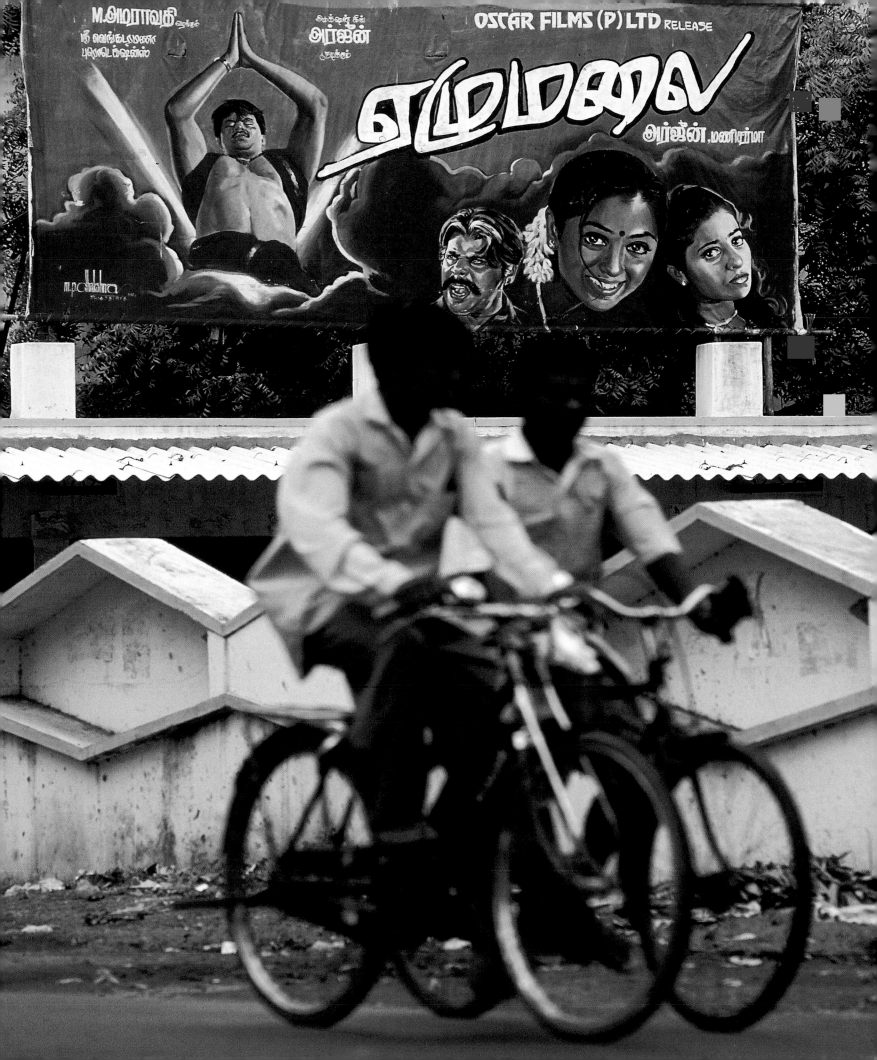

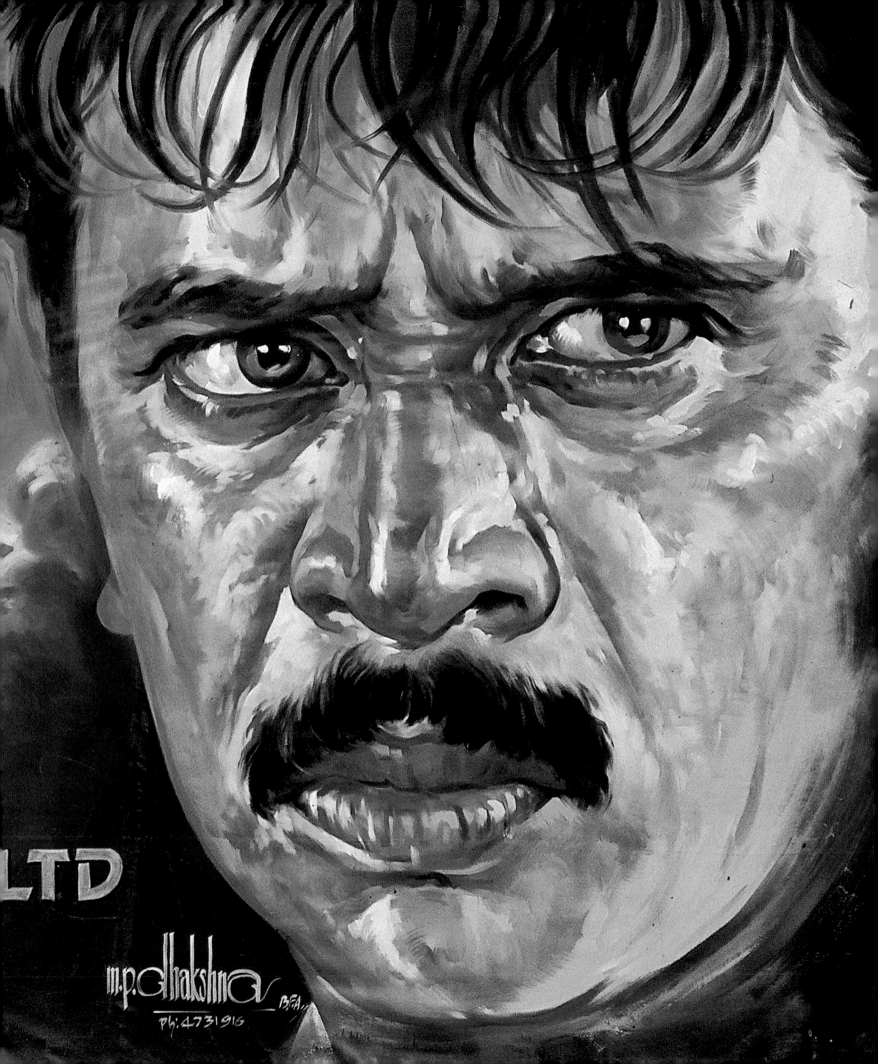

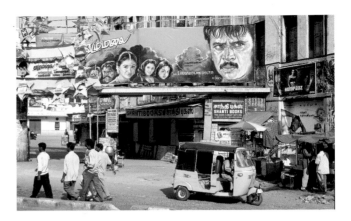

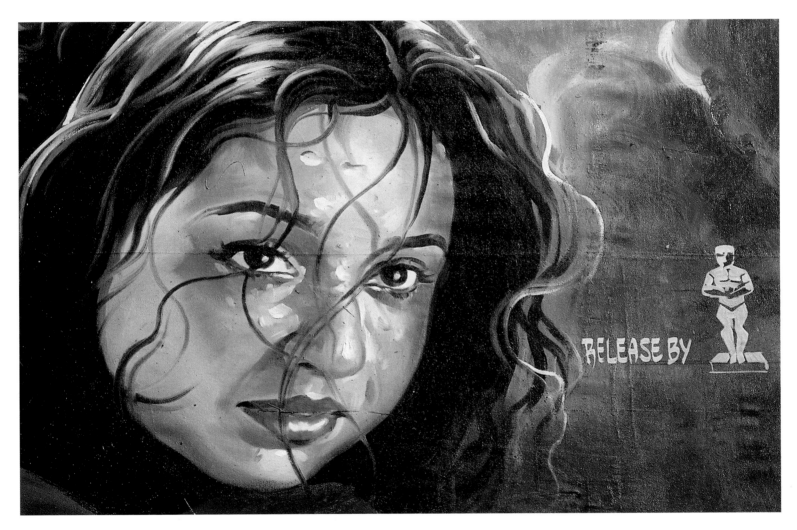

billboards into magazines, television and even food packaging. In Tamil Nadu, the hand-painted posters convey the tried and tested screenplay formula featuring a policeman, a hero covered in sweat and blood, a bit of love interest and perhaps a TATA truck hurtling uncontrollably down a ravine. The treatment is loose and brushstrokes are rapidly applied in contrast to the more considered Mumbai studio poster style. The flick of the brush at the end of a moustache accentuates the anger in a man's face; cold blue strokes highlighting the edge of a woman's face symbolize the innocent in danger. Film songs may be released before the film itself and get played on the street and sung in men's 'beauty saloons' (the usual term for a barber's shop). The actors and actresses take the lead roles in this dream factory: there are heroes and heroines, gods and goddesses. Sometimes, when ego and convictions are both strong, the players go on to apply their skills to politics.

'Strong and bitter words indicate a weak cause' is the 'thought of the day' at Jolly Maker Apartments. The words are typeset with the variable letter spacing characteristic of do-it-yourself graphics. The sign is displayed on a flimsy aluminium easel next to the concierge's desk on the ground floor of M.F. Husain's Cuffe Parade apartment block. This is a wealthy area of Mumbai, and the security staff at the

113

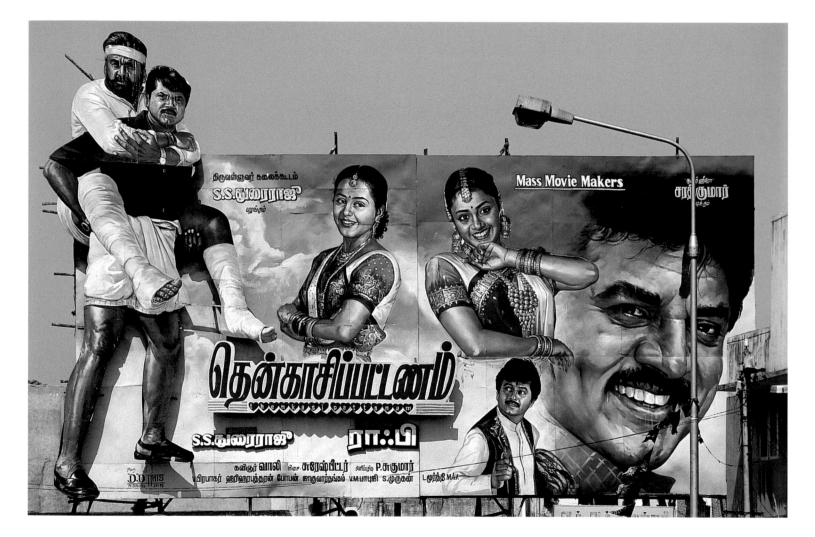

gates and in the foyer reflect the status of the residents. Maqbool Fida Husain is one of India's most important contemporary artists. He works in a variety of media and considers himself more than just a painter. He has produced poetry, installation art and, most recently, film. His early roots as a film hoarding artist may have influenced him in considering painting the only medium capable of expressing a purely Indian culture.

Husain was 20 years old when his father lost his job as timekeeper at a textile mill in Indore, in the state of Madhya Pradesh. His love of drawing and painting brought him to Mumbai to work for an acquaintance who had set up as a film hoarding painter; the year was 1936. He started by mixing huge tins of colour and helping his employer, Shabab, paint in the backgrounds of the billboards. Even by 1930s standards his salary was a pittance at less than half a rupee a day. He seized every opportunity to supplement this meagre wage and sold his first painting to a restaurant owner for a month's worth of meals. This billboard phase of Husain's career created a sound foundation for his life's work. As he later explained: 'In making billboards, I trained one eye to constantly see the rest of the painting in the distance, and my hand to make adjustments in scale and relate distance to the area I was working on. I do not recollect too many occasions since

ABOVE In Chennai, film hoardings make great use of cut-outs in an attempt to illustrate the narrative. TOP AND FACING Hoardings painted with acrylic on vinyl give a flatter result than those executed in oil.

when I have changed, repainted or corrected my original drawing.' Within a short time he was painting his own hoardings.

Husain's involvement with the contemporary art movement in India in the 1960s led him to reject Western influences. But throughout his career, Husain has remained true to his roots – Indian cinema. His film *Gaja Gamini*, made in 2000, seems to relate to his widely publicized fascination with the actress Madhuri Dixit; he has painted her portrait several times. Dixit starred as Nisha in the 1994 film *Hum Aapke Hain Koun*, a film that Husain has seen 68 times.

On the first floor of Jolly Maker Apartments we are welcomed by Husain's son. A narrow corridor leads to a light, airy room with windows on two sides. Husain sits cross-legged on a low divan bed covered with large cushions. He has white hair, a white beard, white shirt and white *puthloon* (loose-fitting trousers). This vision of a traditional Indian is spoilt only by the pair of heavily tinted spectacles perched on his nose. As he finishes a conversation on his mobile telephone, we are offered tea. Opposite him is a state-of-the-art widescreen television, DVD and video player and shelves heavy with tapes and discs. The other walls are covered with enormous colour and black-and-white prints. The photographs show Madhuri Dixit on set and on location in Paris. Husain has started to overpaint the photographs in

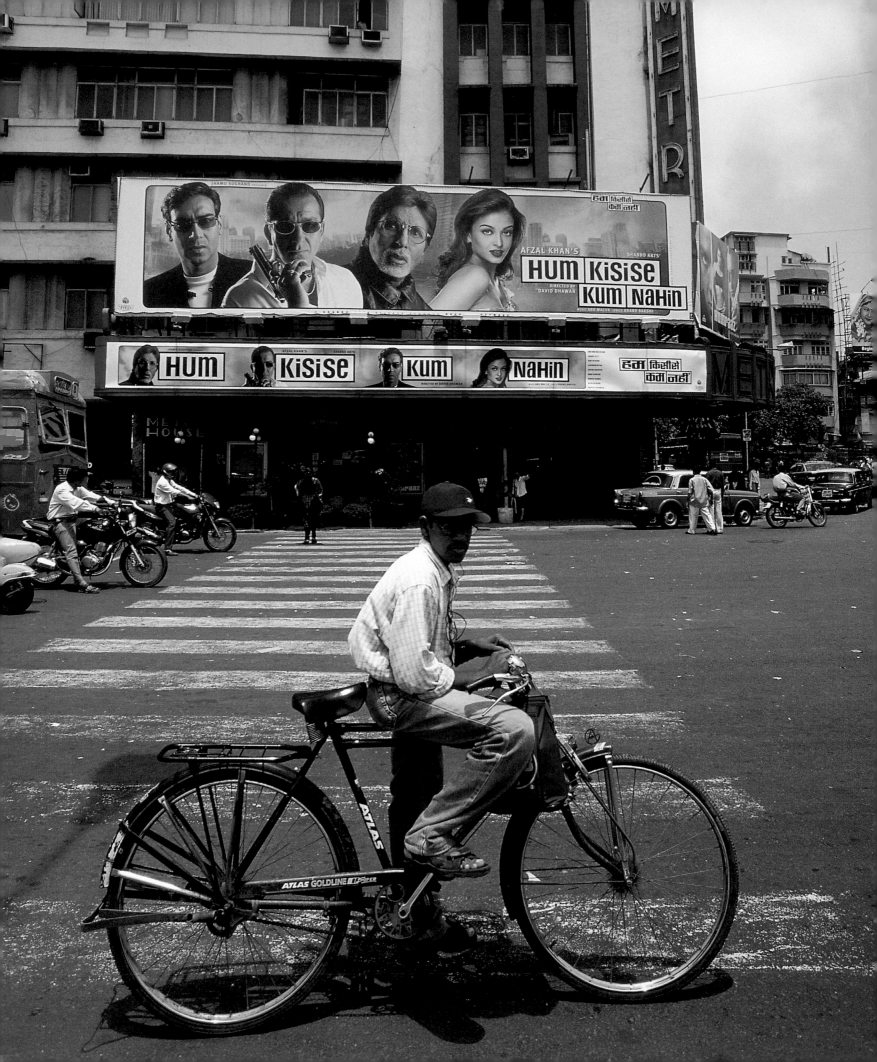

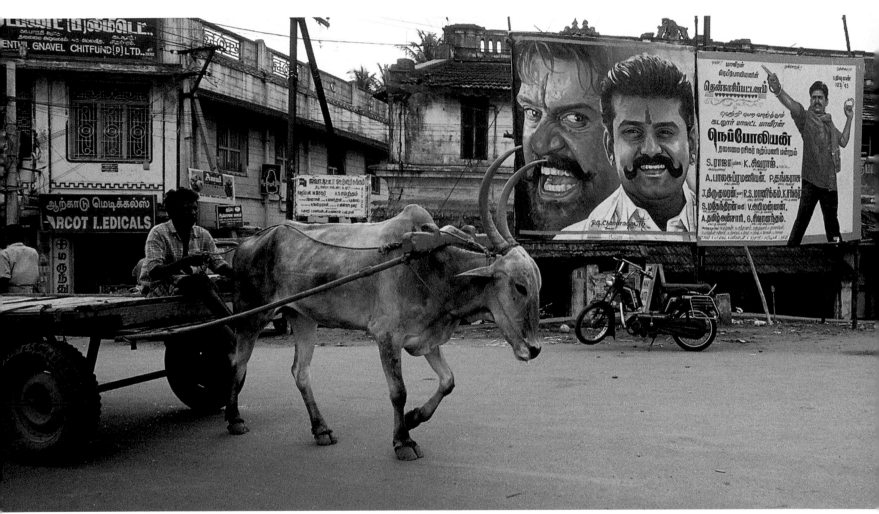

colour and explains that they are works-in-progress. The process, if not the environment, suddenly seems familiar as I think of Balkrishna Vaidya and his hoarding-painting studio in north Mumbai. The fusion of art, cinema and folklore begins to make sense in Husain's apartment. He gives me a book of the making of his film *Gaja Gamini* in which he explores womanhood across a period of 5,000 years.

Art and cinema have amalgamated with politics to create the visual essence of Indian cinema. To the Westerner, Bollywood poster art may at first appear gaudy, but to the Indian it is a looking-glass into another world – an escape that lasts longer than the three and a half hours spent in the cinema. These images present the story in what is sometimes an almost Renaissance painting style, not in technique precisely, but rather in the curious juxtaposition of elements – lone portraits, lovestruck couples, all on a background of stormy, lightning-filled sky. The text may allude to a love triangle that resolves itself in such a way as to underline that family is the most important thing in life, or tell a tale of 'the good will out' sort involving a heroic conflict between a college boy and a powerful urban criminal.

Posters offer a visual précis of the story. In the case of *Mother India*, the image of a young and virginal goddess requiring the support of her family to repel foreign powers was used as explicit political propaganda. During the late 1940s and the transition to independence,

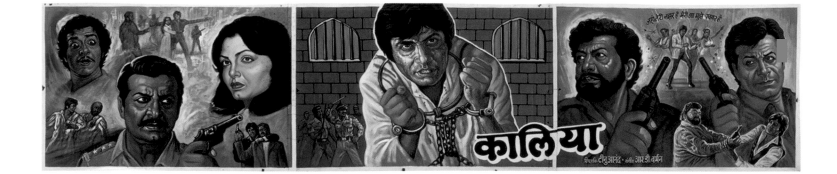

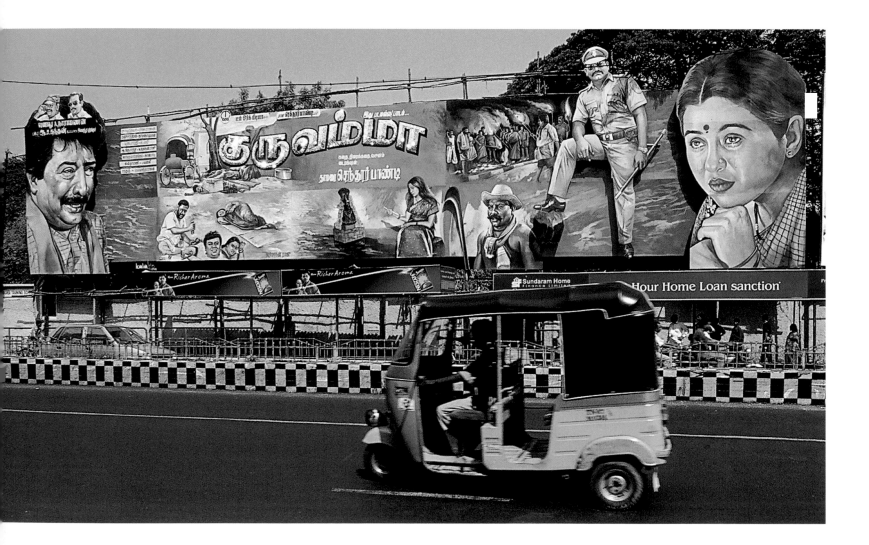

symbolism was used in the design of posters. The map of India was a popular design element, as were Hindu gods and goddesses, to promote the idea of a nation with a heritage of its own. Films featuring allegories of injustice overcome were particularly popular with cinema-goers who had lived under imperialist rule.

M.F. Husain's film is a piece of art-house cinema and as such it will not reach all of India's daily 14 million cinema-goers, but he shares their infatuation with the medium all the same. The average film-goer is prepared to pay the equivalent of a day's wage to visit the cinema. Between the birth of the talkies in 1931 and the end of the century India produced over 30,000 feature films. Its film industry is the largest in the world and is growing quickly beyond its own shores.

Back in M.F. Husain's luxury apartment, being in the presence of the Indian contemporary art set and the cinema élite means playing a part in its own flighty and fictional narrative. The cultural trappings, the unintentional name-dropping and the heightened security all blend to suggest the beginning of a film script. Reality returns once we leave Jolly Maker Apartments. The film has ended.

TOP The triptych is a popular format for cinema hoardings. Films of the 1970s and 1980s continue to be shown in cinemas. A handcuffed Amitabh Bachchan appears in the centre panel advertising one of his earlier films, *Kaliya*.
ABOVE Films are often rereleased many times. Some of the more momentous and unforgettable passages from the screenplay are illustrated on hoardings in order to jog the memories of the target audience.
FACING Western films get the hand-painted treatment too.

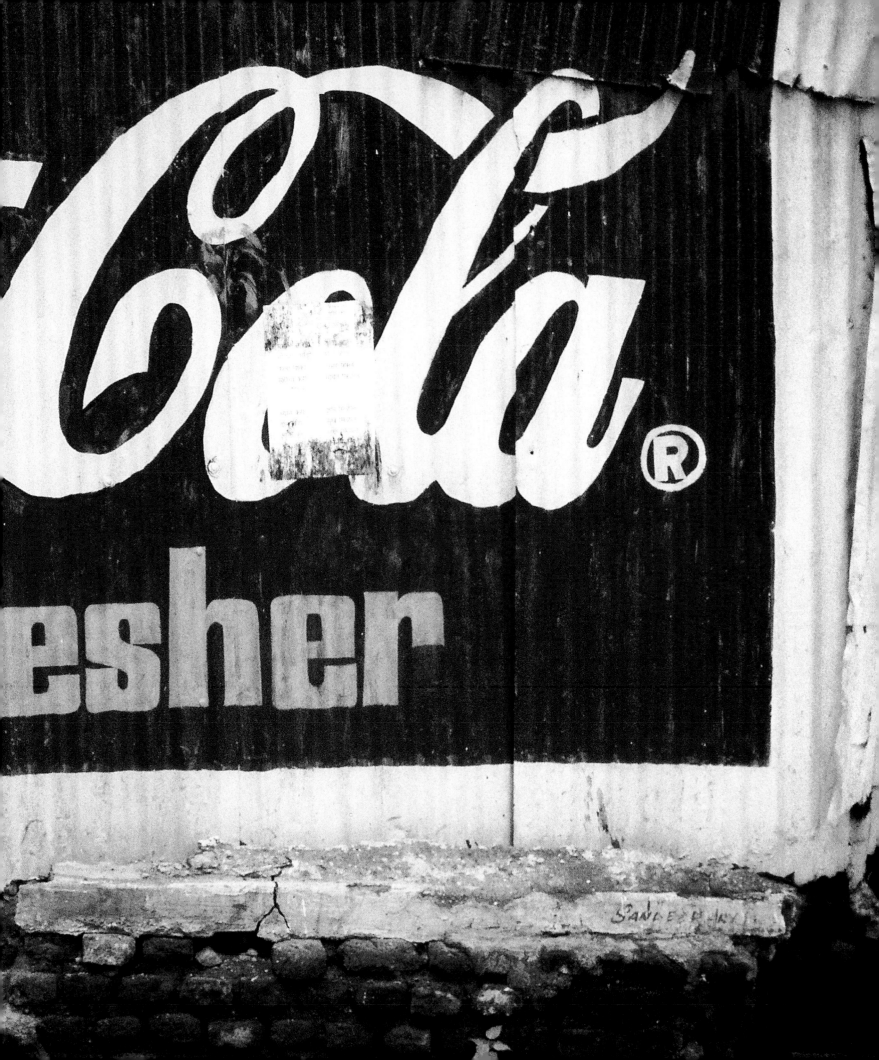

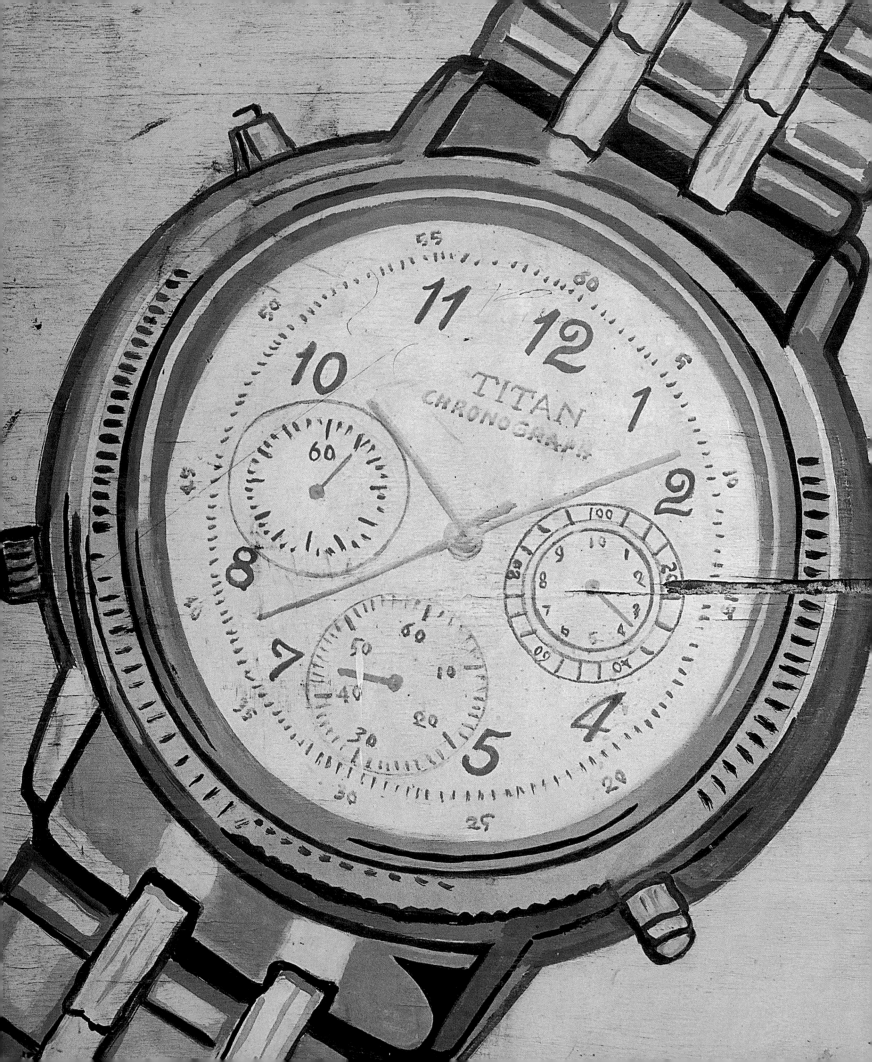

ROOP SANGAM STUDIO & COLOUR LAB

Kodak PHOTOSHOP

Network Member

येथे कचरा टाकु नये

PREVIOUS PAGES AND ABOVE The darkened skies of the monsoon season alter prismatic hues and saturate colours.
FACING Miniature precision engineering as represented by the sign painter.

Saturation point

You can smell it before it arrives. It has the odour of a hint of distant, freshly mown meadow blended with the delicate aroma of Japanese tea. The skies darken, a slight breeze stirs the leaves on the trees and street life quickens its pace, intent on shelter. The warm summer rain comes from the southwest and falls daily from June to August. If you are lucky enough to be on Mumbai's Chowpatty Beach when a monsoon front arrives, you can take cover among courting couples by the *bhelpuri* stalls and watch the surf rise and the coconut palms bend under its influence. The southeast coast is also affected by a northeast monsoon which brings rain from October to December. The average 12 inches of rain per day bring relief for some and misery for others; farmers face their busiest time of year as they prepare their fields for planting, rivers rise and sweep away roads and railway tracks, and many people are made homeless. Street vendors and their goods are drenched as they desperately unfurl tarpaulins and continue to attempt to divert flash-flood waters into the nearest road drain by scoring routes in the mud with sticks.

From a purely aesthetic perspective, the changes in humidity at tropospheric and stratospheric levels satisfyingly alter prismatic hues.

||Shree Gajanan Prasanna|| • ||Shree Santeri Prasanna||

Abhishek Creation
PHOTOGRAPHER
DESIGNER & PRINTER

○ **PHOTOGRAPHY**
○ **VIDEO SHOOTING**
○ **DESIGNING**
○ **SCREEN PRINTING**
○ **OFFSET PRINTING**

Colours are saturated during this welcome respite from the bright sun, the shadowy atmosphere turns sun-bleached pink into deep vermilion and pale olive into verdant emerald. The hues of the natural world come alive, as does the colour palette of the signwriter and hoarding artist. The quasi-three-dimensionality of a Sanskrit version of Goudy Hand-Tooled Bold Italic with drop shadow rendered in vivid azure on a sulphur-yellow background takes on a stronger, deeper quality in this half-light than it does in the over-exposed sunlit version. Interiors and doorways, blackened by contrast with the sunlight, suddenly become noticeable when the rains fall and shopkeepers stand in them to witness the downpour and passing pedestrian traffic takes shelter under their awnings.

Paint and posters are applied to walls, carts, vans, buses, lampposts and even to vinyl spare-tyre covers on the back of private scooters – a little extra revenue to advertise the local Hero Honda dealership is always welcome. Freestanding hoardings consist of vinyl stretched over a latticed wooden frame; dozens of panels of sheet metal bound together with rivets make up the equivalent of a 48-sheet hoarding. Recycling is key to cost-cutting in India: panels salvaged from other sites create an interesting jigsaw puzzle of half-images and letters on the reverse side of some hoardings.

ABOVE Multi-disciplinary creative services, Mumbai-style.
FACING The colour palette of the sign painter's art is enhanced by a monsoon downpour followed by bright sunshine.

124

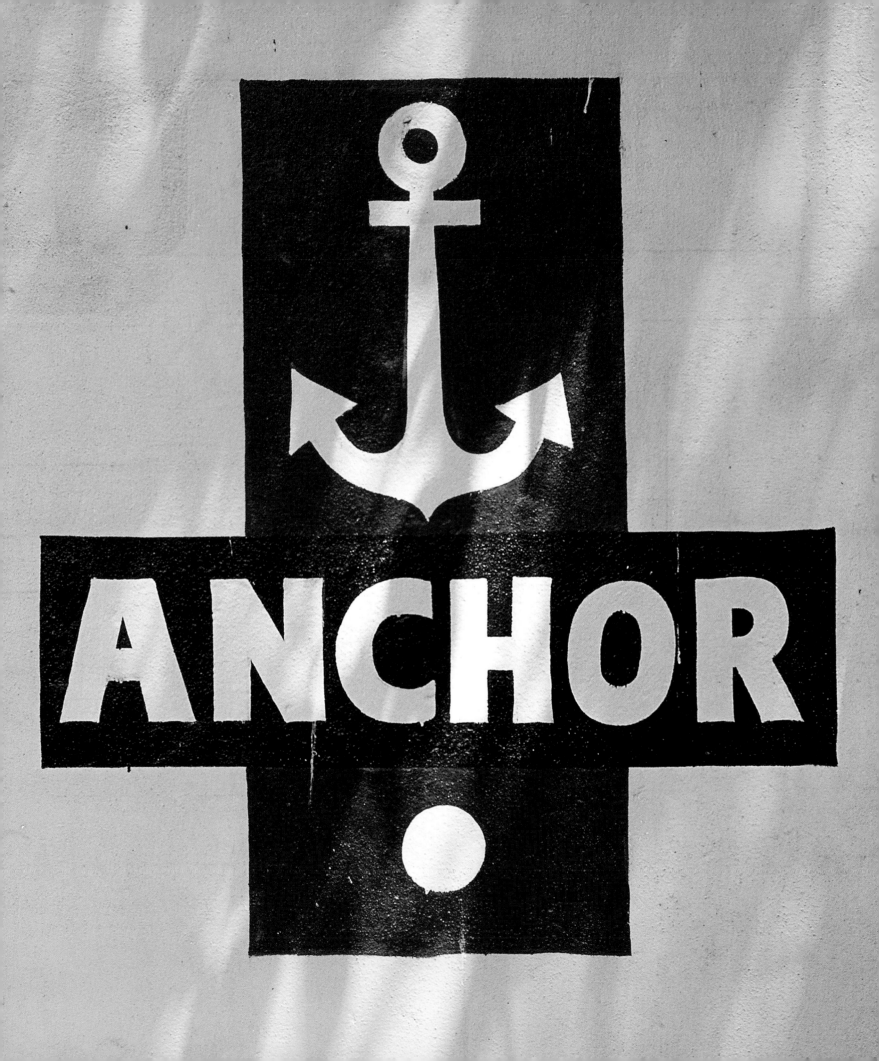

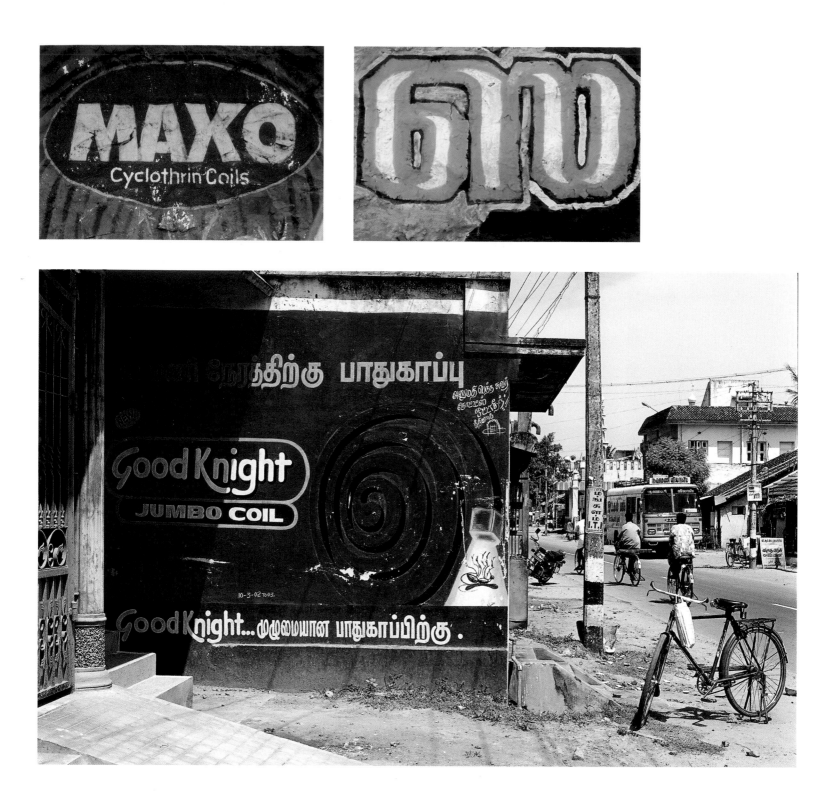

ABOVE Anti-mosquito coils keep the threat of malaria at bay.
FACING Dhobiwallahs struggle to launder clothes at the edge of a river suffering drought conditions.

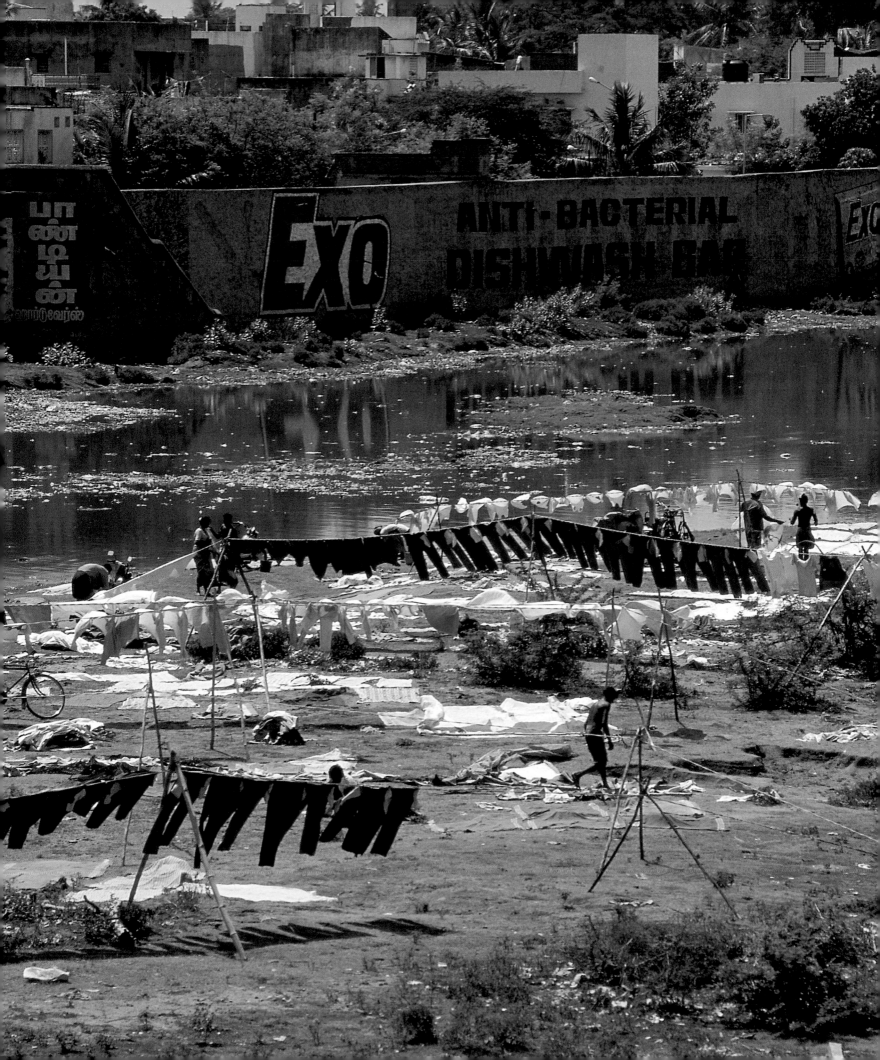

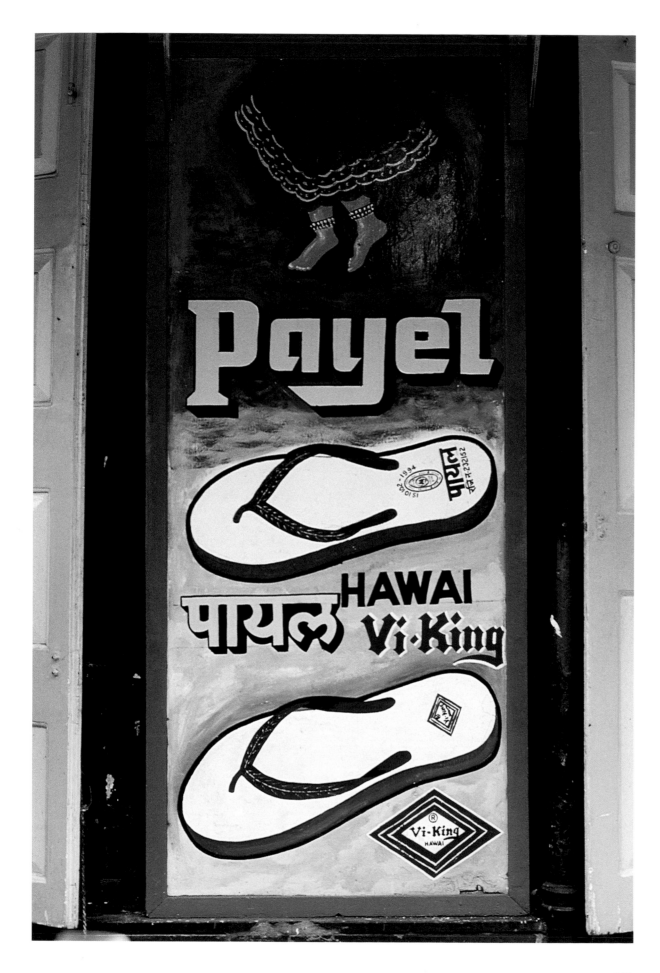

LEFT In Chennai's George Town market every available surface is used for advertising. Two shoe shops share this slim panel.
FACING Engrained colour stains the fingers of a signwriter.
OVERLEAF This metal-panelled hoarding is approximately 30 feet wide and is located in a remote rural landscape. Pothys is a clothing manufacturer and retailer.

In contrast to the cacophony of the city, the metal-panelled hoardings on the side of traffic-free roads buckle and resonate in the hot sun in the still of rural plains. The mirage effect created by the shimmering heat haze that hovers above the black asphalt of a long straight road can be mesmerizing. There isn't much green vegetation on the open arid plains of Tamil Nadu. It is July and the monsoon is late in this part of southeast India. As the Ambassador taxi hurtles towards the seemingly infinite horizon, I can see a speck of colour in the distance. A quarter of an hour later the shape of a roadside advertising hoarding can be picked out, and after a further five minutes a single red word on a yellow background becomes legible: 'Pothys.' It means nothing to me but Dass, the driver, explains: 'Shirt.' The company of Pothys was established in 1930 to sell cotton saris and dhotis created on K.V. Pothy Moopanar's loom by the weavers to the maharajas of yore. Generations later, the most recent of several showrooms has just been opened in Chennai; it is a six-storey marble construction with a hint of Art Deco. (The legacy of the 1930s building boom in India is still very much in evidence, though many of the surviving constructions are now obscured behind a layer of grimy mould.) With Pothys explained, we carry on for miles to the next town and I wonder what the Pothys hoarding is doing there in the middle of nowhere.

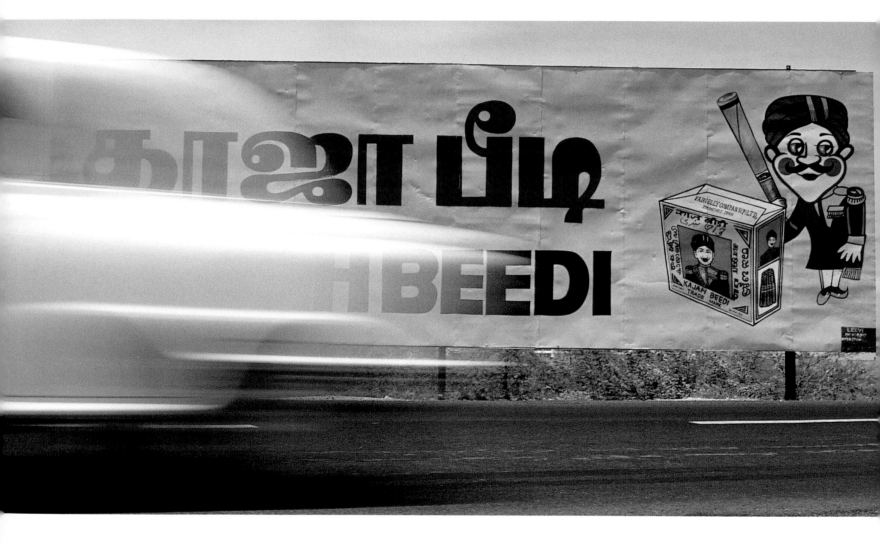

TOP LEFT Packaging design with a romantic theme of two songbirds to brand a diminutive matchbox.
ABOVE The manufacture of Beedi cigarettes is an important industry in Tiruchirappalli in southern India.
FACING TOP A public-health warning in Mumbai.

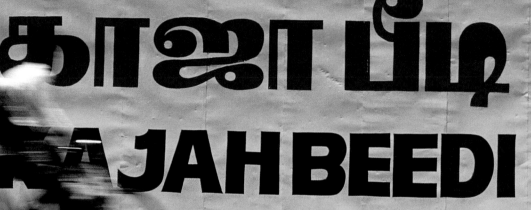

The answer is obvious enough. Prior to the 18th century, the advertising business consisted of hawkers simply calling out the names of their wares. In the 20th century, the satellite channel Zee TV started to broadcast to India's avid, multi-million audience. Despite technological advancements and the extraterrestrial digital communications explosion, the lone hoarding in the middle of nowhere with nothing to distract from its graphics but sky – and further enhanced visually by a small copse of palm trees in the distance – is a picture that stays in the mind far longer than a dozen repeats of a 30-second TV commercial.

In more urbanized areas, the hoarding assumes a more aggressive and multitudinous aspect. Edges of flyovers and hundreds of domestic exterior walls are littered with large, rectangular placards advertising everything from life insurance to pimple ointment. Most Indians ignore or embrace the hoardings, but some protest. Corporation committees are set up to deal with their fungal encroachment. But the civic bodies find it increasingly difficult to regulate the growth of their city's billboard skyline as the advertisers wield considerable political influence.

Antiquity

Rare
Premium Whisky

Distilled, Blended & Bottled
In the Excise Bonded Warehouse
By Pampasar Distillery Limited
Hospet, Bellary Dist , Karnataka
For Shaw Wallace & Co. Ltd.

Contents 750 ml
Produce Of India Strength 42 8% v/v

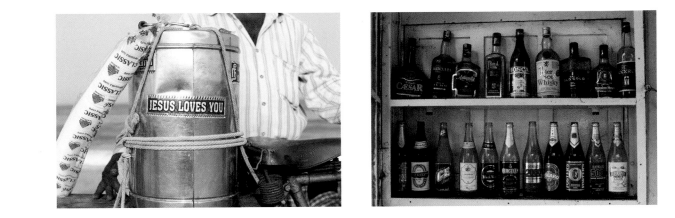

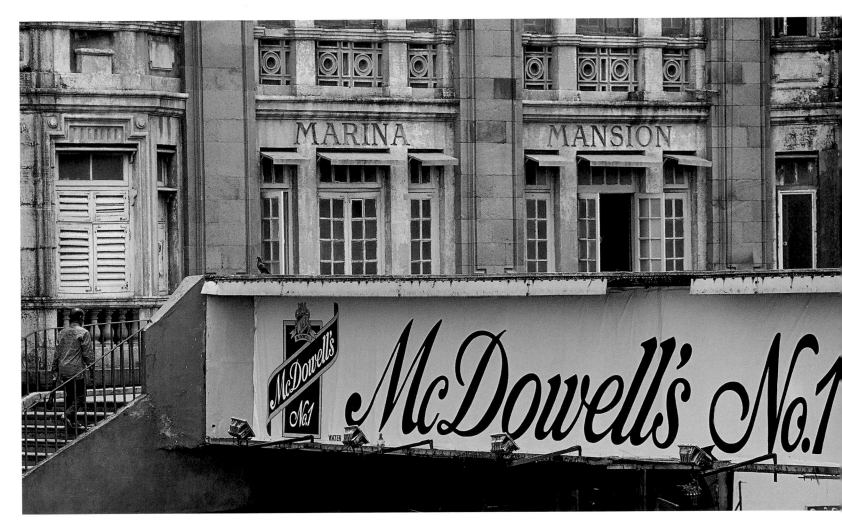

TOP LEFT Tea total: a tea vendor on Chennai's Marina Beach shares his religious convictions.
TOP RIGHT AND FACING A liquor store in Pondicherry displays its wares.
ABOVE Liquor advertising on a pedestrian bridge in Mumbai.
OVERLEAF An advertisement publicizing an appropriate brand in the former French colony of the Union Territory of Pondicherry.

135

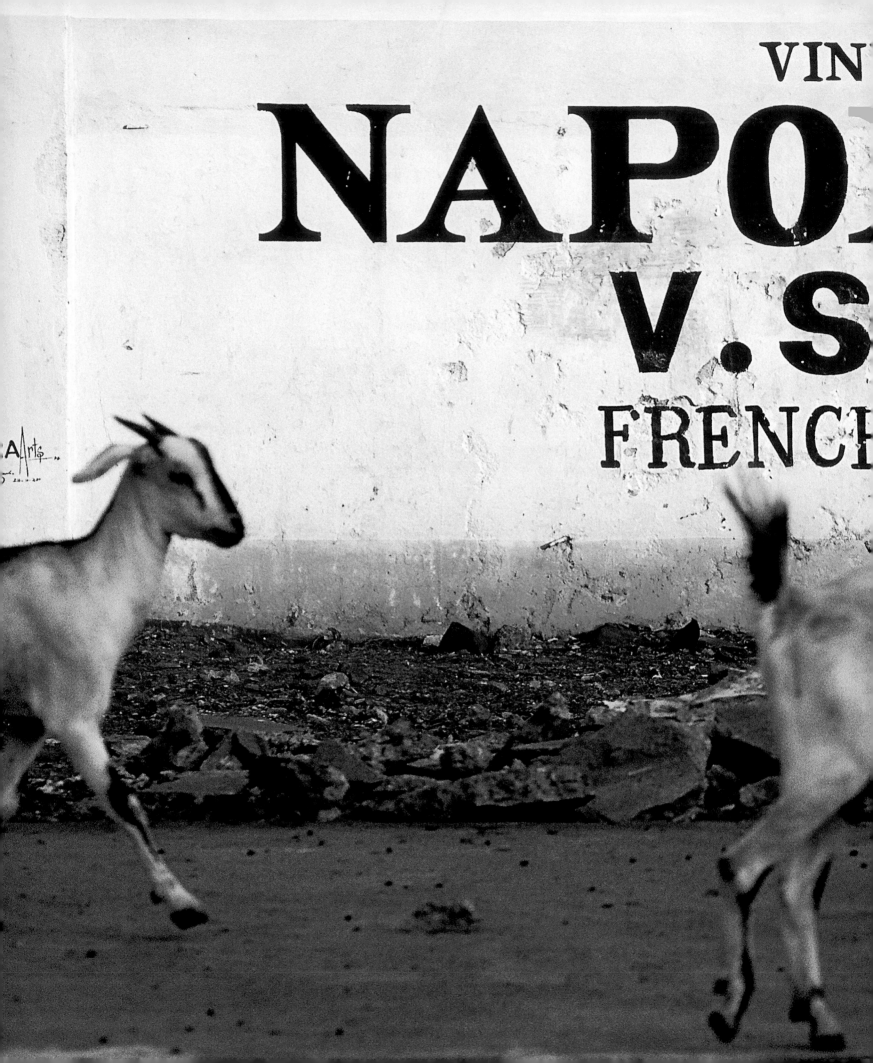

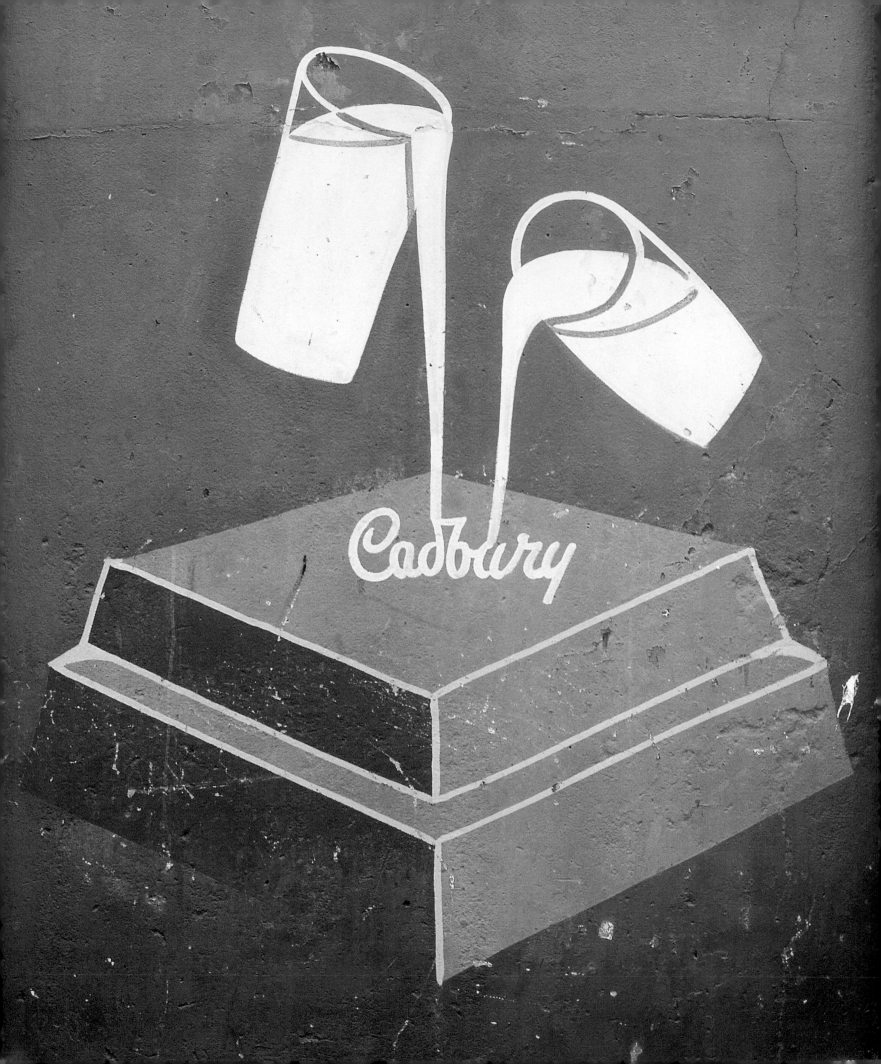

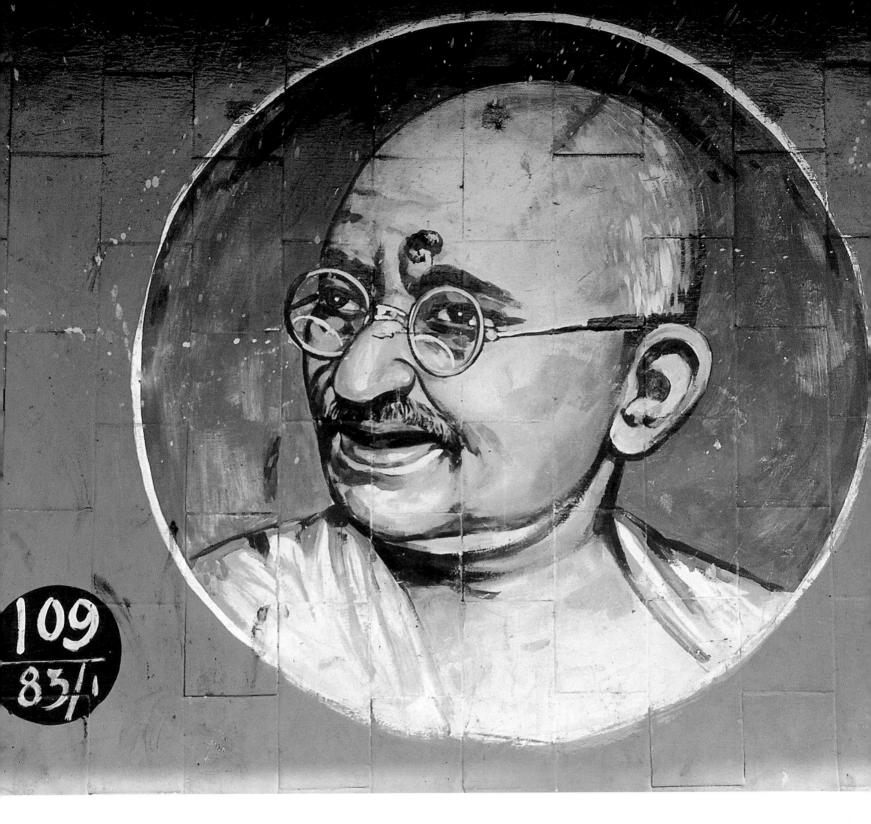

ABOVE Mohandas Karamchand Gandhi, the father of Indian independence. Gandhi was dubbed 'Mahatma' (Great Soul) for defending the rights of the poor during his political career.
FACING Cadbury has had to adapt its recipe for India's warm and humid climate.
OVERLEAF Battery manufacturer Ever Ready advertises its products with fiery gusto.

Chocolate, baby oil and milk

The girl was about five years old and wore a thick cotton dress that was heavy with grime. Her young feet were already showing signs of splayed toes as a result of having to walk barefoot everywhere over broken concrete pavement and hot Tarmac. Her father was playing cards with friends on an upturned oil drum next to a terrace of low-rise shacks. Bits of furniture and cooking pots lined the narrow space between the shacks and the noisy, shuddering traffic. Occasionally, unfriendly fluorescent light would reveal the scant interior of the homemade shelters. On a rope and timber bed, a bony old man dressed in a patterned dhoti slept with one arm bent over his face.

The small girl was sitting cross-legged on the roadside as a scrawny, almost featherless chicken pecked discriminatingly through the litter. She tugged hard on the udder of a tethered goat, put the teat in her mouth and drank the warm milk. On the other side of the road, intermittently visible through the passing trucks and taxis, was a Cadbury chocolate advertisement. The hand-painted commercial illustrated Cadbury's unique selling point – two glasses of milk in every bar or, so it appeared in this case, two glasses in every chunk. Fresh, white milk was shown flowing from a clean, clear glass into a chocolate chunk against a corporate-lilac background.

On the other side of the road, the goat and the girl were oblivious to the irony of the situation. A chocolate company processes millions of gallons of milk to provide middle-class Indians with a luxury snack, while a child on the street makes do with unpasteurized goat's milk. The latter may be fresh, nutritious and natural, but the girl may never taste the delights of milk chocolate.

When it comes to advertising, middle-class India is a market worth attracting. By the end of the 20th century, India's bourgeoisie was estimated at 300 million people. This is a class that was virtually non-existent in 1947 when India gained independence. The impressive growth continues. This is potentially one of the world's leading economies. Initially, India was favoured over, say, China by international trade because of its use of English not only as a business tool but also as the language of government. China had the further disadvantage of not sharing the democratic ideals of India and the West. Now, however, Western views vary. 'The problem with India is that it continues to be a country of great potential. Which means it never actually happens,' I am told by a British acquaintance who went to Mumbai for four years to set up a financial institution. 'People are finding it easier to do business in China.' She may be right: China is developing faster. Indian exporters could probably do better if they wanted to, but many Indian companies

ABOVE Corporation committees are set up to deal with the fungal encroachmnet of billboards in the city. The contact telephone numbers are for the billboard agency.
FACING The latest technology still makes use of the skills of the traditional sign painter.

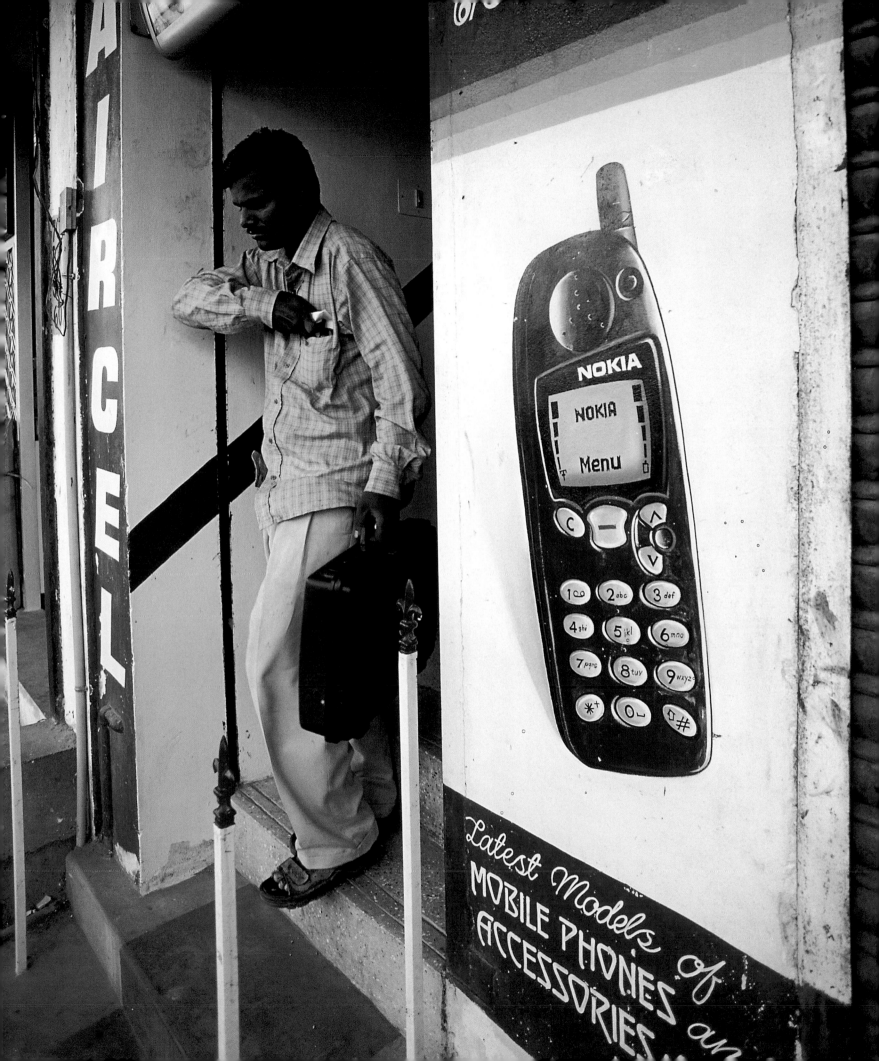

aren't concerned with the global market because they believe the domestic market is large enough. Surely the 1.2 billion population is sufficient to sustain any service or product, runs the reasoning. Nonetheless, more than a third of the population is too poor to be able to afford an adequate diet, let alone experience the delights of a disposable income. To witness the middle-class shopping experience in Mumbai, Delhi or any highly populated city in India is to understand the local market potential. There are shops selling millions of yards of clothing material, either raw and off the roll, or as ready-mades. There are shops selling cameras, mobile phones, portable mini-disc players and other, frankly non-essential, items. The happy-to-spend domestic market not only exists, but is very active.

Marketing and advertising are considered an essential part of commerce in India, more important sometimes than the product itself. To supplement his multi-million-dollar salary for film roles, the god of Indian cinema, Amitabh Bachchan, endorses hundreds of products. In a shop in Madurai, I noticed a large photograph of him on some packaging as I was waiting in a queue. Lots of large headline text and a speech bubble containing an endorsement quote from the famous actor filled the A4-sized card. At the bottom of the sheet, a cellophane window revealed what the product for sale was: a school pen. Bachchan, in this case, is far more important than the product.

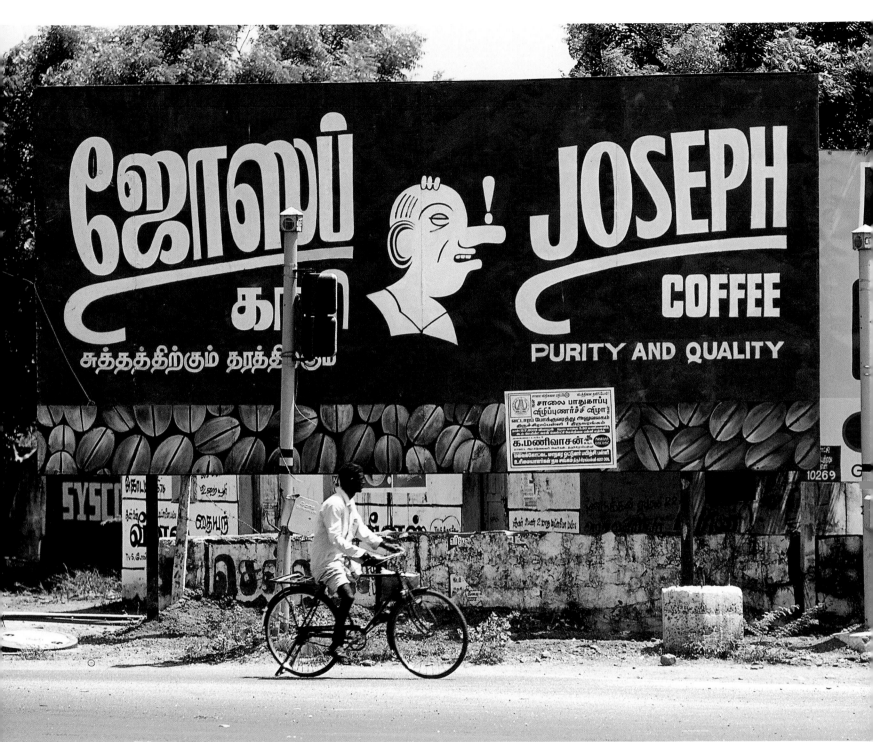

The Big B, as he is known to millions of Indian film fans, has been a megastar for three decades and his audience is devoted. In Dubai in 1988, investor Sylvester Stallone appeared for the opening of his latest Planet Hollywood, as did Bachchan. The crowds mobbed the Indian action hero and ignored the Hollywood star. Assuredly the pen will sell.

 In India, the history of mass-selling started in the 19th century as classified advertisements appeared for the first time in the *Bengal Gazette*, India's first weekly newspaper. Retailers' catalogues provided early examples of marketing promotions, and advertisements appeared in newspapers in the form of lists of the latest merchandise from Britain. In the 1920s, the first foreign-owned advertising agencies, such as Ogilvy & Mather and J. Walter Thompson, set up business in India, while American importers hired a magazine managing editor called Jogan Nath Jaini to run the first national agency created exclusively to represent US interests. By the early 1940s, there were a number of Indian agencies. Making money out of selling a product with advertising soon became a popular and profitable pastime for the numerate and creative of mind. Leela Chitnis became the first Indian film actress to endorse Lux beauty products. The first television commercial was seen in 1978. By the end of the 20th century the media boom was in full swing with the growth of cable

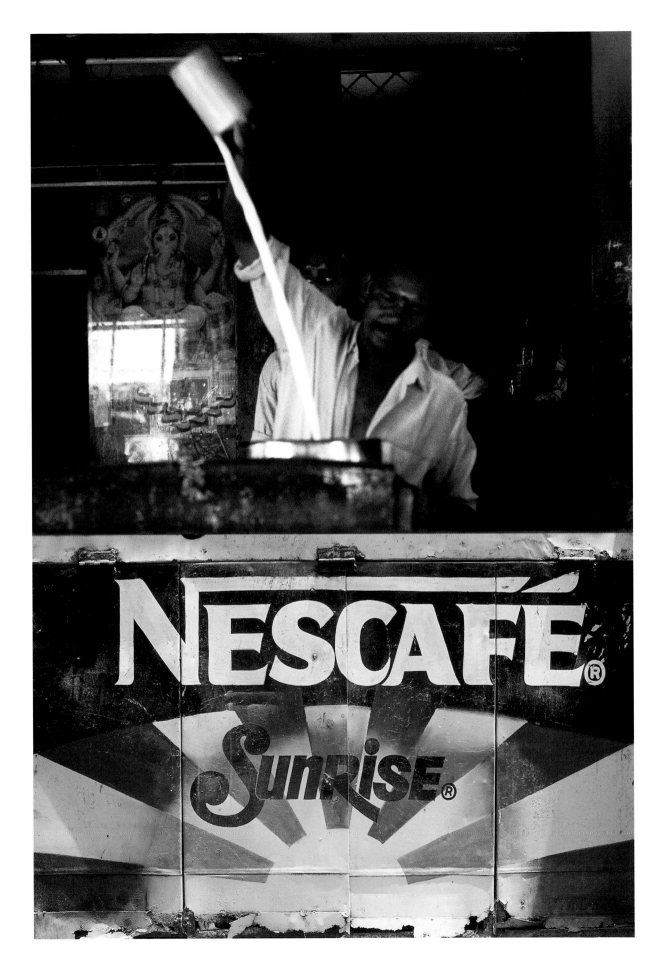

RIGHT Cappuccino Hindu-style: the milky froth is achieved by pouring hot milk into the coffee cup from a great height.

FACING Tea is one of the oldest beverages; grown in China since prehistoric times, it was being produced on a commercial scale there by the 8th century. In India, Darjeeling produces the bulk of the crop – about 25 per cent of the country's total.

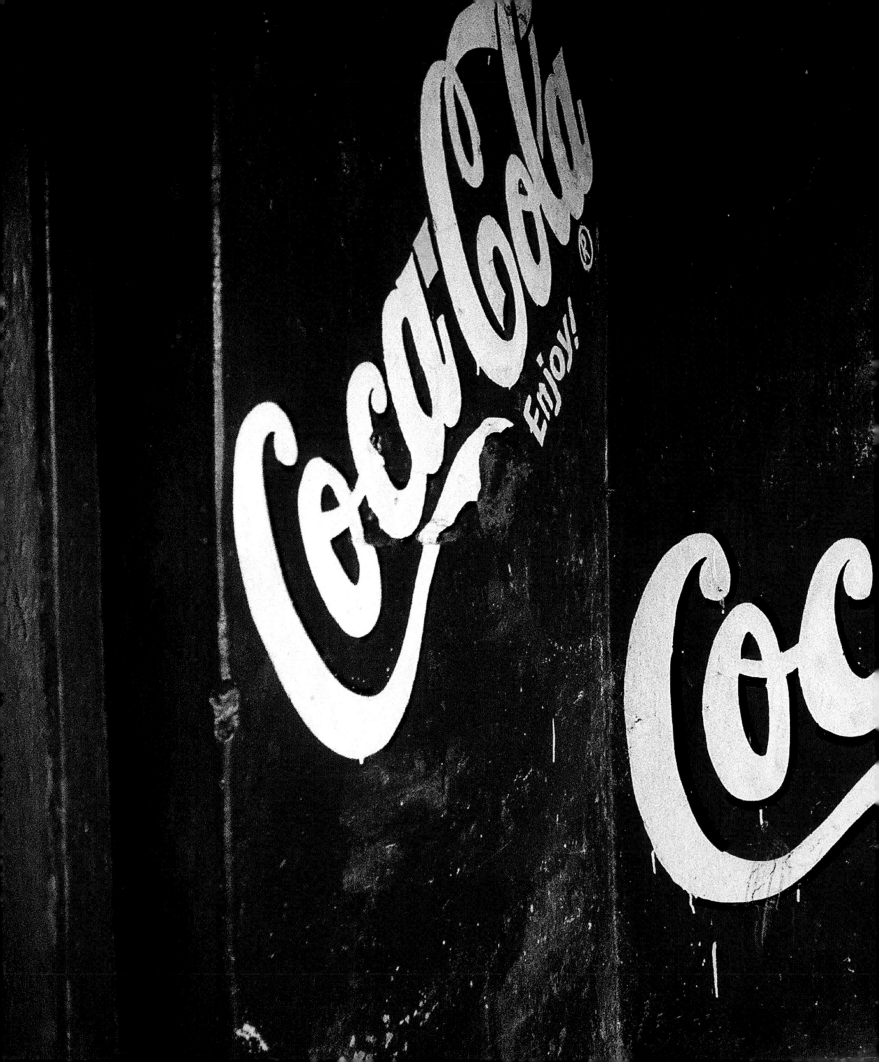

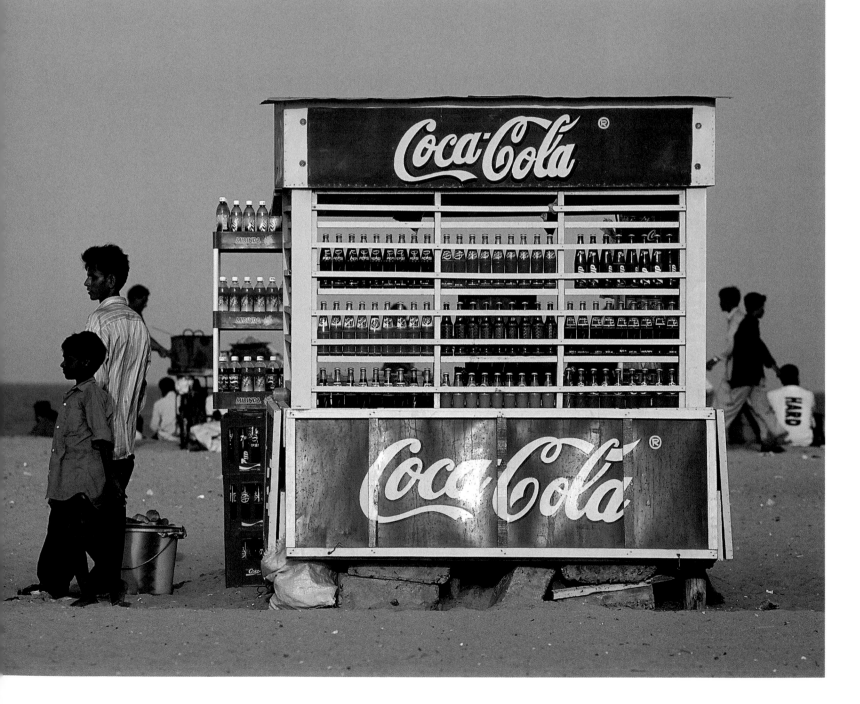

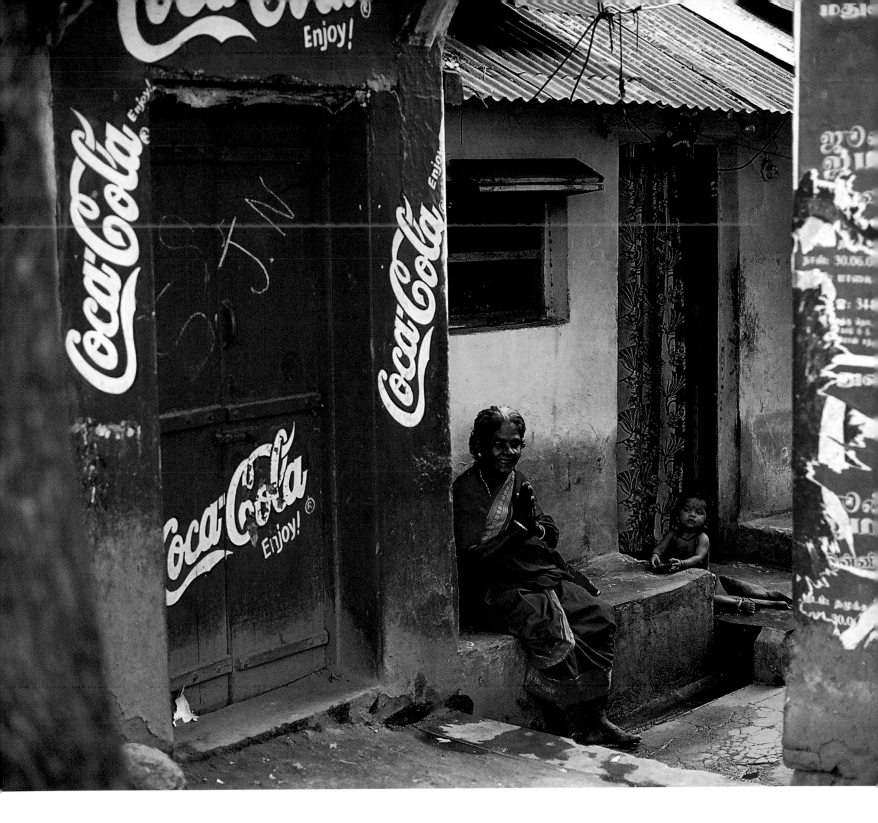

The cola wars are raging: 'International Cool' and blanket advertising are some of the reasons why Coca-Cola and Pepsi will win the battle over local rivals such as Thums Up.
FACING, TOP RIGHT Strange fruit: a unique display for soft drinks at a roadside 'cool stop'.

and satellite television, and the first India-targeted satellite channel, Zee TV, was broadcasting.

Brand awareness takes on a new dimension and a fresh potential as television audience figures are fed back to the marketing analysts. The Indian middle-income group is considered to be one of the fastest growing in the world. Increasing urbanization and globalization are rapidly affecting social structures. The lifting of restrictions in accordance with the demands of the World Trade Organization (of which India is now a member) has meant an influx of imported food and drink products. Western food has become fashionable and fast-food outlets abound. In major cities across India, McDonald's are serving the Chicken Maharaja and the McAloo Tikka Burger. The vendor smiles, hands over the food and concludes the sale with 'Have a nice day' in Hindi, while Colonel Sanders winks his approval from a promotional display in the front window of a Kentucky Fried Chicken franchise.

The United States of America is India's largest trading partner and plays a dominant role in India's trade. At the beginning of the 21st century, it accounted for over 20 per cent of India's exports and almost 8 per cent of its imports. Non-traditional items such as gems, jewellery and clothing have been the mainstay of the export market to the USA. Apart from oil, India's main import from America is

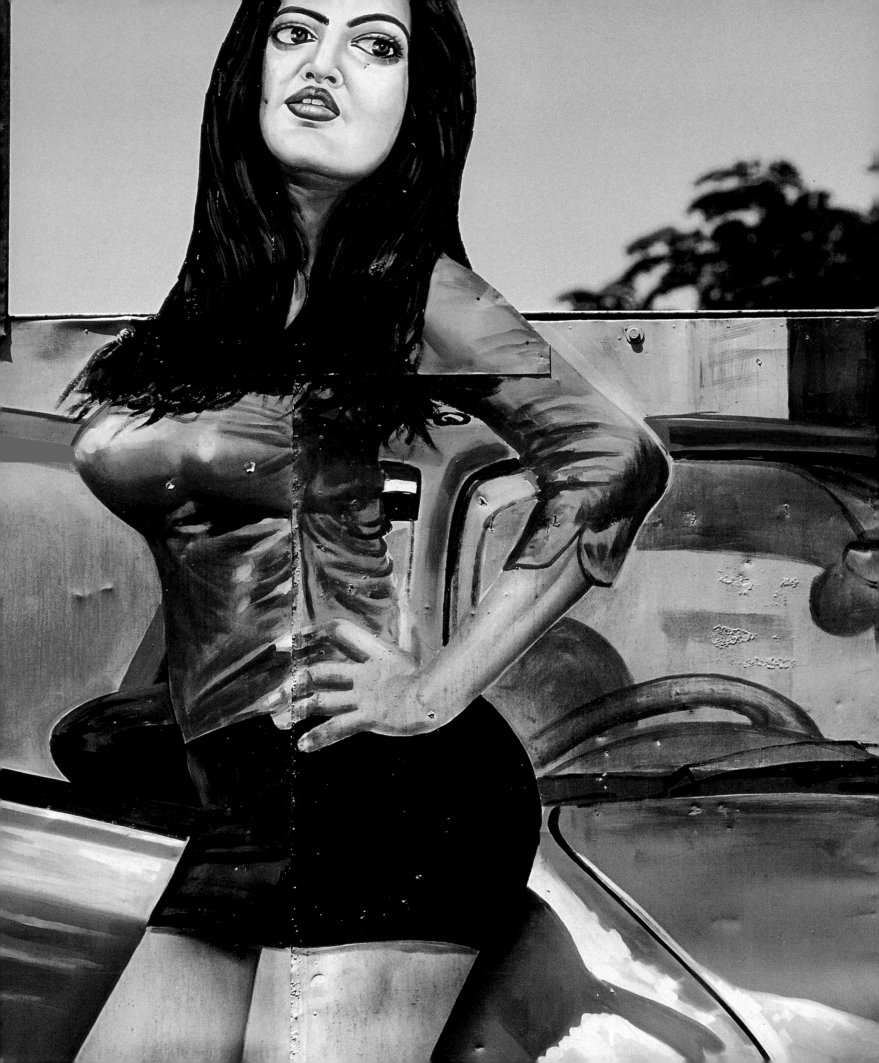

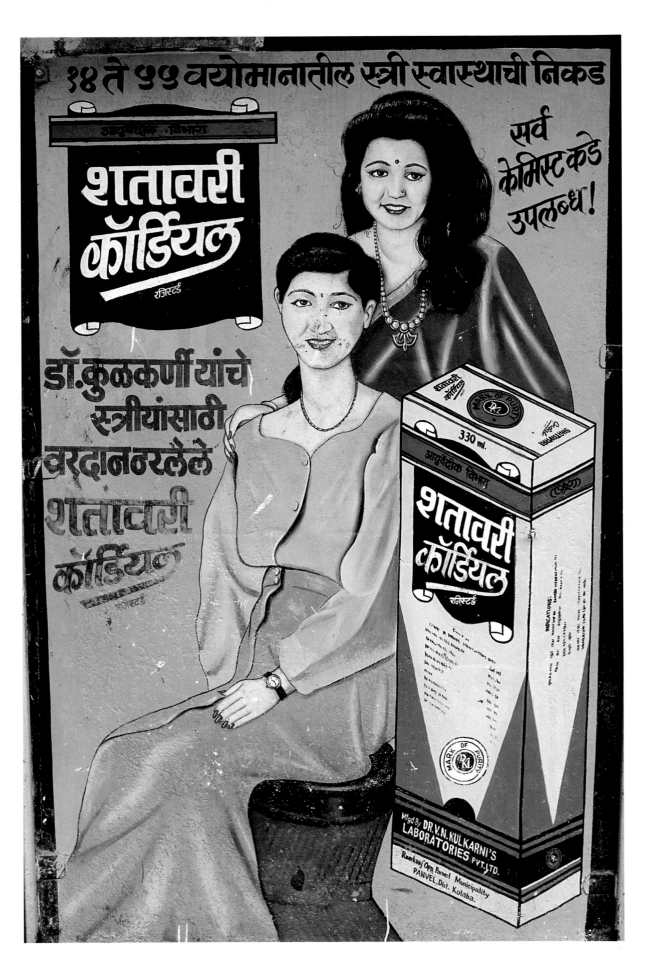

RIGHT An advertisement for hair dye –
written in Marathi.
FACING Lady of the road: an
advertisement for Maruti cars.

153

electronic goods and machinery.

Food and drink are on the list of increasing exports from India. Imports, meanwhile, have been waging war. Coca-Cola has been vying for a place on India's Major Imports list. The battle has been raging to grab a share of an estimated $2.5 billion soft-drinks market by the end of 2005. Coca-Cola entered India in the mid-1950s but, along with other multinational companies, was ordered to leave by the nationalist Janata Dal government in 1977. The West's staple beverage re-entered the market in 1997 by means of the Indian bottling company Brindavan; in 1998 it set up its own plants.

While the international giants were banned, local cola companies emerged to fill the potentially huge gap in the home market. India's Thums Up cola enjoyed a winning streak in the period of foreign banishment. Some also considered that the Coke and Pepsi tastes were simply too bland; Thums Up's aromatic flavour appealed to the local palate. Coca-Cola has therefore had to adapt its marketing recipe, if not its mix of ingredients. It has sponsored cricket for the first time – a wise move, as cricket is the national game: *Indians are very good cricketers, therefore Coca-Cola must be a very good drink.* Famous and revered Indian screen stars have also been employed to deliver the

ABOVE Delivery vans of the four-wheeled and three-wheeled varieties. FACING A happy street cleaner with a pedal-powered vehicle sponsored by a brush manufacturer.

message of national acceptability. Coke and its most powerful adversary, Pepsi, have been fighting on-screen battles, with each hiring Indian film stars and directors to spar for public attention in television commercials. Tactics are aggressive as campaigns for supremacy are fuelled by escalating advertising and promotional budgets. 'International Cool' and the desire for status symbols are among the reasons why Coca-Cola and Pepsi will win the cola wars over local rivals.

Baby oil is another potentially huge market in India. Baby massage is part of the domestic cultural heritage, passed on from mother to daughter and from ayah to infant. Although Johnson's Baby Oil is relatively inexpensive, the Indian market already had cheaper rival products in plentiful supply, such as coconut, groundnut and olive oil. A local company, Dabur India, marketing a baby oil called Lal Tail targeted at the rural population, has managed to gain the biggest market share, outselling Johnson's.

'Made in India' may still suggest unreliability in Western minds. However, perceptions are changing: once principally thought of as a hippy destination for British pop stars wanting to find themselves, India has become associated with more commercial ideas over the past few decades, such as the natural organics so popular with UK importers of clothing in the 1970s and 1980s and the use of such

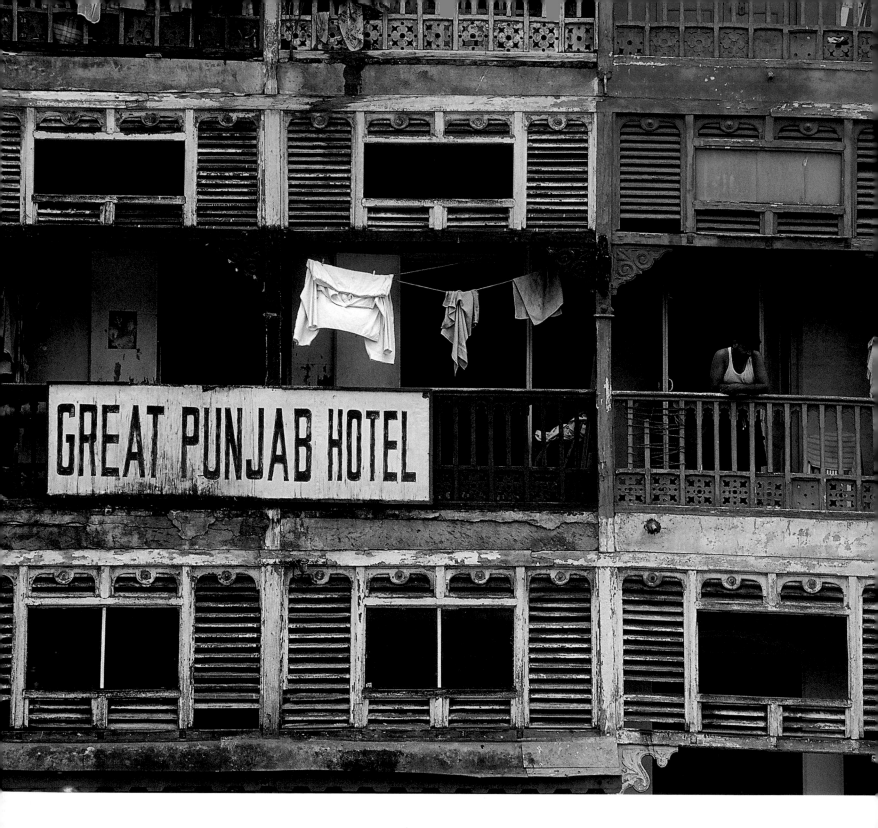

'radical' ingredients as hemp in soap by the cosmetics industry. This is having a beneficial entrepreneurial impact on the country. The cola wars and the struggles for market shares are a mere flurry in the avaricious activity of thousands of years of international trade. Cultures and exporters adapt to befriend their potential market and to suit local conditions. Cadbury had to adapt its recipe – to stop the precious confection from transforming itself into liquid ambrosia in the warm Indian climate – but not necessarily its marketing strategy.

But as the middle-class population grows, so does poverty. India still has the world's largest number of poor and they are as common a feature of everyday life as the commerce that surrounds them. The contrasts between rich and poor may not be as apparent as in the days of Rajput sovereignty, maharajah dynasties or colonial rule – the dividing catalyst now is burgeoning commerce. Education and social empowerment of the economically weaker sections of society are expected to alleviate the problem of poverty over the next 50 years: it will be a very long and gradual process. Meanwhile, the small girl opposite the Cadbury advertisement survives on benevolence and goat's milk.

ABOVE **A room with a view – of downtown Mumbai.**
FACING **The media buyer and advertising agent have a variety of surfaces and spaces to choose from to publicize their wares.**

ABOVE Wall painting advertisement near Chennai.
OVERLEAF This crisply-rendered letter with classic drop shadow forms part of signage promoting the Cake Shop in Chennai.

Acknowledgements

Thanks to: Laurence King, Jo Lightfoot, Laura Willis and Felicity Awdry at Laurence King Publishing; project editor Robert Shore;
Divia Patel, Curatorial Assistant at the Indian and South-East Asian Department, Victoria and Albert Museum; Helen Portas, Victoria and
Albert Museum; Damian McCollin-Moore, BFI; Balkrishna Vaidya, Hemant for translating and all the staff at Balkrishna Arts, Mumbai;
Rosie Catherwood; Lopa Khahari; Irene Dass; Zandra Rhodes; Andrew Logan; Robert and Roma Bradnock/Footprint India Handbook 2002;
MF Husain; Reshma Masrani; Sanjay Masrani; Gilly Lovegrove; Edward and Babs Lovegrove; Alec Lovegrove; Jonty Sharples; Carolyn Dunn;
Mani Mann; Ranjana Naidu-McFarland; Siama Ahmed; C Mariadoss; Naresh Savaria; Mohan Sivanand; Deepali Nandwani.
 A very special thank you to Andrew Hasson for his excellent photographs and for his companionship during an unforgettable journey
through southern India.